SHOOT!

EVERYTHING

YOU EVER

WANTED TO

KNOW ABOUT

35MM PHOTOGRAPHY

EDITED BY
LIZ HARVEY

AMPHOTO
AN IMPRINT OF WATSON-GUPTILL PUBLICATIONS
NEW YORK

Dedicated to the memory of my father

Shoot! is every editor's dream: a project that gives you the opportunity to work with extraordinary talent and material. I want to thank each of the photographers who graciously agreed to have their work included in this book. Many thanks as well to my colleagues: Mary Suffudy, for conceiving the project; Marian Appellof, for guiding me along the way; Jay Anning and Ellen Greene, for their expertise and invaluable assistance; and Robin Simmen and Sue Shefts Traub, for their support.

Copyright © 1993 by AMPHOTO
First published in 1993 in New York by AMPHOTO,
an imprint of Watson-Guptill Publications,
a division of BPI Communications, Inc.,
770 Broadway, New York, NY 10003

Library of Congress Cataloging-in-Publication Data
Shoot!: everything you ever wanted to know about 35mm photography/edited by Liz Harvey.
 Includes index.
 ISBN 0-8174-5869-7 (pbk.)
 1. Photography—Amateurs' manuals. I. Harvey, Liz.
TR146.S5155 1993 92-39858
770—dc20 CIP

Manufactured in Japan

9 10 11 12 13 14/07 06 05 04 03 02 01

Edited by Liz Harvey
Designed by Jay Anning
Graphic production by Ellen Greene

CONTENTS

INTRODUCTION

Photography is often referred to as "writing with light." This apt description captures the very essence of photography—its compelling combination of technique and creativity. As an avenue of expression, this visual medium gives you the opportunity not only to record reality, but also to interpret it. You perceive the world in motion, as a continuum, yet photography enables you to stop time, to freeze and capture moments on film.

The photographs you make are limited only by your skills, imagination, desire, and tenacity. So if you want to produce aesthetically appealing and technically proficient images, you need to become a student again. You must be willing to learn photographic processes step-by-step, and to practice them until they are second nature to you. You must also be willing to open your mind to new, unexpected, and perhaps even startling ideas and approaches.

Next, you have to find someone to teach you. You could, of course, seek out one individual. But you'll get a more well-rounded education if you have a variety of instructors who are considered to be some of the finest professionals in the field. This idea was the driving force behind *Shoot!*, and the goal was to bring together in one volume the most informative text and the most striking images from the many photography-instruction books Amphoto has published. *Shoot!* is just that, a compilation of the best of Amphoto's best. Assuming the role of instructor, fourteen photographers share their expertise, technical knowledge, and personal vision. Collectively, they tell you everything you ever wanted to know about 35mm photography. And while their approaches to photography differ, and in some instances even conflict, all of them are valuable. As you read this book, you'll undoubtedly find yourself preferring some photographers to others. But don't let this deter you from trying alternative methods. Remember, a good student must have an open mind and be willing to experiment.

Shoot! is designed for both neophyte photographers who want to master the medium and advanced amateurs who want to shoot for stock or hope to turn pro. If you're just starting out, you can treat this book as a basic course in photography. You can read *Shoot!* from cover to cover, learning essential principles first and then progressing to more complex techniques. For example, you'll see how to operate a 35mm camera, light meters, flash units, and tripods; how to choose and use lenses and filters; and how to decide between color and black-and-white film, as well as between print and slide film. How to effectively compose an image and how to shoot in different lighting situations are also covered in detail. And exposure, a difficult concept that photographers often find confusing, is demystified via a series of side-by-side comparison shots and easy-to-understand language. You can also learn how to print black-and-white photographs step-by-step.

If you are a more experienced photographer who wants to sharpen your skills and produce professional-quality images, you can think of *Shoot!* as an intensive workshop. After reviewing the fundamentals, you might decide to focus on freezing action, shooting deliberate double exposures, or practicing what to do when there is no middle tone to read. Otherwise, you might decide to concentrate on the section devoted to areas of specialization and career possibilities. These include travel, underwater, wildlife, beauty, fashion, food, and still-life photography. Then you can take a look at the appendix to discover how to successfully market your work as stock.

Shoot! is an invaluable reference that will help you develop a thorough understanding of 35mm photography. This, in turn, will enable you to derive more satisfaction from your photographic efforts and improve the quality of your images. Finally, the exceptional material of Amphoto's best authors in *Shoot!* will undoubtedly inspire you to develop your own style and to create your best photographs ever.

–Liz Harvey

CONTRIBUTORS

Excerpts have been taken from the following books, listed here alphabetically by author.

John F. Carafoli
FOOD PHOTOGRAPHY AND STYLING

Based in New York City and Boston, John F. Carafoli is a food stylist who began writing and styling feature stories about food for *The Boston Globe*. His writing and styling have since appeared in *Bon Appetit*, *Better Homes and Gardens* (magazine and cookbook), *Ladies' Home Journal*, and *Prevention*. Some of his recent still-life and television accounts include Pepsi, Ocean Spray, McDonald's, the Ground Round, and Pepperidge Farm.

Patricia Caulfield
CAPTURING THE LANDSCAPE WITH YOUR CAMERA *and* PHOTOGRAPHING WILDLIFE

Born in Chicago and raised in Iowa, Patricia Caulfield held a variety of editorial positions at *Modern Photography* magazine. She resigned as executive editor at the magazine in 1967 to devote herself full time to nature photography and conservation. Caulfield has been a contributor to many magazines, including *Audubon*, *Natural History*, *National Geographic*, and *National Wildlife*. She lives in New York City.

Lou Jacobs, Jr.
AVAILABLE LIGHT PHOTOGRAPHY *and* SELLING STOCK PHOTOGRAPHY

Lou Jacobs, Jr., a well-known writer and photographer, is the author of more than 20 books on photography, including *Developing Your Own Photographic Style* and *Selling Photographs*, both published by Amphoto. He is a past president of the American Society of Magazine Photographers (ASMP) and is currently a member of its board of directors. Jacobs has taught photography courses at UCLA, Cal State Northridge, and Brooks Institute of Photography, and has written extensively for photographic magazines. He lives with his wife, Kathy, in Cathedral City, California.

Seth Joel
PHOTOGRAPHING STILL LIFE

Maintaining a studio in New York City since 1979, Seth Joel has produced books, posters, and exhibition catalogs for the Metropolitan Museum of Art, the Museum of Modern Art, the Brooklyn Museum, Fashion Institute of Technology, and the Armand Hammer Foundation. His work has appeared in various magazines as well, including *Smithsonian*, *Connoisseur*, and *Art News*. He lives with his wife and two children in New Jersey.

Lucille Khornak
FASHION PHOTOGRAPHY

Lucille Khornak is a former fashion model who moved to the other side of the camera in 1978. She owns and operates a studio in New York City. Her photographs have appeared in many major publications, including *Vogue*, *Newsweek*, *The New York Times Sunday Magazine*, and *New York* magazine. Her clients include Emanuel Ungaro, Yves St. Laurent, Pierre Cardin, Givenchy, Helena Rubinstein, and Coty Cosmetics.

Joe Marvullo
COLOR VISION

Joe Marvullo is a professional photographer who lives and operates a studio in New York City, and gives lectures on photography throughout the United States. His clients include IBM, Citibank, Pierre Cardin, Mobil, and ABC-TV.

Joe McDonald
THE COMPLETE GUIDE TO WILDLIFE PHOTOGRAPHY

A photographer, writer, and lecturer, Joe McDonald leads photographic tours to exotic places around the world and conducts photography workshops throughout the United States. His images have been included in the calendars of the Audubon Society and the Sierra Club. McDonald's photographs have also appeared in such national nature magazines as *National Wildlife*, *International Wildlife*, *Audubon*, *Natural History*, and *Wildlife Conservation*, as well as in *Newsweek*, *Time*, *Smithsonian*, and *National Geographic*. He and his wife, Mary Ann, live in McClure, Pennsylvania.

Joseph Meehan
THE COMPLETE BOOK OF PHOTOGRAPHIC LENSES *and* THE PHOTOGRAPHER'S GUIDE TO USING FILTERS

A former professor in the State University of New York system, Joseph Meehan has also taught photography courses at the School of Art, Ealing College, London, and the National Taiwan Academy of Art, Republic of China. In addition, he is a contributing editor to *Petersen's Photographic* and writes for the *British Journal of Photography*, *Industrial Photography*, and *Photo District News*. His other Amphoto title is *Panoramic Photography*. Meehan resides in Salisbury, Connecticut.

J. Barry O'Rourke
HOT SHOTS

J. Barry O'Rourke, a photographer whose work regularly appears in such magazines as *Ladies' Home Journal*, *Bride's*, and *Newsweek*, owns and operates a studio in New York City. In addition, he is the co-owner of The Stock Market and serves on the board of directors of the Advertising Photographers of America. O'Rourke is also the author of another Amphoto title, *How to Photograph Women Beautifully*.

Bryan Peterson
LEARNING TO SEE CREATIVELY *and* UNDERSTANDING EXPOSURE

Bryan Peterson is a professional photographer who specializes in corporate and industrial annual reports. His photography seminars showcase his unique teaching methods. His work has appeared in numerous magazines, including *Popular Photography*, *SLR*, *Pacific Northwest*, *Oregon*, and *Wine Country*. Peterson's clients include Nike, Amoco, Minolta, Nikon, Manufacturers Hanover, Burlington Industries, and Weyerhauser. He resides in Portland, Oregon.

George Schaub
BLACK AND WHITE PRINTING, SHOOTING FOR STOCK, *and* USING YOUR CAMERA

George Schaub is the editorial director at PTN Publishing Company, a publisher of photographic trade magazines. His work has appeared in various magazines, including *Popular Photography*, *Travel & Leisure*, *The New York Times*, and *Darkroom Photography*. His other Amphoto titles are *Professional Techniques for the Wedding Photographer*, *The Amphoto Book of Film*, and *The Amphoto Black and White Data Guide*. Schaub lives with his wife, Grace, in Sea Cliff, New York.

Charles Seaborn
UNDERWATER PHOTOGRAPHY

A professional underwater photographer, Charles Seaborn has been a contributor to many magazines and professional journals, including *Audubon*, *Natural History*, *Geo*, *Oceans*, and *Skin Diver*. He makes his home in Rose Lodge, Oregon.

John Shaw
THE NATURE PHOTOGRAPHER'S COMPLETE GUIDE TO PROFESSIONAL FIELD TECHNIQUES, JOHN SHAW'S CLOSEUPS IN NATURE, *and* JOHN SHAW'S FOCUS ON NATURE

John Shaw is a nature photographer who regularly publishes his photographs in such magazines as *Audubon*, *National Wildlife*, and *Natural History*, as well as in filmstrips, advertisements, and books. He teaches summer field workshops across the United States and leads photographic tours to a variety of destinations. Shaw lives with his wife in Greensboro, North Carolina.

Nevada Wier
ADVENTURE TRAVEL PHOTOGRAPHY

Nevada Wier is a professional photographer who specializes in remote-travel photography, particularly in Asia. Her images have been published in a number of magazines, including *Audubon*, *Discovery*, *Geo*, *Natural History*, *Popular Photography*, *Sierra*, and *Smithsonian*. She lives in Santa Fe, New Mexico.

PART ONE
EQUIPMENT

GEORGE SCHAUB

THE CAMERA COMPONENTS

The modern 35mm *single-lens-reflex camera* (SLR) is a highly sophisticated instrument. It contains complex circuitry, miniature motors, and microchips capable of making decisions based on preprogrammed memories that react to instantaneous changes in light and focus. Today's camera bodies have the "brains" that perform exposure—and in some cases, focusing—calculations. They also handle the more mundane, but no less important, functions of providing a light-tight chamber for film, a mechanism for film advance and rewind, a place for the shutter, and a mount on which to place the lens. Think of an SLR body as a control center from which you can exercise any number of options to influence the way a picture is made. By *programming,* or alerting the automatic features of a camera to your wishes, you can use it as a fully automatic, spontaneous picture-making machine that still allows you to shoot with a personal touch. You also can use it "manually," making decisions based on the information the camera and your instincts provide.

First, you need to understand what those three letters "SLR" mean. An *SLR camera* uses one viewing lens for focusing and capturing light. In contrast, the *rangefinder camera,* which also takes 35mm film, has a separate viewfinder that approximates the view of the lens in use, but isn't directly connected with the light path from the subject to the viewing screen.

Reflex refers to the way light travels from the subject to the viewfinder. In SLRs, light comes in through the lens and is reflected up by a mirror to a focusing screen that is found just below the camera viewfinder. A groundglass is located at the base of a box of mirrors, known as a *pentaprism.* What you see when you look into the camera is a corrected view of the scene made by a double set of mirrored surfaces in the housing. Without this setup, you would see an upside-down image in the viewfinder.

In addition to these components, all 35mm SLR bodies share certain features and functions. These include a viewfinder, film chamber, pressure plate, film-takeup spool, film-advance mechanism, film-rewind function, shutter, and shutter release, as well as a coupling device for attaching a lens. Depending on the individual camera, a number of other dials, switches, pushbuttons, and displays give control over picture-making decisions.

When you first pick up a camera, you're confronted with a thin, rectangular body made of plastic, metal, or a combination of these two materials. On the front of the camera body is an opening usually surrounded by a circular metal ring. This is the *lens-mounting flange* that enables you to *couple,* or mount, any number of interchangeable lenses to the body. This ring usually contains contact points or pins; these link the "brains" of the camera with the lens itself.

Every brand of camera has a distinct mounting system. This means that you must use a lens specifically designed for that particular camera, one made by the camera company itself or an independent lens manufacturer. Using an incompatible lens is impossible because it simply won't mount on the camera body.

Camera makers often change the coupling system when they bring out new camera models, making older lenses obsolete. While some older lenses from a manufacturer will fit on its new camera models, they may not be able to communicate with the camera itself. Also, lenses for manual-focus cameras often won't function on the autofocusing counterparts of the same brand. Before you purchase a lens, therefore, always make sure it is compatible with your camera.

In order to mount and disengage the lens, you must first push a lens-release button, which is usually located beside the lens on the lower left-hand side of the camera body. This releases any mechanical linkage between camera and lens.

Before you mount your lens, however, look inside the front, or *throat,* of the camera. The first object you'll see is a *mirror* angled at 45 degrees; this reflects light coming through the lens onto the viewing screen and/or metering cell in the camera pentaprism. When you take a picture, this mirror snaps up and out of the way. This is the source of the characteristic "clunking" sound of an SLR and allows the light to pass onto the film that sits by the opened shutter directly behind the mirror assembly.

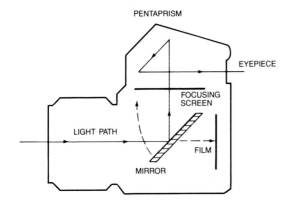

PENTAPRISM

EYEPIECE

FOCUSING SCREEN

LIGHT PATH

FILM

MIRROR

The viewing and exposure system in an SLR moves light in a number of ways. After light comes through the lens, it is first reflected off the camera's mirror to form an image of the subject on a horizontal focusing screen. The light is then bounced back and forth between the mirrors of the pentaprism, the housing atop the camera. These mirrors correct the image so it is right-reading. When the exposure button is pressed, the mirror flips up and out of the way, the viewing screen goes blank, and the film is exposed. Once the exposure is complete, the mirror returns to its original position.

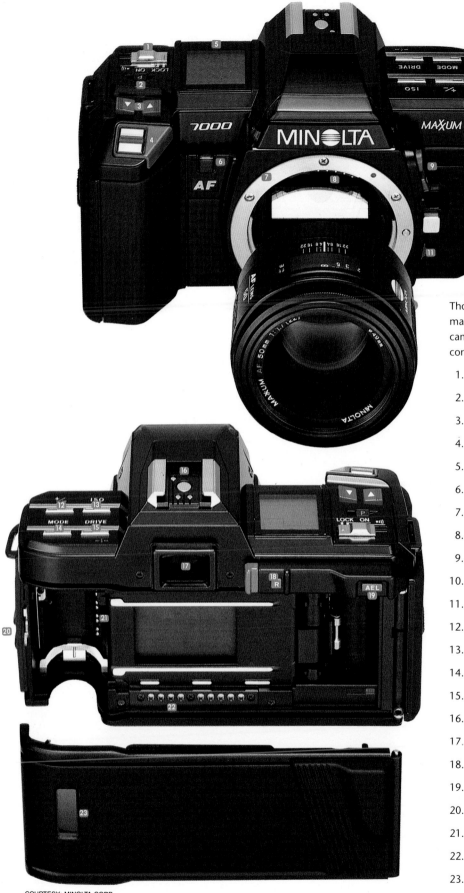

Though SLRs vary from model to model, many have the features shown on this camera, an autofocusing electronically controlled SLR:

1. On-off button

2. Reset button

3. Shutter-speed keys

4. Shutter-release button

5. LCD panel

6. Self-timer LED

7. Mounting ring

8. Lens contacts

9. Aperture keys

10. Remote-control terminal

11. Focus-mode switch

12. + / - key

13. ISO setting

14. Mode selector

15. Drive key

16. Hotshoe

17. Eyepiece

18. Rewind switch and release

19. Autoexposure lock

20. Back-cover release

21. DX contacts

22. Accessory back contacts

23. Film-type window

COURTESY: MINOLTA CORP.

The throat also contains a number of black-coated *baffles* and light-insulating materials. These seal the film, protecting it from light when the mirror is down and enable you to change the lens even when film is in the camera. Never tamper with these delicate casings; you might disturb their light-blocking qualities.

After you inspect these parts, mount a lens on the camera and take a look through the *viewfinder*. This enables you to see the same picture that will be recorded on film, usually minus about 3 to 5 percent at the edges. Today's viewfinders also serve as information-display centers, where a host of numbers, colored dots, lightning-bolt symbols, and blinking *light-emitting diodes* (LEDs) tell you about light levels, shutter speeds, apertures, exposure-mode selection, and, in autofocusing cameras, focus confirmation. The amount and type of information displayed varies from camera to camera. In short, viewfinders allow for complete control of the camera without the need for you to remove your eye from the finder.

The viewfinder's pentaprism housing also contains a *metering cell,* which can't be seen. A few cameras have the metering cell located below the mirror in the camera; some have cells in both locations. This light-measuring instrument provides the data that the camera then translates to aperture and shutter-speed settings.

Many SLRs also come with interchangeable *focusing screens.* A focusing screen is the glass on which the image appears when you look through the *viewfinder.* Some screens have a split-image rangefinder in the center surrounded by a *microprism collar,* all of which is surrounded by a matte groundglass. The split in the circle is a critical focusing aid. When subjects are out of focus, lines or shapes on either side of the split in the circle don't align; when the subject is in focus, they do. The microprism is composed of many prisms of glass that break up the surfaces within a scene, making it easier to focus, especially in dim light.

Focusing screens in autofocusing cameras contain rectangular brackets, located in the center of the frame. This is the autofocusing target: the camera will attempt to focus on any subject within this area. The location of the target can create a problem when you're composing with the main subject out of the center of the frame. In some cases, the autofocus system will give you incorrect readings unless you modify your focusing technique with the aid of an *autofocus-lock button.*

The next features you should be familiar with are located on the top plate of a modern SLR. This plate has, in addition to the *on-off button* (sometimes incorporated in the shutter release), a number of dials and buttons that are used to "program" the camera. Some SLRs have conventional dials with engraved numbers; others have pushbuttons and switches that read out on *liquid-crystal displays* (LCDs). Both types perform the same functions; the LCDs just add a bit of high-tech window dressing. The *LCD panel* is the information center for choosing and confirming different programs and is a checkpoint on camera-operating systems. Some of the information the LCD shows may also be seen in the camera

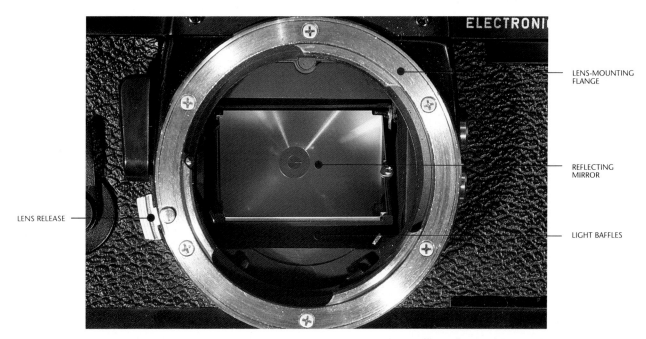

LENS-MOUNTING FLANGE

REFLECTING MIRROR

LENS RELEASE

LIGHT BAFFLES

This inside view of the front of an SLR body without a lens shows the light baffles, reflecting mirror, and some of the mechanical and electronic linkages many of today's cameras use to pass information from camera to lens and back again. Each camera system has its own mounting system, so you must use compatible lenses or you simply won't get a proper fit.

Located on the inside back of the camera, the pressure plate keeps the film flat as it passes from the cassette to the takeup spool. If dust or grit accumulates on this plate, blow it off with pressurized air or whisk it away with a soft brush.

viewfinder; however, in order to minimize distractions in the finder, most camera makers put all the information on the LCD. Some pushbutton or toggle controls on modern SLRs have multiple uses, and the LCD panel indicates which function has been selected by the way it lights up. A *reset button,* found on some SLRs, is the escape switch that lets you cancel any mode other than the "normal" operations you may have set on the camera; pressing the reset button returns the camera to fully automatic operation.

The *camera back* is hinged to the body and opens when you release the *safety-catch button* or lift the *rewind crank* with a decisive tug. Professional-style SLRs have completely removable backs, enabling you to replace them with a data back that allows for the imprinting of the date and time on the film or a long-roll film back that can hold up to 250-exposure-length films. Other camera backs work as intervalometers; that is, they program the shutter to fire over a fixed sequence of time. In the future, these backs will interface with computers and other electronic devices.

Looking inside the camera back, on the left-hand side of the film chamber, you may see a set of gold-plated pins. These are the *DX-code-reading contacts.* Nearly every conventional film made today is DX-coded. When you place a roll of film in a camera with DX-reading capability, this code informs the metering system of the *speed,* or light sensitivity, of the film in use, and relieves you of the bother of setting the film speed manually. The code is actually a series of black and silver boxes printed on the film cassette. There are two ways of telling if a film is DX-coded: one is the prominent display of the code on the film box and cassette; the other is the presence of an odd checkerboard of squares on the film cartridge. Don't worry if you don't see any DX-code-reading pins in your camera; you can set the ISO code manually on the appropriate dial.

Attached to the camera back is a sort of floating metal plate, called the *pressure plate.* Because film has a natural curl to it, more or less emphasized by temperature and humidity, the pressure plate plays the critical role of keeping the film flat as it passes through the camera. The pressure plate is very delicate, so avoid touching it. Any misalignment can cause problems with film flatness,

which will adversely affect sharpness in the final image. If any dust or grit lands on the plate, use compressed air and a soft brush to clean it. Be aware that grit left on this plate may scratch the film as it passes.

While you still have the camera back open, inspect the *shutter curtain,* the metal or cloth rectangle that sits squarely in the center of the film channel between the guide rails. When the shutter is released, a set of curtains —a leading and a following curtain—opens and travels across the film plane for a specified period of time. As the light entering the lens then passes through the open shutter, the film is exposed. The length of time in which this happens depends on the shutter speed set by you or the autoexposure system of the camera. The shutter curtain is also quite delicate, so take care never to touch it.

The *shutter* is cocked, or made ready to fire, whenever the film is advanced. The *advance lever* is usually located on the top of the camera body. Motorized-advance cameras have the advance function built right into the *shutter-release button.* When you take a picture, a motorized-advance camera automatically brings the next frame of film behind the *shutter gate.* On manual-advance cameras, the shutter-release button is either near or a part of the advance lever. In these systems, you take a picture, then advance the film, which automatically cocks the shutter. Some cameras permit you to make double exposures on the same frame of film by prereading a switch or electronic command device that enables you to disengage the advance from the shutter-cocking function. And some motorized-advance cameras feature an option that lets you select either *single* or *continuous* advance; single means one exposure is made each time you press the shutter-release button, while continuous means that exposures are made one after another as long as you hold your finger down on the shutter release.

Many shutter-release buttons have a threaded opening in which you can screw a *cable release,* a long, flexible pin attached to a plunger, which, when pressed, fires the shutter. This comes in handy when you're making long exposures (it prevents potential camera shake) or when you want to fire the shutter while not actually standing near the camera, such as when you're arranging a still life or posing a subject. Radio-remote cable releases,

THE LCD PANEL

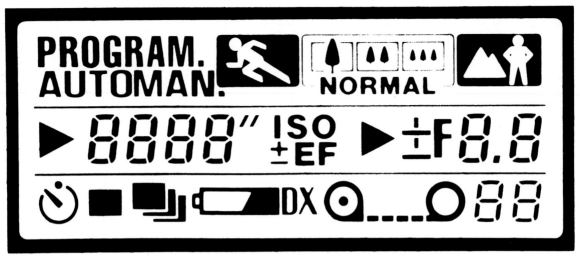

(COURTESY: RICOH CORP.)

This panel shows all the symbol and number displays this LCD can provide; when it is in use, not all information shows up at once. Starting with the bottom third portion of the LCD, going from left to right, the first display you see is a clock symbol for the self-timer. The black rectangle indicates that you've selected single-frame film-advance mode. The series of black rectangles that follow means that you've chosen continuous film-advance mode. The battery symbol is a battery-check device. When the DX mark stays lit, you have a DX-coded film in the camera.

The first dot-in-a-circle shows that film is loaded, the dotted line confirms that film is advancing through the camera, and the last circular form in the group indicates that you've finished the roll of film. The last set of numbers is your frame counter.

In the middle tier of this display sits much of the exposure information. On the left side, the delta mark indicates that you've chosen shutter-priority exposure mode. The numbers that follow—shown here by a series of 8s—usually tell you the shutter speed, but the ISO of the film is also displayed here when you're setting it manually. The "B" (for Bulb) setting also appears here when you're shooting long time exposures. The "+ /- EF" mark shows that you've chosen to deviate from the automatic exposure by from 1/3 to 2 or 3 full stops. The ISO mark atop this indicates that you've set the film speed manually, or overridden the DX-coded speed of the film in the camera. The delta to the right of this indicates that you've chosen to operate in aperture-priority mode. The "+ /-" mark to the right is used to set the exposure compensation on the camera; the numbers next to it read out the degree of compensation that has been set. Next in line is the "F," which indicates the f-stop in use on the camera; here it reads "8.8."

The top tier of the readout explains which exposure mode you are in. *Program* means one of the program modes; *auto* means either aperture- or shutter-priority, which is confirmed by one of the deltas on the middle tier. *Man* shows that you are in manual-exposure mode. The program mode has a number of permutations. For example, the leaning figure to the right indicates program-action mode, in which the camera selects both aperture and shutter speed, but favors a high shutter speed at the expense of a narrow aperture, in the exposure equation. The *normal* sign with the little trees indicates a "regular" program, an exposure mode where aperture and shutter speed are optimized for general-purpose shooting. The big tree means that the camera itself has chosen "program-tele," where the exposure will favor a faster shutter speed over a narrow aperture in exposure calculations, simply because you have a telephoto lens mounted on the camera and the program is set up to prevent camera shake. The two trees mean a "normal-normal" program, where both aperture and shutter speed are given equal weight, for general shooting, and are set by the camera because it "knows" that you have a lens with a moderate focal length—40mm to 110mm—mounted on the camera. The three trees indicate *program-wide,* which means a narrow aperture (for greater depth of field) is given priority over a fast shutter speed in exposure calculations—yes, the camera knows that you're using a wide-angle lens. Finally, the last pictograph of the man and the mountain indicates *program-depth* mode, in which you bias the program so that a narrower aperture (for greater depth of field) is favored over a fast shutter speed in the exposure calculation regardless of the lens in use.

with electronic transmitters that can trip the shutter from as far as 40 feet away, are also available.

Many SLRs have what is known as a "two-stage" shutter-release button. Light pressure on the button may, depending on the model camera, fulfill a number of tasks: it may switch on the metering system, start the search of the autofocusing system, "lock" the focus or the exposure, or even turn on the entire operating system of the camera itself. Applying additional pressure to this button releases the shutter to expose the film.

The *ISO dial*—or pushbutton—on top of the camera enables you to input the speed of the film in use. This essential information serves as the basis for the exposure data recommended by the metering system. For example, given identical lighting conditions, an ISO 100 film needs more light for correct exposure than an ISO 400 film. If the camera's operating system can't tell which film is in the camera, it has no way of making a decision as to what specific aperture and shutter speed should be set for a correct exposure. As mentioned earlier, cameras with DX-code-reading pins make this setting automatically.

The *shutter-speed input dial*—or pushbuttons—lets you select a specific shutter speed. On most cameras, shutter speeds work in steps that halve the time of each succeeding speed. A typical range of shutter speeds includes: 1, 1/2, 1/4, 1/8, 1/15, 1/30, 1/60, and so forth, up to 1/2000 sec. and faster. (You'll notice that fractions of a second are expressed as whole figures on the shutter-speed dial or LCD readout; for example, 1/30 sec. is expressed as "30." Often, numbers below 1 sec. on speed dials are marked in another color; in LCDs, either the fractional value or a coded symbol gives a clear indication of what speed is in use.) Each successively higher speed allows half as much light to enter as the speed that preceded it; or, conversely, a one-stop decrease in the shutter speed allows

in twice as much light. The most common shutter speeds range between 1/30 sec. and 1/250 sec., although there are many times when faster or slower speeds are used. For example, a 1 sec. exposure time could be used to make a picture at night while 1/2000 sec. could be used to freeze an athlete's quick moves.

One other symbol you may see on the shutter-speed dial is a red "X," or one of the numbers in the 1/60 sec.-to-1/250 sec. range marked in red. This is the *flash-synchronization speed*, which is set whenever you use an electronic flash. This setting is much less common today because *dedicated* flashes automatically set up the camera's operating systems to shoot at "sync" speed. These flash units work in concert with the camera to automatically calculate the amount of flash necessary for correct exposure. All of this is done in the time it takes to push the shutter-release button.

The flat piece of metal with two guides on top of the camera pentaprism is the *hot shoe*, the mount and electrical contact for an auxiliary electronic flash.

A metal disc within the guides is the contact point for the pin on the base of the "shoe" of the flash. When the shutter is released, an electrical charge moves through the contact point to the pin to trigger the flash.

Another feature is the *exposure-compensation dial*. You can use this dial to override the camera's exposure decisions without having to manually input the shutter and aperture settings. When the dial is set at "0," the exposure is made at whatever settings you or the camera have chosen. At +1, you're adding one extra stop to the exposure; when it is set at -1, you're subtracting one stop from the exposure. Although the autoexposure system usually does a good job, you may wish to calculate the exposure yourself. But when the light is "difficult" (very high in contrast, or coming from odd directions), when

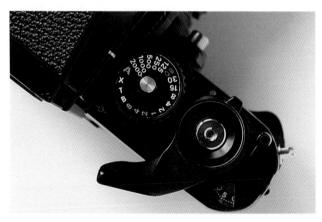

By stroking this lever, you both advance the film to the next frame and cock the shutter in the camera. More and more, the lever is being replaced by pushbutton, motorized film advance.

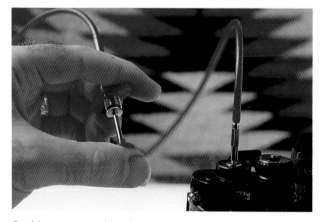

On this camera, a cable release can be screwed into a threaded opening in the shutter-release button, enabling you to fire the shutter without physically touching the camera. This comes in handy for long time exposures. Electronically controlled cameras have separate cable-release sockets for the same task, although you may be limited to using only the release specially made for your camera.

you want to make a creative "mistake," or when you simply think you have a better idea than the camera does, a biasing dial lets you do this with little fuss.

While many cameras still have conventional controls, on some you can select aperture by using pushbuttons located on the camera itself. Your selection is then fed to the lens, which sets the *f*-stops according to the electronic signals it receives from the camera operating system.

The *exposure-mode selector* is located either on the shutter-speed input dial or as part of a pushbutton system that reads out on the camera's display panel. Choosing an exposure mode tells the camera the way you want it to read aperture and shutter speed in order to obtain a correct exposure, as well as the particular effect you might want in a picture.

Mode options may include *aperture-priority* (AV), *shutter-priority* (TV), *through-the-lens flash* (TTL), *program* (P), *program-tele, program-wide,* and *autoexposure* (AE). Even manually setting aperture and shutter speed is now considered a mode.

You may encounter an autofocusing-mode selector switch on the front of the camera (many focus-mode) selections are made via pushbuttons, with readouts on the LCD). This selector may give you a choice of *single* or *servo-autofocus,* which is also known as *continuous,* or *action-priority* (AF). You can also choose a *manual-focusing mode* on autofocus cameras. With single AF, the camera's focusing system seeks out one subject and prevents you from shooting if it can't obtain correct focus. With continuous AF, the camera's focusing system

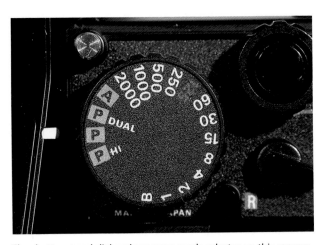

The shutter-speed dial and program-mode selector on this camera are combined. Shutter speeds range from 1 to 1/2000 sec. and Bulb ("B"). Synchronization speed (the shutter speed that you set when shooting flash) is 1/125 sec., marked in red. The programmed or autoexposure modes available are: "A" for aperture priority—you choose the aperture and the camera selects the shutter speed; "P-Dual" for dual program—the camera selects both aperture and shutter speed, but when wide-angle lenses are mounted on the camera it favors a smaller aperture and thus selects slower speeds, and when a telephoto lens is mounted it sets a fast shutter speed and a wider aperture setting, which will prevent blurred exposures due to camera shake; "P" for program—the camera selects both aperture and shutter speed for correct exposure based on a pre-programmed balance of the two; and "P-Hi" for high shutter speed program—the camera selects a high shutter speed regardless of the lens on the camera, then aperture is selected. Each of these programs offers you a way to personalize exposures without losing automation.

continually adjusts for a subject, refocusing the lens if it moves. Here, you can take a picture even if the camera hasn't locked onto a specific target. With manual focus you turn off the autofocus system and rotate the lens-focusing collar yourself, and focus according to what you see in the camera's viewfinder. All these modes may sound disconcerting, but keep in mind that they are simply program codes that tell the camera how you want its automation to work.

On the front of the camera body there are a number of pushbuttons and switches. One is the *depth-of-field preview button,* usually located on the right-hand side of the body. When you're focusing or composing, you look at the scene through the widest *aperture,* or opening, that the lens has. However, when you take a picture, the lens automatically *stops down,* or closes, to the aperture you or the camera has selected. For example, you may have a lens with a maximum aperture of *f/*1.4, but when an exposure is made, the lens stops down to *f/*8, a much smaller opening.

When a lens stops down, it changes the amount of light entering the camera and the way that light is focused upon the film, and the visual effect of *f/*8 is quite different than at *f/*1.4. One way to see what effect aperture has on the picture is to use the depth-of-field preview button before the picture is made. This will give you a clear idea of what the *depth of field,* or zone of sharpness, will be in your final picture.

Another control you may encounter on the front of the camera is the *autoexposure-lock button* (sometimes

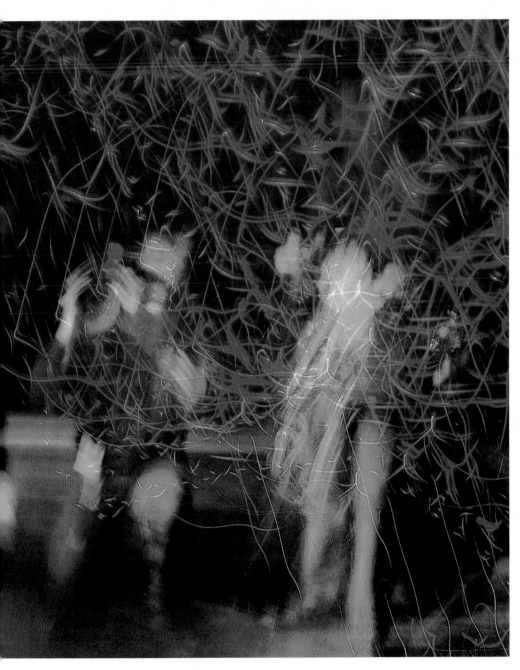

Some interesting effects can be obtained with long exposures, particularly if you have subjects that move while the picture is being made. This picture, shot inside a darkened room around which laser lights were playing, was made in aperture-priority mode set at *f/*5.6; the shutter stayed open for about 4 sec.

The exposure-compensation dial is a great asset when you want to automatically override the autoexposure system of the camera. In this portrait, the camera meter read the overall scene, including the dark background and the red shirt, and although good detail is recorded in the scene, the face is overexposed (above). Another picture was made with the camera set on -1 exposure compensation (right); the resulting exposure used the automatic reading as a guide, then subtracted one stop for a better result. As you shoot, you'll learn when exposure compensation is helpful.

located in the shutter-release button). In effect, depressing this button freezes the camera on a certain exposure setting and prevents it from altering the setting even if the lighting changes. This comes in handy in contrasty light when you want to expose for the brightest or darkest part of the scene.

An *autofocus-lock button* on the camera body or in the shutter-release button works in the same fashion as the autoexposure-lock button, but here you freeze a certain focusing-distance setting, whether or not the camera-to-subject distance changes. When you look into the viewfinder of an autofocus camera, you see a set of brackets in the center of the frame: this is the *autofocus-detector indication.* You must place these brackets "over" the principal subject in order to focus correctly. For occasions when the subject isn't centered, you can still focus on it, lock the focus, and then recompose as you wish.

The base of the camera body has only a few notable features: the rewind button, the tripod socket, and the battery compartment. In addition, some professional cameras have removable plates for motor-drive or power-wind connections. The *rewind button* actually releases the forward gear setting in the film advance and allows the film to be pulled backward into the cassette. Motorized

rewinds do this automatically, but in general you still have to engage a rewind switch to get it all going. Some cameras decide all this for you and begin to rewind once the last available frame has been exposed.

The *tripod socket* is a threaded inset that permits you to mount the camera on most tripods and monopods. Tripods come in handy when you want to make exposures longer than 1/30 sec. or to use a long telephoto lens. Without the aid of a steadying device, you'll find that shooting at slow shutter speeds—or even moderate speeds with a long lens—can cause camera shake and blurry pictures.

Many SLRs are completely dependent on *batteries:* no power means no pictures. Always keep a fresh set of batteries on hand, and make sure the *contacts,* the metal tabs in the battery compartment, are kept clean. If they become covered with grit, use a soft pencil eraser to remove the deposit. Also, if you don't plan to use your camera for more than a month, remove the batteries to prevent corrosion.

On some cameras, the *battery-check button* is placed near the on-off switch and should be tested before the camera is used; on others, checking battery power involves turning on the camera and looking through the viewfinder or at the LCD display.

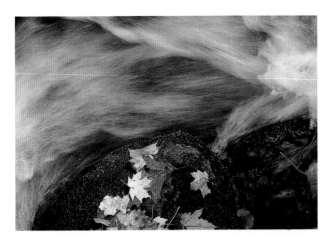

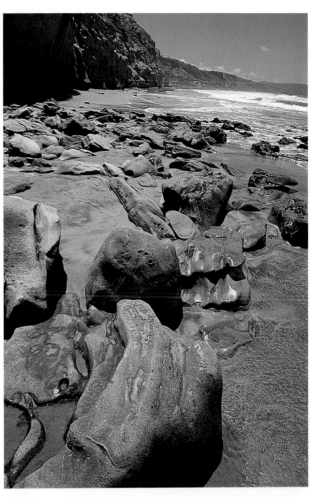

You can use the various autoexposure modes to select the way a scene will be recorded. In aperture- and shutter-priority modes, you select one of the values (aperture or shutter speed, respectively) and the camera automatically sets the other. Shutter-priority mode is useful when you want to choose a certain shutter speed to freeze the action or to shoot at a slow speed to create a sense of motion in a single image. In the picture of the leaves, shutter-priority mode was chosen and set at a speed of 1/15 sec. (above). This relatively slow speed gave the flowing water a smoother, more continuous sense of motion. Aperture-priority mode is useful when you want to control depth of field or the zone of sharpness in your picture. You can set the aperture for either a shallow or deep zone of sharpness. In the shoreline shot, an aperture of f/16 yielded sharpness from near to far (right).

The autoexposure-lock button comes in handy when you want to override the autoexposure system of the camera but still use the autoexposure function. For this scene, one photograph was exposed according to the in-camera meter reading (right). Though it is a fine rendition of the scene, it lacks the drama of the darker version. In the second shot, the meter reading was made directly from the bright area and locked in; then the original composition was reframed and shot (far right).

JOSEPH MEEHAN

BASIC PROPERTIES OF LENSES

To fully understand how a lens can be used to its greatest technical potential, you should be aware of the fundamental lens properties. These are focal length, aperture range, shutter, angle of view, and covering power. The result will be a refinement of your picture-taking technique as well as a way to evaluate your need for other lenses. Furthermore, knowing how to better control the final image will lay the groundwork for trying new approaches to composition.

Focal Length

Focal length is the single most important lens property because it controls *magnification* of subject matter: how much of the scene is recorded and how the objects in the scene relate to each other. The focal length of a lens is the distance it takes for light rays to focus at the same point. If the light rays go beyond or fall just short of this point, the image will be out of focus. A lens' focal length is usually given in millimeters (mm).

The focal length assigned to a lens is always based on a focus point of infinity. This is the spot where everything in a scene is in focus from that point to as far as the lens can "see." The larger the focal length, the more likely it is that the lens is a telephoto; the smaller the focal length, the better the chances are that the lens is a wide-angle. Between the *long-focal-length* telephoto lens and the *short-focal-length* wide-angle lens lies the so-called "normal" focal length of the *standard* lens. Lenses that have only one focal length are called *fixed-focal-length* lenses. Those that change via an adjusting ring are commonly referred to as either *true-zoom* or *variable-zoom* lenses.

To operate true-zoom lenses, you move a single ring on the lens barrel back and forth in order to increase or decrease the focal length. At the same time, you can rotate this ring to adjust the focus. *Variable-focus* models have two rotating rings: one ring changes the lens' focal length, and the other controls focus. All zoom lenses are labeled and categorized by their minimum-to-maximum focal lengths. For example, an 80-210mm lens has a minimum focal length of 80mm and a maximum focal length of 210mm. Zoom lenses might be in either the telephoto or the wide-angle range, or they might combine a wide-angle minimum focal length with a telephoto maximum focal length; this combination zoom lens includes a normal setting as well.

Angle of View

Closely connected to a lens' focal length is its *angle of view*, which indicates how much of the scene the lens sees. The angle of view serves as the basis for labeling a lens as a telephoto, a standard, or a wide-angle.

Covering Power

All camera lenses are designed to be used with certain types of film. The size of the circular image that lenses project is called the *image circle*; it is large enough to surround, or cover, the frame of the final image on the film. So if you take a lens intended for 35mm film and use it with a larger-sized film, its *covering power* won't be extensive enough. As a result, *vignetting*, which is the darkening of the image's corners, will occur. In a situation in which the covering power is extremely inadequate, a darkened circle appears around the image. Conversely, using a lens from a larger-format camera on a smaller camera works because there is more than enough coverage.

Photographers who use 35mm lenses aren't very concerned with covering power because they almost always shoot with lenses designed specifically for their cameras, or at least the same camera format. As such, ample coverage is built-in.

The range of lenses available today is staggering, as is the difference in results when a simple lens switch takes place. I photographed this house with a 1000mm lens from a distance of 3 miles. If I'd chosen a 50mm lens, the house would have been the size of one of the chimneys.

Angle of Coverage

Angle of coverage is a measure of the entire image circle of the lens. Don't confuse this with the angle of view. The angle of coverage simply refers to the *image-forming cone* of a lens. As mentioned earlier, the image circle refers to the area that produces sharp images. Once again, the size of the image circle is determined by the specific lens design.

Aperture

Don't confuse the uppercase "F" that signifies focal length with the lowercase "f" used to denote *f-stops*. Here, the "f" refers to the size of the *aperture*, or the lens opening. This is the bladed diaphragm inside the lens that opens and closes to control light, much like the iris of the eye. An *f-stop*, then, is a measurement of the size of the aperture opening. The higher the *f-stop* number is, the smaller the opening is. For example, $f/2$ lets more light enter the lens than $f/8$ does. This doesn't seem logical because 8 is bigger than 2, but all *f-stops* should be thought of as fractions. So think of $f/2$ as $1/2$, which is larger than $1/8$ ($f/8$).

Today, all lenses used for general photography follow a standard *f-stop* scale. While no lens has a complete set of stops from $f/1.0$ to $f/64$, all lenses set at the same *f-stop* theoretically transmit the same amount of light. Moreover, the change in the amount of light that any two full, adjacent *f-stops* transmit is the same. For example, switching from $f/4.0$ to $f/5.6$ is a difference of one stop less light, as is switching from $f/22$ to $f/32$. The aperture settings on 35mm lenses are the *click-stop* type, some of which have provisions for half-stop increments. A standard lens in 35mm photography typically has *f-stops* to $f/16$ or $f/22$.

The formula "Maximum aperture equals the focal length of the lens, divided by the lens' diameter" is used to establish the *f-stop* that allows the greatest amount of light to reach the film. Depending on a lens' maximum aperture, photographers tend to classify it as *fast* or *slow*. So a 50mm lens with a maximum aperture of $f/1.4$ is considered fast compared to a zoom lens with a maximum aperture of $f/3.5$ set at 50mm. Some large lens openings, such as $f/1.0$, $f/1.4$, and even $f/2.0$, very often enable you to take pictures in low light or at fast shutter speeds in moderate light. They also make the image seen in the viewfinder of certain cameras very bright and easy to focus. When considering lenses, keep in mind, though, that lenses with fast apertures are bigger and heavier because they contain more light-gathering glass, and are much more expensive than other lenses.

All fixed-focal-length lenses have both their focal length and maximum aperture indicated on them. For example, a 105mm 1:2.5 lens has a focal length of 105mm and a maximum aperture of $f/2.5$. With zoom lenses, however, you might also see a double *f-stop* designation, such as 28-85mm $f/2.8-3.5$. The two apertures are indicated because the lens' maximum aperture changes along with its focal lengths. In this example, the lens openings begin at $f/2.8$ for the 28mm focal length and progressively change to $f/3.5$ by the time the lens reaches the 85mm focal length.

Controlling Exposure

Selecting apertures is one of two ways that you can control exposure in exact, measured amounts. Photographers use the terms *stopping down* and *opening up* to describe what happens when they change the amount of light reaching the film. They do this by turning the aperture ring located on the lens to a smaller *f-stop* number, which is stopping down, or to a larger number, thereby opening up. Aperture settings are quite accurate—when the lens blades are lubricated and are clean.

Automatic apertures are the norm for SLR cameras. The lenses on this type of camera remain wide open until the moment of the exposure. The aperture closes down to the selected *f-stop* as the mirror swings up, and the shutter opens and closes. If the mirror then resets to its original position, it is an *instant-return* mirror. Automatic apertures are great for focusing, but they can be deceptive when you compose a picture.

Shutter Speed

The second way to control the amount of light reaching the film is via the *shutter*. The "door opening and closing" analogy is often used to explain the relationship between the shutter and the aperture. How far you open the door to allow light to enter a darkened room represents the *f-stop*, while how fast you open and close the door corresponds to the *shutter speed*. This is the time between the opening and closing of the shutter, usually measured in parts of a second. Like *f-stops*, shutter speeds have been standardized. Each successive change in the shutter speed is equal; that is, if you move up the scale, such as from 1/4 sec. to 1/8 sec. or from 1/125 sec. to 1/250 sec., you double the speed and halve the amount of light that is transmitted. Conversely, moving down the scale, such as from 1/60 sec. to 1/30 sec. or from 1/2 sec. to 1 sec., halves the speed and doubles the amount of transmitted light.

Remember, a similar "halving/doubling" principle is at work with apertures. For example, switching from $f/8$ to $f/11$ halves the amount of light reaching the film; this applies to any other change between a larger and the next smaller full-stop aperture. The opposite is also true; when you open up one stop, such as from $f/5.6$ to $f/4.0$ or from $f/32$ to $f/22$, you double the amount of light that enters the lens. What actually exists then is a series of equal steps of change in the amount of light reaching the film two different ways: via the aperture or the shutter.

The aperture/shutter relationship is a boon to photographers because these controls have different effects on composition. Apertures control not only exposure, but also depth of field. Shutter speeds affect the way movement and action are presented in a two-dimensional photograph. So if you want to manipulate one control, the other one will offset any changes in exposure.

1000MM LENS

600MM LENS

300MM LENS

200MM LENS

135MM LENS

105MM LENS

85MM LENS

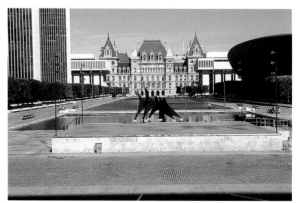

50MM LENS

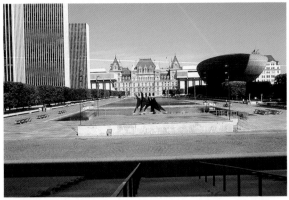

35MM LENS

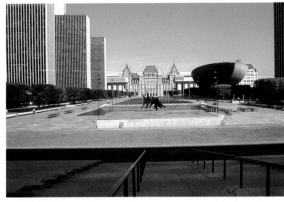

28MM LENS

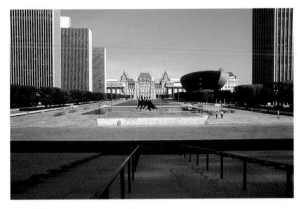

24MM LENS

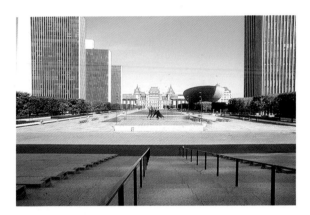

20MM LENS

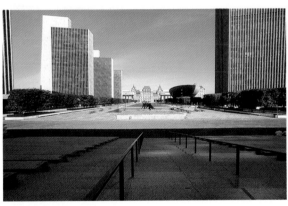

15MM LENS

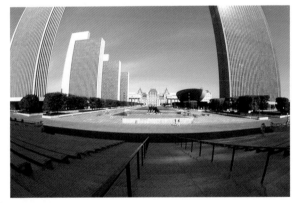

FISHEYE LENS

These photographs of a plaza show the differences in angle of view of various standard, wide-angle, and telephoto lenses. All of the pictures were taken with a 35mm camera from the same viewpoint.

PATRICIA CAULFIELD

HOW LENSES WORK

I have many lenses ranging in focal length from 18mm to 640mm. Would I like more?—you bet, but I would add slowly to the selection I have, getting to know the lenses one at a time just as I've done in the past. Every focal length represents a different way of seeing and showing what I see in photographs. It takes me a long time to begin to exploit the potential of a new lens and to integrate it into my work. Here are a few general ideas to keep in mind when buying and using lenses.

"What does that lens take in?" is the question most often asked about a specific lens. How far you are from the subject affects the answer just as much as the focal length of the lens. Generally, wide-angle lenses include more of a scene and render it smaller than a camera's standard 50mm or 55mm lens. Telephoto lenses exclude much of a scene and render what you frame with them larger than your camera's standard focal length.

Focal length determines more than magnification. There are good reasons for using lenses of different focal lengths other than the obvious differences in the image size they produce. Changing the apparent size and space relationships between near and distant objects in a picture is one of the best and most frequent reasons for switching lenses. Wide-angle lenses can be used to stretch, or extend, space. Telephoto lenses can be used to collapse, or compress, space.

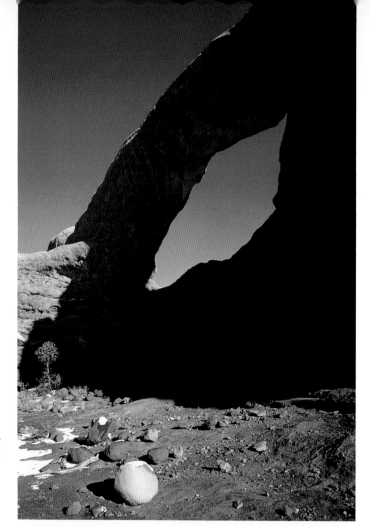

I used a standard 50mm lens for the picture of the rock and the arch from the vantage point where I first noticed the scene's photogenic potential (top). This wasn't a small boulder—it just looks small in relation to the giant arch. The minute I saw the scene, I wanted to make the boulder look bigger and more significant.

For another shot, I got much closer to the boulder and used a 20mm lens (bottom). Notice that the size of the hole in the rock hasn't changed appreciably; however, the boulder's size has multiplied many times. By itself the wide-angle lens didn't make the boulder bigger; getting up close and shooting it within a few feet did. With the standard lens I couldn't have approached the boulder this closely and still have included it along with the arch in the photograph. With my standard lens, I could have photographed part of the boulder's surface, or I could have framed the arch and found a vantage point that perhaps included a bit of the top of the boulder; however, I couldn't have rendered both the boulder and the arch in sharp focus. Such depth of field isn't possible with any but the widest wide-angle lenses.

The window is about the same size in both pictures. The distance I lost coming in for the second picture correspondingly enlarged the rock window by about the same amount that using the wide-angle lens reduced it. The closer subject distance and the shorter focal length cancelled each other out.

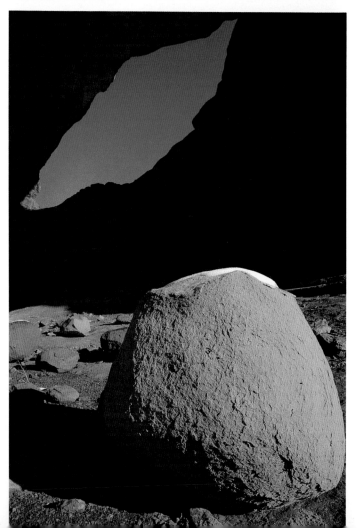

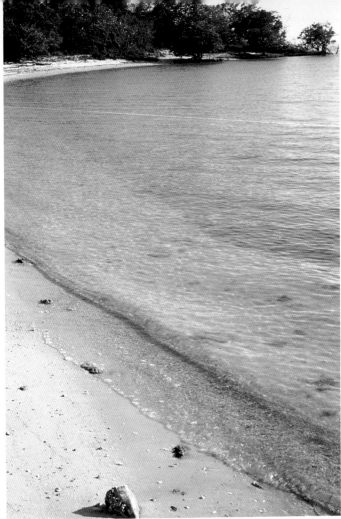

The difference between the camera's distance from the closest and farthest parts of a subject is the key to these spatial phenomena, not just the focal length of the lens. Wide-angle lenses are more useful for photographing inanimate subjects than for photographing animals because often you can't get close enough to wildlife to use a wide-angle lens effectively. Even with a long lens, you must get much closer to animal subjects than most people realize.

For landscape photography my first accessory lens choice would be a 28mm or 35mm wide-angle. However, I do use long lenses—usually up to about 300mm—in basically three situations: when I can't approach and frame a small section of a subject any other way; when I want the flattened perspective that a long lens gives; and when I'm including an animal in the scene and can't get any closer.

At first glance, these pictures of a shell and the surf at a Florida beach seem similar, but in the shot made with a wide-angle lens, the background is greatly reduced (bottom). This shell is in fact much smaller than the boulder (opposite page). To make the wide-angle picture of the shell, I didn't need to lose as much distance as I did photographing the wide-angled boulder.

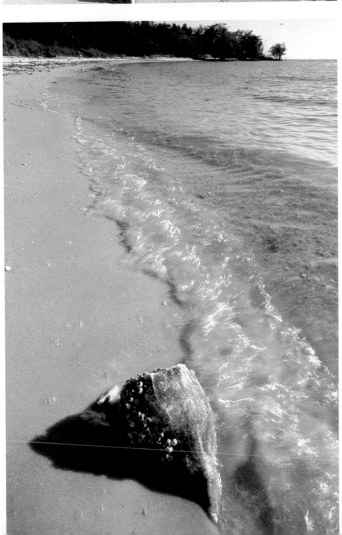

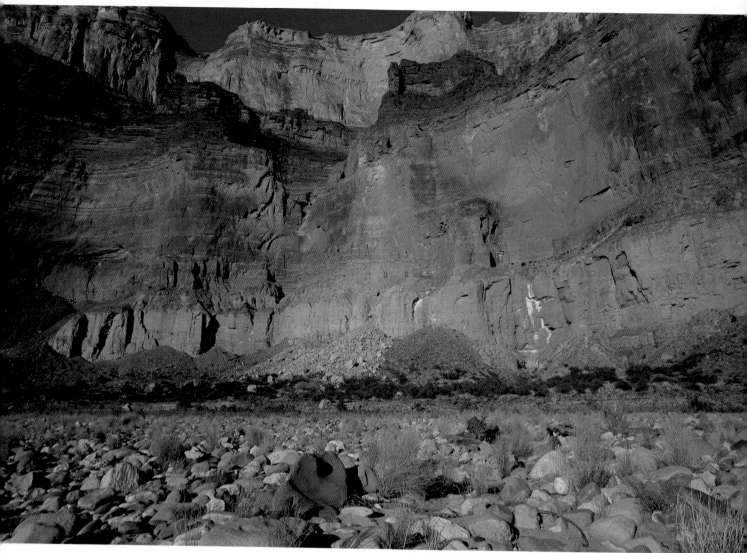

The widest wide-angle lens I had was perfect for making this scenic of the cliff face behind the boulder field at Hovenweep along the Colorado River in the Grand Canyon. Here the background dictated my lens choice. To include the entire cliff top to bottom I had to use a 20mm or wider-angle lens from the farthest available vantage point on the giant boulder-strewn sandbar. Any lens that was longer excluded either the cliff top or the boulder field, and I definitely wanted both.

If you try alternately covering the top and then the bottom of the picture, you'll see why. The cliff alone is interesting, but it isn't a complete scenic. And with the top covered, you can't see the convoluted edge or the contrasting blue sky.

Extreme Wide-Angle Lenses: 15–21mm

I use extreme wide-angle lenses for a number of situations, especially when I want to include as much as possible of what is before me in a single picture. Often the background will dictate my lens choice.

I also use extreme wide-angle lenses a lot to exaggerate the size of foreground objects in relation to backgrounds. I often use my 20mm lens to photograph flowers and other inanimate subjects, though if the opportunity presents itself, I am perfectly happy to use it on wild animals, too. Such opportunities are quite rare.

Wide-Angle Lenses: 28–35mm

How to decide which focal-length lens to use isn't always as obvious as in the Hovenweep landscape, where my back was literally against the wall to get what I wanted in the picture while working with an extreme wide-angle lens. Other than in such shooting situations, where some aspect of the terrain limits your mobility, you'll find that compositional decisions largely dictate your choice of different lens focal lengths.

I might want a foreground object to loom large in comparison with something in the background, or I might want to create some extra distance between objects. Often I'll take pictures with lenses of various focal lengths and then decide which perspective I like best after the pictures are processed. A distinct preference for one photograph over another variation of a scene isn't at all a foregone conclusion. Many times I like all the versions I take, rather than preferring one to all the others.

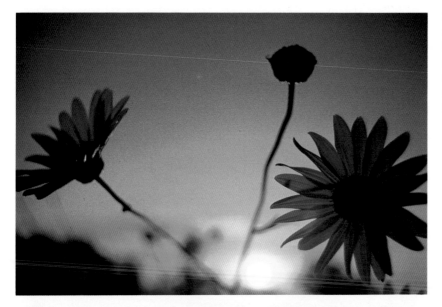

I wanted big flowers and a small sun in this sunrise picture, and I wasn't especially limited in my choice of camera-to-subject distance. As usual when I have vantage-point flexibility, I also took some pictures with longer lenses. After the processing was done, I decided that I liked this 35mm version best.

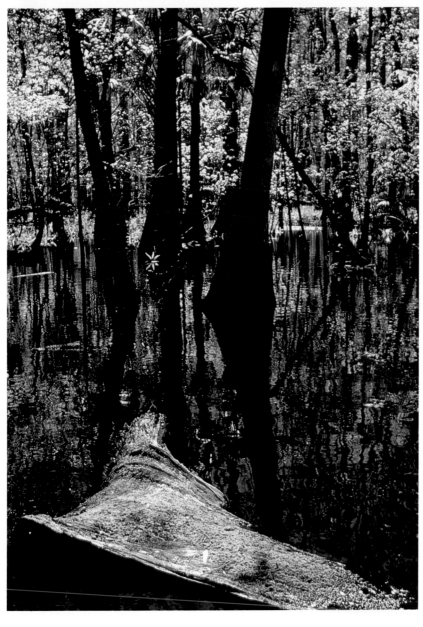

I chose a 35mm lens to make this picture of the Oklawaha river swamp in Florida because it gave me the relationship I wanted between the background trees and the partly submerged fallen log in the foreground. I didn't have anything like unlimited mobility because I was wading in the swamp itself. I could have used a wider-angle lens to come closer, or I could have backed off and tried to get all the same elements in the picture with a standard lens. But I liked the picture the way I saw it, the way you see it here, so I didn't even attempt to make any variations of it while shooting.

Standard Lenses: 45–58mm

In the photography press much publicity has been given to the various virtues of all lenses with special focal lengths. There is undue emphasis on unusual images made by wide-angle and telephoto lenses, and on the many problem situations that can be solved by using them. If I depended on what I read for what I know, I would think I could dispense with my standard lens altogether and never miss it. Fortunately, what I know comes more from what I've done than from conventional photographic reading; therefore, I strongly believe my standard 55mm lens is the most useful I have. Because mine is a macro lens, it offers much closer focusing than most standard lenses.

The 55mm lens is probably one of the most versatile, and it is too often ignored in favor of more special optics. I deplore the general preoccupation with equipment, and I try to teach my students to work with a minimum of different lenses. Many amateurs believe that buying a special lens makes it possible to get all sorts of great pictures. In fact, it doesn't help a bit. Until they learn to take good pictures with the lens they have, they won't be able to make great pictures with a lens of a different focal length, either.

On Florida's Lignumvitae Key, my 55mm lens was the best choice for taking this picture of the island's one rocky shore at dawn. The terrain limited my movement: a few feet to the right, I was back in the dense jungle growth; a few feet to the left, I was in the water; a few feet forward, I didn't have the trees as a frame. And if I used a wide-angle, the background was too small; a few feet backward, I was stuck in the ooze of a mangrove swamp.

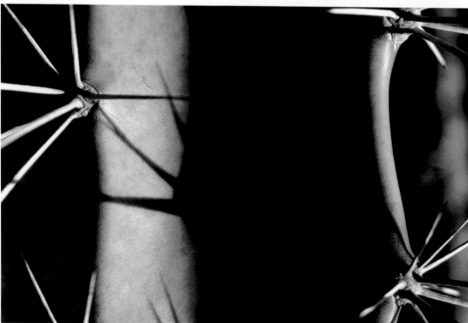

Lignumvitae Key is composed of many plant communities, including a dry, sandy, inland stretch populated with prickly pear and night-blooming cereus, which are both spined, cactus-like plants. I made this dramatic closeup of plant spines with my 55mm macro lens.

Short Telephoto Lenses: 90–105mm

My lens in this range is a 105mm, and I use it a lot. For landscapes it is much more useful than my longer telephotos. With them I may seize a significant detail within the larger scene, but with the 105mm lens I can make a larger range of pictures including overviews that represent the whole scene.

The smaller telephoto lenses are still short enough to be very versatile and are regularly useful for many different subjects. I take a lot of flower photographs with my short telephoto lens, sometimes using an extension tube if I want to focus closer than the lens itself permits. Many short telephotos are available as macro lenses. My newest lens is a 105mm macro, and I'm still exploring its potential.

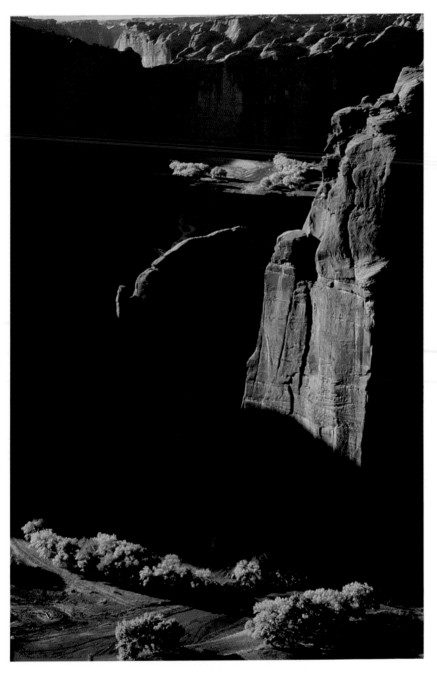

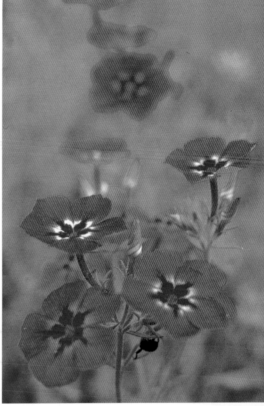

I stood on the rim of Canyon de Chelly National Monument in Arizona to take this autumn picture (left). Including more than a sliver of sky confused the composition. Only the 105mm lens showed the dry river bed in good juxtaposition to the sweeping curves of the canyon walls, and to the textures in the foliage and shadow.

Short telephotos are wonderful for closeups with such subjects as these flowers (above). I focused them as closely as possible without adding an extension tube to my 105mm lens. The exposure was 1/250 sec. at f/4 on Kodachrome 64 film.

JOSEPH MEEHAN

CLASSIFYING FILTERS BY FUNCTION

A filter can affect a light source and thereby alter the appearance of the final image two ways: by changing the proportions of colors in the light hitting the film, and by changing the behavior of the light waves themselves. Most filters fall into one of these two groups. Filters that change the color content of light are colored and are referred to as *chromatic.* Filters that physically change light waves and have no color are classified as *nonchromatic.* In general, the main functions of chromatic filters are to correct for color imbalance, or *color correction,* or to control color contrast. Nonchromatic designs, on the other hand, can be used to modify the light by reducing its intensity, cut down on glare and reflections, change the sharpness or focus range, or remove part of the non-color spectrum that film is sensitive to, especially the ultraviolet section. You'll find that some of these changes may be accompanied by an apparent change in the color of the final image, but this is usually a secondary effect.

A third category consists of a diverse group of *special-effect* filters. Their purpose isn't associated with the main functions of chromatic and nonchromatic filters. Instead, these filters are designed to produce a wide variety of effects that go beyond what you might think of as visual reality. Special-effect filters utilize both chromatic and nonchromatic mechanisms.

With the exception of being able to increase a light source's intensity, filters can affect all of its qualities in subtle or more obvious ways. Likewise, their results can be altered by changes in the light itself. For example, the effect of a diffusion filter on a highlight area is much greater with a small light source, such as the afternoon

sun, at a sharp angle to the subject, than with a large light source illuminating the overall scene, such as an overcast sky. You might find it helpful to think of filters along the lines of the musical concept of "variations on a theme." In essence, every prime effect can be modified, depending on the conditions under which you use the filter. Furthermore, filters can also have secondary uses, and they can be combined with other filters for still more variety in your images.

Color-conversion and light-balancing filters change the Kelvin temperature of the light reaching the film. As you can see, conversion filters are very strong and come in two colors: the 85 amber-orange series (top row, far right) and the 80 blue series (bottom row, far right). Light-balancing filters are available in two forms, the 81 amber series and the 82 blue series, and are much less dense in coloration. Here you see the 81C, 81B, 81A, and 85A amber filters (top row, left to right) as well as the 82C, 82B, 82A, and 80A blue filters (bottom row, left to right).

All I needed to give this shot of buildings at sunset extra warmth was an 81A warming filter.

For these landscape photographs, I started without a filter (top) and then interpreted the scene by adding a CC20 magenta filter (center) and then switching to a 23A medium-red filter (bottom).

JOSEPH MEEHAN

SPECIAL EFFECTS WITH FILTERS

You can employ filters in a number of ways to obtain what are loosely called special effects. The most common approach is to use a filter that introduces some unusual, perhaps even bizarre, effect. The result may seem quite unreal or distorted. For example, *multiple-prism* filters produce repeated images of a subject. *Starburst* filters, on the other hand, create long shiny star patterns that radiate from small, intense light sources. In both cases idle intent is neither to correct for some inadequacy in the light or film nor to provide an authentic rendering of the scene. Special-effect filters bring their own unique attributes to the image.

Starburst and Diffraction-Prism Filters

This group of filters depends on the presence of a small or pinpoint light source in order to produce their individual effects. Starburst filters and their variants, *cross-star* filters, have lines running through the clear glass or resin; this causes a starburst or the longer cross-star lines to radiate out from the light source. These filters are used quite often in television productions of stage shows and are frequently employed in night shots. In both cases there are many small light sources or mirror reflections, as in the sequins on a singer's gown. The number of starbursts and cross stars depends on the filters' design. The stronger the light source, the larger and brighter the effects. Most strong reflections, such as the metallic sheen of a car in daylight, produce the same effects as light sources.

Not surprisingly, the additive primaries (red, green, and blue) occasionally appear when these filters are used with strong light sources. Furthermore, manufacturers have

Starburst filters work best when aimed at small light sources. Here, you can see the effect of the Cokin 8 Star filter (top) and the fan-like halo prism filter made by Cromatek (bottom).

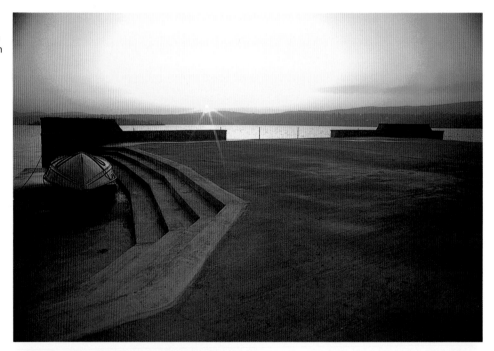

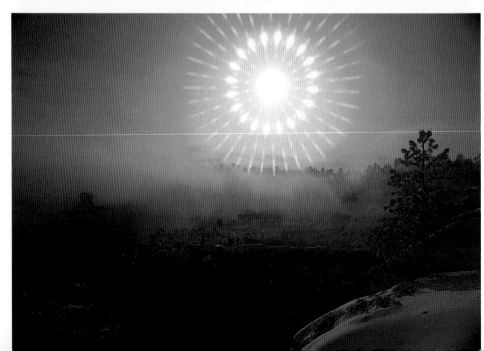

come up with all kinds of *diffraction-prism* designs that radiate the primary colors in wheels, fans, and circular starbursts. Filter quality is a factor in how much *flare* accompanies all of these effects. This causes a loss in contrast, which isn't always a bad idea in such high-contrast situations. Nevertheless, flare does tend to be critical with starburst filters in, for example, stage shots, although better quality filters have this well under control.

Multiple-Prism and Streak Filters

Multiple-prism filters, as the name implies, deliver several repeated images in any number of patterns. Take a look at The Repeater by Cokin. The arrangement of these multiple images comes from the manufacturer cutting a facet into the flat surface of a thick filter, causing an iteration of the scene in a circular or triangular pattern, as well as parallel repetitions from the center to the edge. Yet the image remains clear and undistorted. Faces, flowers, cars, and other quickly recognizable subjects are the best choices for this treatment.

A variation of this design is the *streak* or *speed* filter, which imitates the blur effect of a moving object. Here, the facets are prism-like and produce an elongation of the repeated image, blurring them into streak. Still another type of filter gives the impression that you've zoomed in on a subject using a slow shutter speed, causing "zoom streaks" to shoot inward toward the center of the picture. Naturally this filter is called a *radial-zoom* filter.

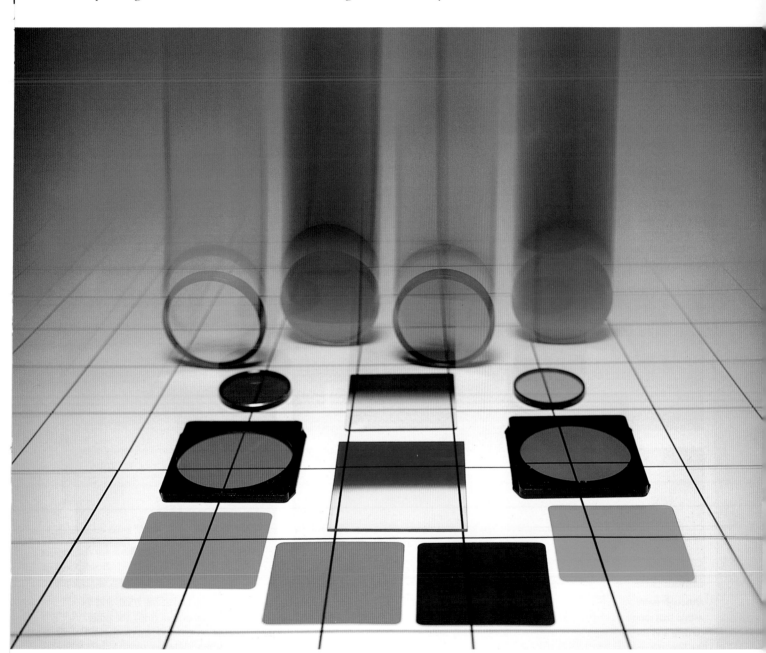

I used a Cokin speed filter and a Tiffen 0.6 graduated neutral-density filter in the upper half of this studio shot.

JOHN SHAW

THE CRUCIAL ACCESSORY: A TRIPOD

If you want to improve the quality of your photographs, the best single accessory you can buy is a sturdy, well-made tripod. All working professional nature photographers shoot every exposure possible with their camera mounted on a tripod. Some photographers are proud of their ability to handhold long exposures, bragging that they can shoot at 1/8 sec. with a 105mm lens and get sharp results. I can't do this. I don't think they can either.

The only way to determine the sharpness of transparencies is to examine them critically on a lightbox with a top-quality magnifier. This is what magazine and book editors do to every slide. You can't tell whether slides are sharp or not by projecting them. The quality of a projected image depends on how good the projector lens is, and most aren't camera quality.

It isn't that unsharp photographs are bad. At times a soft-focus picture might be exactly what you want. It is a question of control: Can you get a razor-sharp image whenever you want?

An old rule of thumb applies to holding a camera by hand. For acceptable pictures, never try to handhold at a shutter speed slower than the focal length of the lens being used. For example, the slowest speed to safely handhold a 50mm lens is 1/60 sec. For a 135mm, the slowest speed is 1/125 sec., and so on. You can see that handholding restricts you to working in bright light, using short lenses, using high-speed film, or accepting fuzzy pictures. The solution is simple: use a tripod.

Many photographers overlook the importance of the tripod head and how it can influence their work. For doing carefully studied scenes or precise closeup work, I prefer a pan-tilt head over all else; its movements along the horizontal and vertical axes are totally independent. Trying to recompose a few degrees vertically, without moving at all horizontally or flopping to the side, is impossible except with a solid pan-tilt head. Be sure to mount the head correctly. With a good head you should never have

to loosen the camera screw to recompose. Almost all pan-tilt heads are made so that one control handle comes toward you and the other is to your right. The camera will flop to the left for a vertical, and you can still tilt it downward. If you're loosening the camera to tilt it, something is wrong.

Large ball-and-socket heads are good for action shots since there are fewer controls to adjust. Usually, if you're photographing larger animate creatures, precise framing isn't as critical as the need for maneuverability. Be warned, however, most ball-and-socket heads are far too small to support a camera outfitted with long lens and autowinder. The following

are my suggestions for good-quality, solid equipment. They take into consideration the problems with low-level subjects:

Gitzo 320 tripod: my standard tripod

Gitzo 224 tripod: a little lighter in weight; my backpacking tripod

Bogen 3029 or 3047 tripod heads: pan-tilt heads; basically the same; the 3047 has a quick-release system

Bogen 3024 tripod: good alternative, less expensive (3020 tripod complete with 3029 head)

Slik Pro-Ball tripod head: ball-and-socket head, the smallest I'd suggest.

BARNWOOD *(Handheld)*. Kodachrome 25, 55mm lens, 1/30 sec. at *f*/5.6

BARNWOOD *(With tripod)*. Kodachrome 25, 55mm lens, 1/30 sec. at *f*/5.6

To illustrate the difference that a tripod can make, I first shot the closeup of a piece of barnwood with a handheld camera (top and bottom left), then with a tripod (top and bottom right). Shooting Kodachrome 25 at *f*/5.6, I used a 50mm lens at one shutter speed slower than its focal length, or 1/30 sec. Even though I braced myself as much as possible, the resulting photograph isn't as sharp as the tripod version.

To shoot this red cup fungi on moss (opposite page), I used a tripod and a 105mm lens, and exposed Kodachrome 25 for 1/2 sec. at *f*/11.

The Slik Pro-Ball tripod head is probably about the smallest head that you should use (left). The Bogen 3047 tripod head features a quick-release system (above).

JOHN SHAW

THE PORTABLE CAMERA SUPPORT

When you're working in rough terrain trying to follow a moving animal, a tripod is slow to set up. And in really uneven terrain, every time you move with an animal, you have to readjust the tripod legs. It is also very difficult to use a tripod for shots of birds in flight. But you don't want to hand-hold the lenses that you're using, 300mm and longer, since you know that would yield pictures with unacceptable sharpness.

So long as you have good light, a monopod is the ideal answer. A monopod is simply one tripod leg. While you can buy ready-made monopods, I scavenged mine from an old tripod by adding a threaded mount to the end of one leg. Some photographers use a head on top of the monopod, but I prefer not to do this because it is just one more thing to adjust. Instead, I use a lens with a rotating tripod collar, so that the lens itself can rotate for vertical or horizontal format, and then I just lean into position. This makes a fast-handling, lightweight system, ideal for

stalking. I shoot at as fast a shutter speed as possible. With a 300mm lens I try to always use 1/250 sec. or 1/500 sec., although I've gone as slow as 1/60 sec. with acceptable results.

For photographing birds in flight, especially when they're moving across your field of view, you'll find a shoulder stock very helpful. It is quick and gives just that much added support over handholding a camera and lens. I've actually never seen a commercially made shoulder stock that I like. Most are either too flimsy or too bulky. I made mine from a 1/4 x 1-inch aluminum strap, bent and bolted into shape. Even more than with a monopod, you need good light to shoot with the less firmly planted shoulder stock. My favorite lens to use with a stock is a 300mm F4.5 internal-focusing (IF) lens, which is lightweight, compact, and fast-handling. To stop birds in flight you need a shutter speed of at least 1/250 sec., and if they are close to you, 1/500 sec.

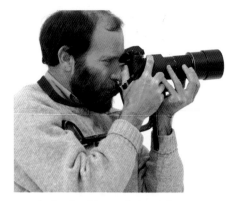

I made the shoulder stock shown here because I've never found a commercially made one that I like. You can see how it can enable you to brace your camera with just enough additional support.

I used a monopod to stalk this deer and her fawn as they moved through a hillside field. I didn't attempt to freeze their movements, but, rather, I waited until they stopped and then I took my photographs. Here I used a 300mm IF lens and exposed Kodachrome 64 for 1/250 sec. at f/5.6.

USING A MOTOR DRIVE

Action photography is the forte of a motor drive or winder. The differences between the two are minor. Both advance the film and cock the shutter when you trigger them. Motor drives generally have a faster top speed in frames per second (fps), up to five fps, and often also have a motorized film rewind. Many winders and most motor drives offer both a single frame mode (you must lift your finger and push the trigger button again for each shot), and a continuous speed (the camera keeps firing and winding as long as the button is depressed).

Advertisements suggest that you can't be a serious photographer without one of these devices. I don't agree at all, believing as I do that subject matter dictates their use. If you want to photograph elk in

Yellowstone in autumn—the males bugling and sparring with each other—by all means purchase a motor drive. But if you're primarily interested in shooting flowers or scenics, why burden yourself with the extra weight?

Some people think that a motor drive ensures that they'll capture the peak action simply by holding the button down. This isn't true at all; you still have to be very selective. Think about it this way: suppose you're shooting at 1/500 sec. to stop action, and your motor drive can advance the film at 5 fps. If you shoot in the continuous mode for 1 second, you've captured 5/500 of the action, but missed 495/500 of it. At 5 fps you could shoot a 36-exposure roll in about 7 seconds. You would spend far more time rewinding the film and

With a motor drive, I know that my camera is ready to perform at a moment's notice—so I won't miss any spontaneous shots of particularly fascinating and nimble-footed subjects. I photographed this snowy egret fishing with a 300mm IF lens, exposing Kodachrome 25 for 1/500 sec. at f/5.6.

reloading the camera than shooting. You must be selective!

Generally I use a motor drive as a fast thumb. That is, I use it just to wind the film so that I'm always ready for the next shot. My motor drive has a continuous speed that I always leave it set at, but I hardly ever just hold the button down. Instead I shoot a single frame at a time by just quickly lifting my finger after triggering the motor. But I am ready to fire a burst if the opportunity presents.

PART TWO
FILM

GEORGE SCHAUB

FILM: PHOTOGRAPHY'S SOFTWARE

Film is the medium on which the image formed by the lens is recorded. Film has characteristics that can be measured, compared, and described, but none of these quite touches its miraculous ability to capture time, light, mood, and emotions in a unique way. Beyond its ability to capture light, film adds expressiveness to the image by converting it to black and white, or by revealing the world in rich, bold colors.

Choosing one film over another can be as creative a decision as selecting a particular combination of aperture and shutter speed over another. Although film choice may be limited by lighting conditions, the variety of films available offers a wide-ranging palette. Learning to discriminate between the qualities and capacities of different films under various lighting conditions is a fundamental part of becoming a photographer. Understanding a film's latitude brings another dimension to the creative choices involved in picture-taking.

There are three basic types of film: *color-negative* for color prints; *black-and-white-negative* for black-and-white prints; and *color-positive* for color slides, or transparencies. Regardless of the type of film, images are recorded through the action of light upon *silver halides,* which are silver crystals (grains) embedded in the film's layered emulsion coating. When light strikes these crystals, they change and form a latent image. When films are developed, the latent image is amplified and the silver halides that were exposed to light are converted to metallic silver. The silver halides not exposed to light are dissolved out of the film by chemicals; this prevents the film from reacting further when it is exposed to light after processing.

The amount of silver altered in development depends upon just how much exposure to light the film received: those areas that were exposed to more light turn darker, while those that received less, or none, are lighter, or clear. This is why a piece of film for prints is called a *negative*—its *tones,* or *densities,* are the opposite of what appeared in the original scene. When prints are made, however, the densities are reversed to create a positive print. Slide films work in essentially the same way, except that the flip from negative to positive is done in the processing steps of the film itself, and a positive image is formed on the original film emulsion.

Each kind of film has certain characteristics of sharpness, grain, color saturation, and contrast, plus a subjective "feel" that makes it unique. Although film speed is a major factor in defining these characteristics, subtle distinctions separate one brand from another, even among films with the same speed. As you shoot, you'll discover the film that best suits your needs, and as you begin to gain experience, you'll be able to match a particular film to the subject matter and mood of each series of pictures you take. With color-print films of the same speed, these distinguishing characteristics are less apparent; the printing step tends to make prints from one film look much like those from another. However, with slide films there is more differentiation: some films are more contrasty, accentuate different colors, or are more *saturated,* or color-rich, than their counterparts.

Color film differs from black-and-white film in one very basic way. A processed black-and-white negative contains a *silver* image; the metallic silver formed in development remains in essentially that same state on the finished film. When color films are processed, color dyes replace the silver image that is the record of the subject. These dyes, however, mirror the densities of the original silver and re-create the lights and derricks and colors of the recorded scene on the film.

Black-and-White Film

Black-and-white film "sees" the world in shades of gray, from white through varying degrees of gray to pitch black. While this may sound bleak, black-and-white film often can offer a more sensuous, evocative rendition of a subject than color film. The subtlety of black-and-white tonality has attracted master photographers to it for years.

Another attractive quality about black-and-white film is its versatility: it can be abstract or starkly real. It can also be effective in nearly every type of photography. Compare the inspiring, majestic beauty of an Ansel Adams landscape with the gritty photograph of an airline disaster that appears on the front page of a tabloid. You'll see that both "work," that each has a quality that color film rarely matches. Even if you aren't bitten by the black-and-white bug, try using a roll of black-and-white film every so often as a way of opening your eyes to its special power.

Color Film

Color films expand on the miracle of capturing light by enabling you to make pictures in vibrant color. The color layers built into the film emulsion—each of which contains light-sensitive silver halides—pass or absorb the light of different colors when they strike the film.

In a sense, films are a sandwich of three basic colors—magenta, cyan, and yellow—that, when combined, form all the colors in the spectrum. Color is recorded through the use of a complementary color-building scheme; when color-negative film is printed, these colors reverse again and blend to form the color of the original scene in the positive print. With color-slide film, the layers form a positive image that accurately represents a scene. This complex yet elegantly simple arrangement is what makes color photography possible.

If you hold a color-negative film—which is more commonly referred to as color-print film—up to the light, you will see a strong orange cast. This "mask" compensates for some of the color deficiencies in the film and is essential to obtaining true colors in a print. However, it also makes a negative difficult to "read" in

When you take a photograph, you're actually recording a negative image; this means that tones are reversed, and that black records as white. When prints are made, the film is projected onto a sheet of light-sensitive paper, which reverses the tones so that they re-create what you saw in the original scene. Black-and-white film sees the world in shades of gray. Notice how all the tones and shades of gray in the negative reverse when the final print is made.

Color-print film begins with a negative, but here the reverse of light and dark tones as well as the color complements of the colors in the original scene form the negative image. When a print is made, both the tones and color values are reversed to form a positive picture. The orange mask over the color negative makes it easier for the printers to get correct color balance; however, this masking also makes it very difficult to "read" a color negative.

Color films are composed of three or more color layers—magenta, cyan, and yellow are the main foundation—that transmit and absorb light. In various combinations, these filter layers form all the colors in the spectrum. In these pictures of a yellow flower, filters were used to illustrate how different colors combine to form other colors, or to block or transmit colored light. First, I used an orange filter over the lens (top left) and then switched to a green filter (top right). Then I made an in-camera double exposure using one of the two filters for each shot (bottom). I shifted the camera slightly after the first exposure so that the filter effects overlap in the middle of the frame, leaving the individual filter's effect on the edges. Yellow emerges when these two colors are combined.

terms of what colors will reproduce in the print. In general, only trained photo-lab technicians can analyze a color negative by eye.

Color-print films are among the easiest to shoot with; they forgive slight errors in exposure and, to a certain extent, color imbalances that may be caused by *mixed lighting,* such as daylight and artificial light sources in the same scene. Also, many problems can be solved in printing: the film can be printed darker if you overexposed the negative, or lighter if you underexposed it. The printer can even change the overall color of the film by switching the color-printing filter pack in the printing machine.

Because color-printing techniques are so advanced and color-print film compensates for mistakes, this type of film should be your first choice when you want color prints and enlargements. Although prints can be made from color slides, they rarely match the quality of those from color-print film and are usually quite a bit more expensive.

With color-positive film—which is more commonly referred to as *color-slide* film—what you see when you project or hold the slide up to the light is the actual processed film. No orange mask blocks your view. As a result, color slides are much easier to read than color negatives are. Also, anyone who views a 35mm color slide projected on a screen or wall may be disappointed in the color print of the same scene. However, unlike color-negative film, almost nothing can be done to correct any serious exposure errors when color-slide film is developed.

Film Speed

As mentioned, the light-sensitive components in film are crystals of silver compounds. The larger the surface area of these individual crystals, the more light they are able to absorb. The more absorptive power they have, the more sensitive the film is to light, or the faster its speed. Films are broadly defined as *slow-, medium-,* and *high-speed.* Slow films are called *fine-grain* films. The rest are assigned *grain ratings,* or *granularity,* accordingly.

Grain usually becomes apparent in the final image when it is enlarged; the process magnifies the grain. This explains why some pictures taken with slow, fine-grain films have a smooth appearance when enlarged, while those shot with *faster* films appear as if they've been produced with gritty sand. As you become more familiar with different types of film, you'll be able to identify the speed of the film used simply by examining the grain in the picture.

A film's speed tells you how sensitive it is to light, and *ISO numbers* indicate how one film speed relates to another. These numbers, or speed ratings, enable you to determine how much or how little light is needed for proper exposure. Obviously, this number is important because it is programmed into the camera when you load film, whether you do it yourself manually or the camera does it automatically through a DX-code-reading system.

Today's films come in a variety of speeds: ISO 25, 40, 50, 64, 100, 125, 160, 200, 320, 400, 640, 1000, 1250, 1600, and 3200. When the ISO rating doubles, there is a one-stop doubling of light sensitivity. For example, an ISO 100 film is two stops faster than a film with a rating of ISO 25, one stop faster than an ISO 50 film, one stop slower than

The incredible flexibility of ISO color-print film can be seen in this group of shots taken on the same roll of film. I started out shooting in a shaded bazaar in a theme park; even though the light was quite contrasty, the film bridged the gap and yielded detail in the shadows of the stalls (top left). I made the next picture without flash inside one of the stores inside the arcade; handholding my camera, I exposed at f/2.8 for 1/30 sec. (top right). Later at poolside, I used a narrow aperture for a deep zone of focus (bottom right). A few nights later at a fair, I made this available-light image at f/2.8 for 1/30 sec. (bottom left). Although not all night shots can be made handheld with an ISO 400 film, this film provides photographers with a certain amount of shooting freedom after the sun sets.

One of the main challenges in photography is calculating the right amount of exposure for any given scene. Here, failure to get enough light onto the film produced an underexposed image—it is too dark, has poor color, and loses important details in the darker portions of the scene, or shadow areas (top). Too much light hitting the film resulted in overexposure, causing a loss of detail in the brighter areas of the scene, or highlight areas, a weakening of colors, and a general loss of quality (center). Finally, the scene was correctly exposed and records the balance of colors and tones as they appeared in the original scene (bottom).

an ISO 200 film, two stops slower than an ISO 400 film, and four stops slower than an ISO 1600 film. The ISO scale is calibrated in 1/3-stop increments as are most exposure-compensation dials. ISO 3200 is currently the fastest film available, and it permits shooting in very low light without flash. How fast films become seems limited only by the imagination of research scientists and the demands of the marketplace.

Although you should always try to match your film with the subject and the light at hand, two color-print film speeds are considered "universal"; that is, they can handle a variety of shooting conditions with good results. These are ISO 200 and ISO 400. Modern film technology has done much to improve all film types, but the chief beneficiaries seem to be these two. Both deliver enough speed to enable you to select a range of apertures and shutter speeds for most shots, are quite sharp, and have relatively fine grain.

Brightness Values and Film Latitude

Films differ in their ability to record a range of brightnesses. This means that some films can render detail in both bright and dark parts of a scene (such as in the chrome bumpers as well as the tire tread on a car), while others might make you sacrifice one or the other of these extremes. The human eye can bridge a fairly wide gap in brightness values and see detail in both light and shadow; however, to compensate for a film's narrower recording range, you may have to adjust the way you see so you'll know what you can record on film when you shoot. It is like the difference between being at a concert and hearing it on tape; both experiences may be satisfying, but tape simply doesn't have the ability to re-create the total resonance of the experience, no matter how much digital processing it may receive.

As a general guideline, the ratios between brightness values can be thought of in terms of contrast. On an overcast day, for example, the ratio of dark to light tones is less extreme than on a sunny day. This contrast range can be determined with actual light readings of the brightest and darkest portions of a scene. For example, an overcast scene may have areas that read in a narrow range of $f/5.6$ to $f/8$; the same scene on a sunny day may produce light readings ranging from $f/16$ to $f/2.8$.

When you record any scene, you must take into consideration the type of film you're using and its ability to record a particular brightness range. Most color- and black-and-white-negative films are able to record a greater range of brightness values than color-slide films. This is because the former have a greater exposure latitude. Color-negative films with ISO ratings of 100, 200, and 400 have almost as much exposure latitude as black-and-white ISO 400 film. These films usually give you a three-to-five stop range (from 1 1/2 to 2 1/2 stops above and below an average reading) and can handle just about the same brightness range as black-and-white film. Color-slide film is less able to handle high contrast, although some films are better able to do this than others. While slide film can be slightly underexposed, the biggest problem with slide

Though all colors reproduce with greater or lesser degrees of intensity, there is something about reds that really "pop," even to the point in some slide films of looking "dripping wet."

film is *overexposure*. An overexposed slide looks "washed out," with weak colors and a general loss of quality.

When film receives less light than it needs for correct exposure, it will be *underexposed*. With negative film, this results in prints that have a muddy, grainy look and lack detail in the darker areas of the scene. In color-negative film, underexposure may also yield greenish-yellow colors and hazy blacks. An underexposed slide can range from dark to totally black. Conversely, when a film receives too much light, it becomes overexposed. As a result, black-and-white prints show excessive grain, color prints may be affected by color shifts, and slides have burnt-out highlights or, in extreme cases, have no detail at all.

Some films forgive exposure mistakes better than others do. Both color-print and black-and-white film can still produce pictures with relatively good quality with about a one-to-two-stop overall exposure error. Color-slide film is more precise and, although there may be exceptions, any exposure error beyond plus or minus one stop results in poor picture quality. Naturally, correct exposure is always best because miscalculations adversely affect picture quality, but you do have some leeway.

In fact, today's color-negative films are designed with a certain amount of exposure forgiveness; this came about

largely because of the proliferation of 35mm cameras that have no manual-exposure systems, which can lead to a relatively high number of exposure mistakes on each roll. But, by working with film that can handle more exposure errors, you can use these cameras to make acceptable pictures in most lighting conditions.

Along with a grain structure, speed, and exposure-error tolerance, every brand and every type of film have a particular look. This look may include a certain way of rendering colors and tones, a lower or higher inherent contrast, or a palette of colors that is more reminiscent of pastel than acrylic paint. As you gain experience, you'll be able to mix and match films with different lighting conditions, subjects, and moods.

Selecting the Right Films

Film brands and types change continually, so having a thorough understanding of their characteristics will help you select film wisely. With color film, one of the main differences that you'll notice among brands is the degree of *color saturation*, or the level of intensity in which different colors are rendered on film. Today, the trend among film manufacturers is toward producing films with "higher" saturation.

Another way in which color films differ is their overall *rendition*, or *tone*. Of course, most films strive to be neutral, but many are either *cool* or *warm*. In photography, "cool" means that the film has a slightly blue cast to it; "warm" means that it has a yellowish cast. These differences in saturation and tone are most apparent with slide films because the transparency is the actual, original film. Conversely, color-negative films reveal fewer variations because, when prints are made, many subtle differences are *balanced*, or *normalized*, by the printing process.

An even more subtle distinction can be seen in the way each film records individual colors. With some films, reds are quite intense and blues are muted. Other films may record bright yellows and near-electric blues, but add a touch of purple to reds.

Similarly, skin tones may be warm in one type of film and cool in another. Again, many of these minor variations may be accentuated or eliminated during processing, but they do exist.

Films also differ in their inherent *contrast*, which refers to the way they record brightness relationships. Some films are more contrasty than others; this can either help when the scene is *flat*, or lacks contrast, or it can pose a problem when the scene itself is contrasty. (However,

sometimes you may want to increase the contrast in an already contrasty scene by using a film with a higher inherent contrast.)

Film choice is a case of luxury balanced by necessity. The luxury comes when you can choose any film for any subject; the wide range of film brands and types offers you many ways to interpret a subject. Necessity becomes a factor when shooting and lighting conditions are difficult. This usually happens in low light, when higher shutter speeds are needed, or in artificial light. Keep in mind this important rule: *it is always best to shoot with the slowest film speed possible.* But you can ignore this rule whenever necessary to get the shots you want.

Don't give up making pictures just because you can't use the slowest film in your camera bag. Because most photographers usually don't carry 10 different types of film, gauge your needs before you go out—whether for a day, a week, or an extended trip. Also, always pack one or two rolls of film you don't think you'll need; you never know when something will come up. Experiment with new films as much as possible. As you work with different films, you'll begin to see how each one has some special way of rendering color, contrast, and tone. Learn to exploit these differences in your work, and make film choice another creative option.

The film you carry with you often determines how you'll shoot pictures as well as the way they'll turn out. The ISO 1000 film used to make this shot of people watching a fireworks display allowed for a fast enough shutter speed for a handheld exposure (above). The other fireworks picture, made by Carl Santoro, was shot on a slower ISO 64 slide film; because the shutter speed was 1/8 sec., Santoro had to use a tripod to ensure a blur-free shot (right). However, the slower shutter speed was used to its best advantage: it recorded both a multiple burst of fireworks and the flowing stream of colors during the longer exposure time.

GEORGE SCHAUB

MATCHING FILM SPEED TO THE LIGHT

Although you can experiment and use any film you want under any lighting condition, some general guidelines for coordinating film speed and lighting will help you get the best results in terms of color, contrast, sharpness, and grain, and give you the most shooting freedom. Here are some typical lighting situations paired with the film speeds that will deliver optimum results.

Daylight, Full Sun

Daylight exposures can often be calculated using the *sunny 16 rule*. According to this time-honored guideline, you can find the correct exposure for any film in full daylight by using the reciprocal of the film's ISO as the shutter speed and *f*/16 as the aperture. So for an ISO 100 film, an exposure of 1/125 sec. (there is no 1/100 on the shutter-speed dial) at *f*/16 will give you a good exposure on a sunny day. Similarly, for ISO 50 film an exposure of 1/60 sec. at *f*/16 follows the "sunny 16" rule. Although this guideline was most useful when exposure calculation was difficult, it can still come in handy as a way of making sure that your in-camera meter is relatively accurate when it reads out exposure information.

Of course, you don't always have to use a slow-speed film, but you may sacrifice some picture quality. For example, both ISO 100 and ISO 1000 films can be exposed in full daylight, but the ISO 1000 photograph will look much grainier than the ISO 100 photograph. Also, the faster film will probably be more contrasty and harsh overall. Of course, you may sometimes want the particular look of a fast film in daylight; this is when it helps to know what happens when you creatively break the rules.

For outdoor shots using color-slide film, there are four slow speeds you can choose from: ISO 25, 50, 64, and 100. Which one is best? When deciding, keep two points in mind: first, the slower the film speed, the finer the grain; second, the film speed determines the range of apertures and shutter speeds that you can use when exposing the film.

ISO 25 film has the finest grain of any camera film made. Its color and sharpness make it outstanding. However, ISO 100 film is two stops faster than ISO 25 film. So if the exposure with the ISO 25 film is *f*/8 for 1/125 sec. on a sunny day, the exposure with the ISO 100 film will be *f*/16 for 1/125 sec., *f*/8 for 1/500 sec., or *f*/11 for 1/250 sec. If the subjects are moving fast or if you want a greater zone of sharpness for your shots (and you're shooting handheld), then you should choose the faster film.

Daylight/Dull or Overcast Sky/Shade

While it may seem surprising, daylight conditions other than bright and sunny are ideal for color photography. One main reason for this is that such light helps to eliminate the problems of excessive contrast. Unfortunately, many people don't shoot when the sun hides behind the clouds, when fog covers the ground, or when rain threatens. But these lighting conditions can provide a special illumination that brings out all the subtle tones and shades of color.

Low light levels mean that you may not be able to use the slower speed films: ISO 25, 50, and perhaps 64, as well as ISO 100 color-slide and color- and black-and-white-print films when photographing handheld. Of course, you can shoot with wide apertures, but this limits flexibility. Luckily, the next group of films, the medium to medium-fast films, provides more speed with only a slight decrease in grain and sharpness. The two main color-print films you should pack on an overcast day are ISO 200 and 400. In some ways, these films are nearly universal in application: they can be used successfully in the brightest to the dimmest light. While it is true that ISO 100 film is best in many ways ISO 200 and 400 films are faster, giving you a bit more shooting freedom with only a slight sacrifice in quality.

Suppose you're traveling and as you tour the sights, you shoot street scenes and museum interiors. You even carry your camera with you to dinner at an outdoor cafe. Naturally, you'll want to bring a number of rolls of film with you—and you might feel that you need a variety of film speeds to cover all possible lighting situations. But if you're shooting color-print or black-and-white film, you can usually stick to one film speed, such as ISO 200 or 400, and take pictures in nearly every lighting condition you encounter, from bright street scenes to interiors of houses and museums. In fact, you can even get some nighttime shots, but only if you can steady the camera on a table edge or a railing. One of the reasons these films are so versatile is their ability to deliver good images even when they are slightly over- or underexposed; of course it is best to shoot the films at the optimum exposure for their speed, but you can always shoot them at one stop higher or lower and still get quite acceptable results. Color-slide films, however, aren't as flexible in terms of exposure; in fact, they're quite exacting. So when you're shooting handheld on an overcast day, you might need an ISO 200 or 400 color-print film.

The primary reason for using a medium- or high-speed film in overcast or dim lighting conditions is that it provides the greatest shooting freedom, enabling you to use a wide range of apertures and shutter speeds. Of course, if you use a tripod or some other camera-steadying device, you can use a slow film in low light by shooting with longer shutter speeds. Unfortunately, a gain in film speed corresponds to a slight loss in picture quality, especially in terms of graininess and slightly less sharpness. You'll have to decide whether or not the sacrifice is worth it. For example, if you're shooting ISO 50 film in the late afternoon as a heavy cloud cover moves in, you may get a reading of *f*/5.6 for 1/60 sec. While this is a reasonable exposure, it limits how you can manipulate

depth of field. To increase depth of field by shooting at *f*/16 you'll have to expose for 1/8 sec. to compensate for the three-stop change in aperture. Keep in mind, however, that this shutter speed is much too slow for a handheld shot and won't stop any sort of movement. In order to use *f*/16 for 1/60 sec., you would need to switch to ISO 400 film, which is three stops faster than ISO 50.

You'll also need a faster film to capture motion, such as when you want to photograph a marathon on a cool, dismal day. With an ISO 64 film, you may get a reading of *f*/8 for 1/60 sec. While this exposure may give you the depth of field you want, the shutter speed may not be fast enough to keep the runners from becoming a blur.

Remember, each increase in film speed gives you a corresponding ability to use either faster shutter speeds or narrower apertures.

Keep in mind, too, that, whenever possible, you should shoot with the slowest speed film you can, whatever the lighting conditions. This guarantees the best grain, contrast, sharpness, and color rendition overall and explains why photographers don't use only the fastest film they can find. Although they would have more leeway in terms of speed, they would sacrifice overall picture quality. But there are times when film choice is dictated by the light or when the effect you want can't be achieved with a slower speed film.

Sometimes you have to wait for the light to be right. In fact, some photographers simply won't shoot in normal, or midday, light and wait for the more dramatic hours of the day to pick up their cameras. My first shot of this fisherman is a normal contrast scene (top). Two hours later, when the sun lowered and the light became more dramatic and contrasty, I exposed by making the highlight, or brightest value in the scene, the most important (bottom). This turned the fisherman into a silhouette, and a straightforward scene into an image with graphic appeal.

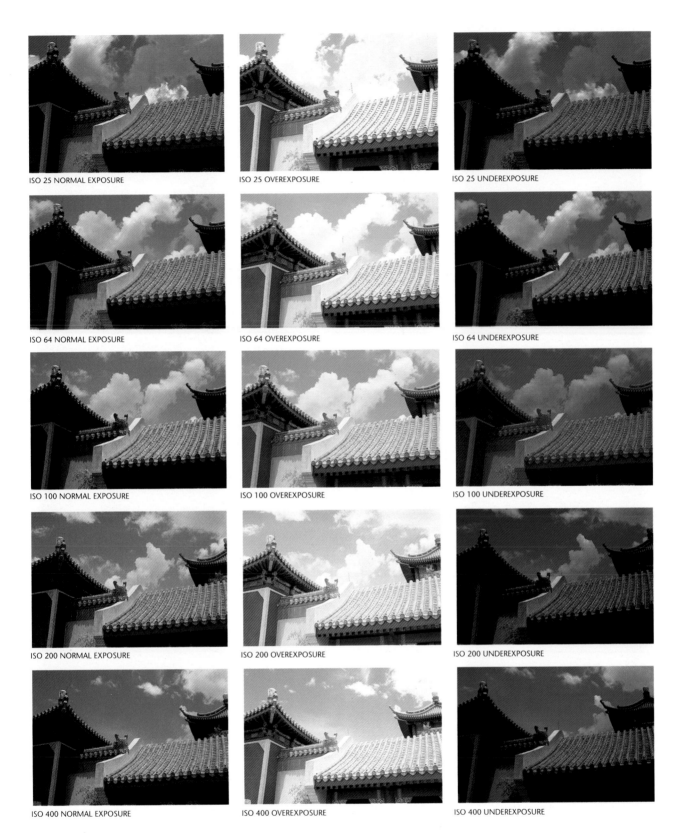

ISO 25 NORMAL EXPOSURE

ISO 25 OVEREXPOSURE

ISO 25 UNDEREXPOSURE

ISO 64 NORMAL EXPOSURE

ISO 64 OVEREXPOSURE

ISO 64 UNDEREXPOSURE

ISO 100 NORMAL EXPOSURE

ISO 100 OVEREXPOSURE

ISO 100 UNDEREXPOSURE

ISO 200 NORMAL EXPOSURE

ISO 200 OVEREXPOSURE

ISO 200 UNDEREXPOSURE

ISO 400 NORMAL EXPOSURE

ISO 400 OVEREXPOSURE

ISO 400 UNDEREXPOSURE

Part of a film's "personality" is the way it handles scene contrast. This scene was photographed on a bright sunny day with a number of different slide films, ranging in speeds from ISO 25 to 400. In each case the scene was shot at the correct exposure and was bracketed for an over- and an underexposure. As you can see, the personality of each film renders the shadow and highlight relationship somewhat differently, with the differences becoming most apparent when exposure deviates from the norm.

GEORGE SCHAUB

LOADING AND REWINDING FILM

Loading a roll of film, which sits in a light-tight cassette, is done in a series of steps. First, place the roll of film into the camera by turning the film cassette upside down (the plastic nib should point downward) and fitting it snugly into the *film chamber* on the left side of the camera's interior. Make sure that the *rewind spindle* at the top of the film chamber extends into the spool. If the *rewind crank* on the top of a manual-loading camera protrudes into this chamber, lift it from the outside, put in the film, and then reinsert the crank shaft into the opening on top of the film cassette. Cameras with motorized advance and rewind mechanisms don't have rewind cranks; with these cameras, you simply fit the film snugly into the chamber. If the film is properly positioned, its shiny side will be facing you.

Next, pull the *film leader,* or *tongue,* the narrow strip at the beginning of the film, until it is long enough to insert into the grooves of the *takeup spool,* which sits in the chamber on the right side of the camera's interior; with autoload cameras, pull the leader over to a marked position on the right side. Then, with manual-loading cameras, push the *film-advance lever* once or twice, or until you are certain the *sprocket holes* on the film are engaged in the *sprocket gears,* and that the film winds firmly on the takeup spool. With autowind cameras, closing the camera back engages the film and advances it to the first frame.

Loading film is one of the most common problems for new SLR owners. For example, you may not line up the sprocket holes on the film leader and the gears on the takeup spool properly, which causes the film to fail to advance when you're taking pictures. You'll know this has happened when you keep shooting and shooting beyond the designated number of exposures on the film, or when the tension on the rewind crank eases after only one or two turns.

You can confirm that the film is advancing properly several ways. With manual-advance cameras, follow this procedure: load the film normally; advance it a frame or two, checking that the film is both snug on the takeup spool and that the sprocket holes align with the sprocket gears; and then close the camera back and advance the film one more frame. Next, turn the rewind crank counterclockwise until you feel a slight tension. Advance the film again and, as you do, watch the rewind crank: it should respond by turning slightly in a clockwise direction. Once it does, you can be assured that the film is firmly in place and will advance correctly.

Here is a common loading sequence for cameras with motorized advances. When you first place the film in the film chamber on the left (notice the position of the film cassette's nib, or lip, and the way the film is cut), the film's leader only reaches about halfway across the film guides. In order to thread the film correctly, grasp the film leader and pull the film out of the cassette until the edge of the leader reaches the colored mark on the right side of the camera. You can then close the camera and push the advance/shutter-release button; the film will advance automatically to the first frame (shown here with an open camera back).

Some cameras come equipped with an advance-confirmation indicator. This is either a porthole-like window with a patterned spinning disc or, on cameras with an LCD, a signal or symbol.

When you finish a roll of film, your camera won't advance any longer, and your advance lever won't budge. Don't force the film-advance lever, even if you've just

come upon a great picture; doing so may ruin all of the earlier exposures. Applying pressure to the lever will, more than likely, rip the film from its fastener in the light-tight cassette. If this happens, you won't be able to rewind the film into the cassette or be able to remove the film from the camera—unless you are in a completely dark room.

The next step is to rewind the film. First, push the *rewind button,* which is usually located on the base of the camera, and then extend the rewind crank (but don't lift it yet—that would open the back and expose the film!) and wind the film back into its cassette. The rewind button releases the "forward" gear setting in the film-advance mechanism and allows the film to be pulled backward into the cassette. You know the rewind is complete when you feel a release of tension on the crank and/or hear a definitive "click" as the film comes off the takeup spool. Turn the rewind crank one more time for good measure, and then pull it up (or open the camera back, depending on your model camera) and remove the film. Motorized rewinds complete all of these steps automatically, but usually you still have to engage a rewind switch to begin the process. Some cameras even start to rewind the film once the last available frame has been exposed.

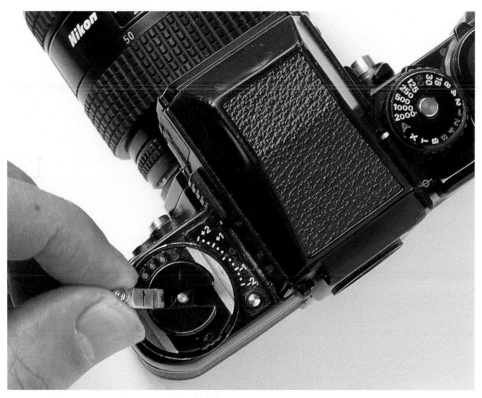

Is your film properly threaded? Once you've loaded your film, you can confirm that it is firmly on the takeup spool by first turning the rewind crank clockwise until you feel a slight tension, then firing the shutter and advancing the film to the next frame. If the rewind crank spins as the film advances, you can be sure it is loaded correctly.

BRYAN PETERSON

PRINTS VERSUS SLIDES

Within seconds of glancing at the film counter in any camera shop, beginning photographers experience sweaty palms, a rapid heartbeat, and a tightness around the forehead. Overwhelmed, they're confronted by neatly stacked rows upon rows of different types of film: green boxes, orange boxes, yellow boxes, and blue boxes.

To narrow down your choices, thereby alleviating some anxiety, follow a few basic guidelines. First, you have to decide between black-and-white or color film. Assuming that you select color film, your next choice concerns the final result. Do you want prints or slides? You can readily identify both kinds of film. Regardless of the manufacturer, all color-print films end in the word "color:" for example, Kodacolor, Agfacolor, and Fujicolor; and all color-slide films end in the word "chrome:" Kodachrome, Agfachrome, and Fujichrome.

Quite often, the question of which brand of film is best comes up in my workshops. One good rule of thumb is to match the color of the film box to the subject or subjects you expect to be shooting. For example, both Fujichrome and Fujicolor come in green boxes, so these films are logical choices for photographing rich green forests and deep blue skies. Kodachrome and Kodacolor, on the other hand, come in yellow boxes and are logical choices for shooting the intense reds, oranges, and yellows of a Vermont autumn. In essence, Fuji's green-boxed film favors cool colors while Kodak's yellow-boxed film is best suited to warm colors.

Additionally, film boxes also provide much-needed information about the film's number of exposures, speed, and format. All 35mm films begin with a designation of 135, followed by the number of exposures possible: 135-12, 135-24, or 135-36. When buying film, keep in mind that slide film is available in only 135-24 or 135-36. In big, bold letters, the film's speed is shown on the box, such as Fujichrome 50, Agfachrome 100, or Kodachrome 200. These numbers refer to the film's sensitivity to light. This treatment of the film speed differs greatly from the small print used on packaging just a few years ago. Finally, the film box indicates the film format. The most popular type of color film—for both prints and slides—is *daylight-balanced.* Simply put, "daylight" refers to natural light, whether it is the deep shade under a willow tree, the strong midday sun, or the light filtering through a skylight into a room.

Only after trying several brands and comparing the results can you make an informed decision about the film that is right for you. I always recommend to my students that they shoot landscapes, portraits, and closeups using at least three different brands, all with exactly or approximately the same film speed. This type of comparison shooting will clarify which film is best for your own personal tastes and your goals. I also strongly recommend sticking with the major brands. Whether you shoot with Kodak, Agfa, or Fuji film, you'll seldom have any trouble getting the film processed, even if you find yourself in some remote region of the world.

Choosing between print and slide film involves many variables. For some photographers, price is a primary consideration. Which film is cheaper, slide or color-print? Processing a 36-exposure roll of slides costs around $6 while processing a 36-exposure roll of color-negative film costs an average of $12. So if you adhere to a ruthless editing ethic, it is clearly much less expensive to shoot slide film. To the surprise of many beginning photographers, you can also make color prints from slides. On the average, a 3½ x 5 print costs about 50 cents. Suppose you have four really great slides in a roll of film and decide to have prints made, bringing the final processing cost to $8. This price is still $4 less than the cost of processing the print film. But most beginners and many amateurs shoot color-print film because the processed film can be easily seen and shared. Slides, on the other hand, are smaller than prints, are more convenient to store, and can be shown to large groups via a slide projector.

Another difference you should think about when buying film is its ability to compensate for errors in exposure. Color-print film is a bit more forgiving when you accidentally overexpose it than color-slide film is; it records rather pale colors when overexposed. However, color-slide film responds to underexposure better than color-print film does. When you underexpose slide film a bit, the colors are usually more vivid and contrast increases. With color-print film, on the other hand, underexposure results in a dense negative. This makes it difficult to pull the color out and onto the printed paper. In general, color-slide films allow for both a one-stop-overexposure and a one-stop-underexposure margin of error, while color-print films allow for a two-stop-overexposure margin of error. Finally, you should realize that color-slide films record permanent images, but the negatives of color-print film can be altered in the darkroom to correct for exposure errors. It is important to note, however, that these exposure corrections are made in the darkroom of a custom lab, not in a lab that processes film in an hour. If it sounds like I prefer slide film to print film, I do. And there is yet another reason why I think that you should shoot slides. Most, if not all, publishing houses want only slides, not color prints.

While professional photographers usually shoot slide film, you may find that you want to shoot print film for certain situations—or that you prefer it in general. Both types of film have advantages and disadvantages. Although slide film provides richer, sharper images, it has less exposure latitude; this means that you must be more precise or you'll end up with unwanted over- and underexposures. On the other hand, print film is more forgiving and can be successfully push- and pull-processed, but its faster speeds produce grainier images. Here, I used slide film (top) and print film (bottom). As you can see, the colors in the slide are more saturated.

FILM SPEED

A film's speed determines its sensitivity to light. When the "right" amount of light strikes the film, a picture is recorded. Selecting the appropriate film speed is far more important than choosing the right brand or deciding between print and slide film. The "right" film speed can ensure a multitude of creative effects via the creative use of the aperture and shutter speed. Conversely, a "wrong" film speed can leave you floundering.

On every box of film, color or black-and-white, the speed of the film is indicated by a number after the brand name, such as Fujichrome 50, Kodacolor 100, and Ektar 1000. If you think of these numbers as light-gathering receptors, you'll be able to appreciate the differences between *high-speed* films, *medium-speed* films, and *slow-speed* films. High-speed, or *fast,* films have ISO ratings of 400, 800, and 1600 and contain that number of light-gathering receptors. Similarly, medium-speed films have ISO ratings of 100 and 200, which reflect their 100 and 200 receptors, respectively; and slow-speed, or just *slow,* films with ISO ratings of 25, 50, and 64 contain equivalent numbers of receptors.

To determine how much longer, you should know that an ISO 50 film offers half as many light-gathering receptors as an ISO 100 film, an ISO 100 film offers half as many receptors as an ISO 200 film, and an ISO 200 film offers half as many receptors as an ISO 400 film. Conversely, of course, an ISO 400 film has twice as many receptors as an ISO 200 film. In effect, each halving or doubling of these light-gathering receptors is considered a stop. So if the correct exposure for the film with 400 light-gathering receptors is *f*/8 for 1/500 sec., what is the correct exposure for the film with 50 light-gathering receptors? By counting back from 400 to 200 to 100 to 50, you can determine the correct exposure via the number of stops. In this example, there is a three-stop difference: 400 to 200 (one stop), 200 to 100 (one stop), and 100 to 50 (one stop), for a total of three stops. Therefore, if *f*/8 for 1/500 sec. is the "right" exposure for 400 light-gathering receptors, then *f*/8 for 1/60 sec. is the correct exposure for 50 receptors.

How did I arrive at this exposure? Because the aperture is *f*/8 for both types of film, you must determine the correct exposure by shutter speed. Accordingly, the first camera's

exposure meter, which you fed the pivotal information regarding film speed, dictates that the camera with ISO 400 film and an aperture of *f*/8 requires a shutter speed of 1/500 sec. The other camera's exposure meter, which you fed the sum of 50 receptors to, then indicates a different shutter speed; 1/60 sec. is correct because it reflects the three-stop difference in film speed. Moving from 1/500 sec. to 1/250 sec. (one stop), and from 1/250 sec. to 1/125 sec. (one stop), and then from 1/125 sec. to 1/60 sec. (one stop) comes to a total of three stops.

Why all the fuss about fast, medium, and slow films? Suppose that for one composition, you decide to use a 200mm lens to isolate a couple of flowers that are about 7 feet from you. Choosing a low viewpoint, you can selectively focus through the foreground flowers, thereby creating a beautiful wash of color around the two flowers that you want to isolate. Directly behind these two in-focus flowers, the sea of out-of-focus color continues. To keep the depth of field limited, you have to set the lens to wide open, which is *f*/2.8 in this case.

In order to use *f*/2.8 (the aperture that limits the depth of field), you have to determine which film speed will enable you to selectively focus. You'll see that at *f*/2.8 either an ISO 25 or an ISO 50 film will produce the desired effect. Don't let the fact that both of these films are available only in slide form trouble you. Why not take this opportunity to try your hand at shooting slides? Finally, with an ISO 50 film loaded in your camera, you can set your 200mm lens at *f*/2.8 and shoot away as the meter indicates a correct exposure of 1/1000 sec.

One day I came upon a row of orange and yellow lilies. With a 200mm lens, I close-focused on one large flower and clearly saw a blurry wash of color in the background. But seeing this out-of-focus background didn't guarantee it would remain out-of-focus on film. To get this effect, I had to consciously select an appropriate lens opening. This aperture is almost always wide open or very near to it.

For the photograph I find more appealing, I deliberately chose *f*/4, an aperture that would isolate the single stem and render limited depth of field (right). Then I turned the shutter-speed dial until the correct setting of 1/1000 sec. was indicated, and exposed at *f*/11 for 1/125 sec. (opposite page). This composition is so busy and the depth of field so extensive that the lone lily gets lost.

JOHN SHAW

CHOOSING FILM FOR SHARP, GRAIN-FREE IMAGES

If you've taken the trouble to buy good equipment and to use good techniques when photographing, then you should also use good film. Shoot the slowest speed slide film that you can use given the existing lighting conditions. The slower the speed, the sharper, more grain-free the film. I recommend using slide film for many reasons. Slide film is capable of producing sharper images with more saturated colors than print film. Slides can be made into prints if you want them far more easily—and with better results—than print film can be made into slides. The results you get with slides are readily apparent. You can instantly see your mistakes and your successes. I can't tell much of anything by looking at a color negative, but I need only a glance at a slide to check exposure, color balance, and other factors. With a bad print, you don't know if it is the result of something you did or something the printer did. Slide film is much less expensive to use. Film wastage is to be expected, especially when photographing animate subjects. Edit your slides by looking at them through a 7X or 8X loupe on a lightbox, and edit ruthlessly. If you plan on ever submitting photographs for publication, magazine and book publishers work almost exclusively from transparencies. And slides made with slow-speed film are the only kind accepted by stock-photo houses.

I conducted an informal survey of 20 of the top wildlife photographers in the United States and Canada. In total, they said that more than 95 percent of their work was done on ISO 64 slide film. The second most used film among them was ISO 25 slide film. Kodachrome was the most widely used brand.

Pick one film and stick with it. Learn its characteristics, so that you have even more control over the image-making process. Choose a film that is widely available. What

happens if you are in an out-of-the-way spot and run out of film? Can you buy more locally? Choose a film that is available fresh and isn't likely to have been sitting on a dealer's shelves for months on end.

In the field, I also suggest that you code your film. I mark the plastic canisters with a round stick-on label, red for Kodachrome 64, white for Kodachrome 25. I place the label on the side of the canister, and when the roll is shot I pull it off and stick it back on the top. At a glance I can tell the type of film and whether or not it has been exposed already.

The extremely fine grain of Kodachrome 25 is shown here to its best advantage. The detail of the delicate sheet web over sphagnum moss and the drops of dew would have been lost had I used a faster film. Shooting with a 105mm lens, I exposed for 1 sec. at f/11.

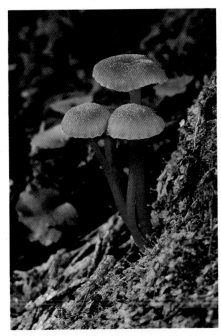

Even when a small detail of a 35mm transparency is blown up, you can still see the quality that Kodachrome gives you. Notice how the detail of the dimly illuminated red mushroom stems is still present and the colors are still true in the large detail (right). Here I exposed Kodachrome 25 for 1/2 sec. at f/16 and used a 105mm lens.

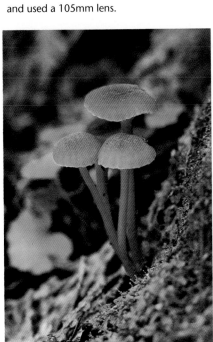

If you compare the same subject shot with Ektachrome film the difference in grain is very apparent. The subtle highlights and intricate detail that is present in the Kodachrome frame doesn't appear on Ektachrome. For this shot, I used the same lens, but switched to Ektachrome 200, exposing it for 1/15 sec. at f/16 (right).

PART THREE
COMPOSITION

PATRICIA CAULFIELD

CLASSIC COMPOSITIONAL RULES

Composing photographs is quite different from analyzing scenes for visual elements. Composition is very personal. People shooting in the same places at the same time don't take the same or even similar pictures. I purposely avoid talking about rules of composition or suggesting that if you didn't apply them, your pictures would be failures. I believe there are many ways to compose pictures, and that one way isn't necessarily better than another. Still, most successful pictures are well composed in some way. Beginning photographers should consciously consider how to compose a picture as carefully as they analyze the subjects' shapes, lines, and textures.

Knowing the classic compositional rules for visual organization and trying to put them into practice can improve your pictures, as long as you also feel free to break these rules. You should know the rules so you can decide for yourself whether applying one or more of them will render the best interpretation of your subject. To put these rules to their best use, interpret them solely as suggestions, not as boundaries to your imagination.

The classic formula for subject placement, practiced by sculptors in ancient Greece and by European painters and architects since the Middle Ages, is called the "golden mean." It says that to produce the most pleasing proportions, a line—or any picture area—should be divided into two parts so that the relationship between the large part and the small part is the same as the relationship between the whole line or area and the large part. For example, when the whole is a 10-inch line, the parts are 3.819 inches and 6.181 inches, respectively. In other words, the 10 inches whole is to 6.181 inches as 6.181 inches is to 3.819 inches. The same principle can be applied to a two-dimensional picture area.

In practice, a rule called the "rule of thirds" is often substituted for the golden mean, though the resulting proportions are different. The rule of thirds states that the picture should be divided into thirds horizontally and vertically. The center of the picture's interest should be placed at one of the intersections of the vertical and horizontal lines.

The rule of thirds can be equally effective when applied to subjects great or small, near or far. I came across these flowers at Chase Lake, North Dakota. I exposed Kodachrome 64 for 1/250 sec. at f/5.6 and used a 105mm lens.

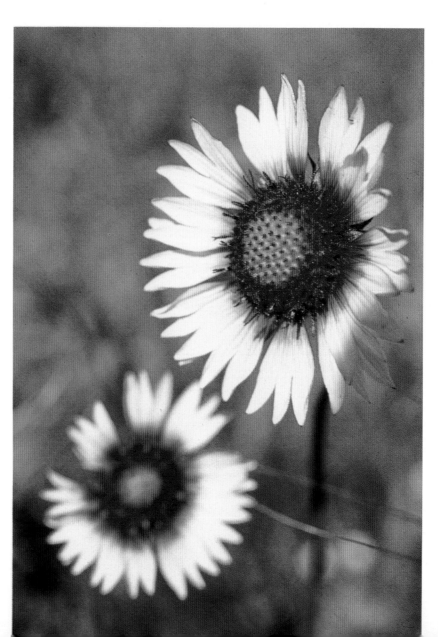

I've put a grid on the photograph on the previous page so you can see for yourself how much the picture complies with the golden mean and the rule of thirds, which are meant to be only general guides to good composition. As stated, the most important parts of the subject should fall on the lines or intersections of grids imposed on it. Although I haven't consciously tried to take pictures according to these rules, I'm surprised to discover how many of my pictures are in accord with them. As you can see from the small picture grid upon it, the strong and pleasing flower closeup benefits from my unconscious application of the rule of thirds. But you can also see from many of my other pictures that my use of these rules is hardly universal. I think that structuring too many pictures according to any rule would doubtlessly be very boring.

Another classic formula for composition is the "S curve." I've taken a few photographs employing S-shaped compositions, but they've been few and far between, and they aren't really good examples of all this convention includes. Obviously, to make S-curve compositions you have to find a subject with an S shape in it. Not every road or river comes with built-in S shapes, and there is nothing you can do about that. I'm not crazy about S curves, so I don't stress looking for them and thereby running the risk of passing by all sorts of other possibilities that might be more interesting to me.

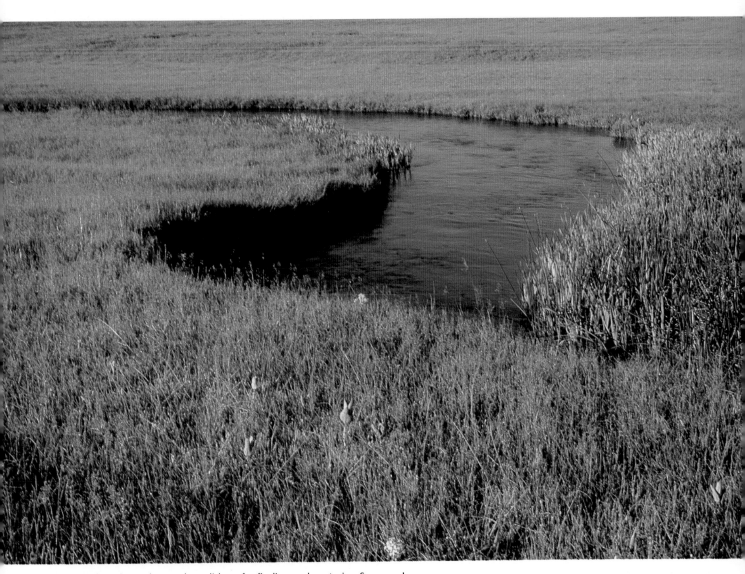

Rivers and roads are the usual candidates for finding and capturing S curves. I discovered the S-shaped creek in this picture in a Nebraska meadow, and I photographed it shortly after dawn with a 55mm lens. The exposure was f/8 for 1/250 sec. on Kodachrome 64.

PATRICIA CAULFIELD

DIVIDING THE PICTURE IN HALF

Reflections of a subject clearly mirrored in still water often invite an equal division of space in the picture frame. The ambiguity of such scenes—what is up and what is down, which image of the subject is real and which is the reflection—provides visual tension and holds the viewer's interest. Another kind of subject—two real objects so similar in size, color, and shape that you wonder if both are real or if one is a reflection—also calls for 1:1 proportions.

The lake's reflection in the picture on the right shows an equal division of space both vertically and horizontally. The flower picture is an example of another kind of subject that can be well composed in 1:1 proportions.

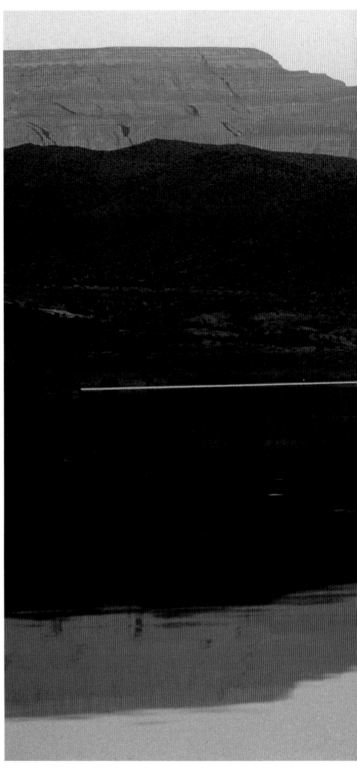

I took the picture of these marsh mallows on a bright overcast day at the Brigantine National Wildlife Refuge in New Jersey. There were lots of the flowers scattered about the marsh, but only one plant was close enough to close in on with a 105mm lens. The exposure was 1/250 sec. at f/5.6 on Kodachrome 64.

For a real mirror image you need a still-water surface, the kind found on windless days in lakes or ponds. Here, the hills around Lake Mead in Arizona reflect in its calm waters just after sunset. I shot this scenic from an anchored boat using a 200mm lens at an exposure of 1/250 sec. at f/4 on ISO 64 film.

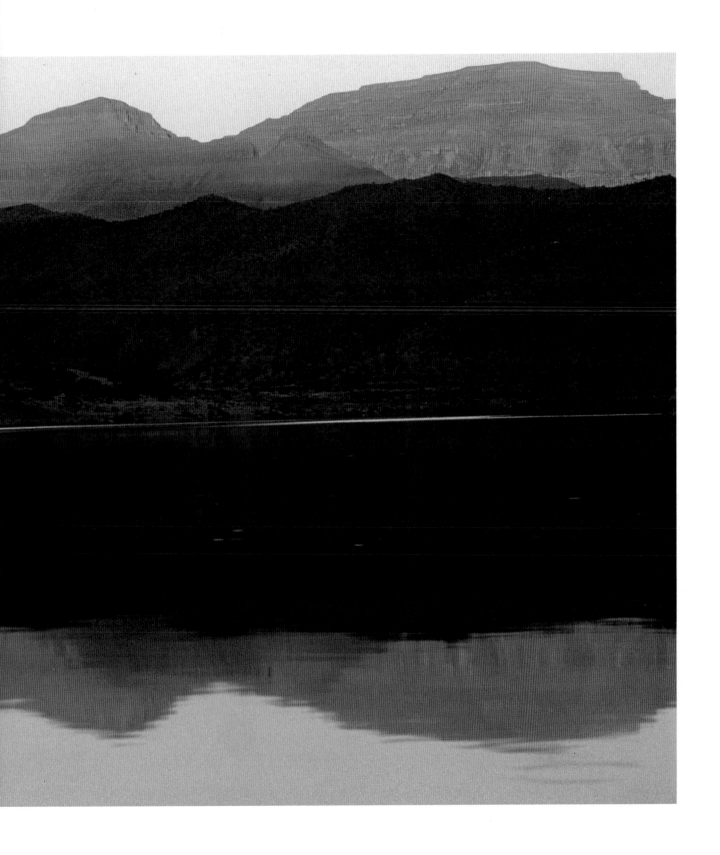

BRYAN PETERSON

FILLING THE PICTURE FRAME

What kinds of photographs command the most attention? Usually those that involve commonplace subjects composed in the simplest way. Successful pictures are limited to a single theme or idea and are organized without clutter. These powerful compositions stand in sharp contrast to most pictures taken by amateur photographers. In their haste to record the image, many end up with pictures that have too many points of interest. The resulting confusion alienates the restless eye, motivating it to seek visual satisfaction elsewhere.

The visual elements photographers work with are line, shape, form, texture, pattern, and color. Every photograph contains at least one of these elements, regardless of the subject, and these elements have great symbolic value—particularly line, shape, and color. They can be experienced as either hard or soft, friendly or hostile, strong or weak, aggressive or passive. Most of the time you see and utilize these elements with unconscious abandon. Your memory and experiences affect your sensitivity to various visual components, and this in turn affects how you use them in your compositions.

I'd like to recommend an exercise for training your conscious mind to observe the various design elements and the way you already use them. I think you'll find the process enlightening. Let me add that I don't usually suggest exercises that concentrate on visual themes because I believe that photographers should avoid developing arid preconceptions about composition. Like having a one-track mind, focusing on only one visual element can keep you from experiencing an entire image; however, the following exercise is designed to enhance

your powers of composition by acquainting you with your own visual prejudices—your strengths as well as your weaknesses.

First, gather 75 of your pictures, preferably without people in them. Set them aside, take a sheet of typing paper, and draw six columns on it. At the top of each column list one of the following: line, shape, form, texture, pattern, and color. Now begin looking at your pictures, one by one, with a critical eye. Carefully study each one, and make a check mark in the column that best describes the element(s) that dominates the composition. After you've looked through all 75, note which columns have the most check marks. (It is likely that at least one column will have more check marks than the others.) Consciously or not, everyone favors certain design elements. Both the content and arrangement of your pictures reveal something about your psyche—that is, assuming that your reason for taking pictures flows from your own feelings and responses and isn't simply an outward attempt at duplicating someone else's style.

Which columns have the fewest check marks? Note the elements that received the lowest scores; then at the next opportunity, grab your camera and head out the door with the goal of identifying and isolating these design components. Take only a telephoto or tele-zoom lens with you. These lenses reduce perspective, which enhances good visual design since the illusion of depth is eliminated. As mentioned earlier, telephoto lenses also have a narrow angle of view that eliminates the surrounding clutter, enabling you to focus on the specific visual elements you want to emphasize.

Once this becomes second nature to you, you'll find that there are many ways to improve a composition. One is to fill the frame with your subject, thereby giving it more weight. Whether you choose to walk closer (which is by far the cheapest route) or to switch to a telephoto lens, your subject should dominate the picture area. This leaves no doubt in the viewer's mind about your intentions.

If you go through your photo album or slide file, chances are you'll discover lots of pictures that don't live up to the expectations you had for them when you pressed the shutter, generally because you weren't close enough to your subjects. It may be obvious what your intentions were, but when a subject is so small that it gets lost in the composition, the resulting pictures don't necessarily convey your intent to the viewer. Many photographers excuse these bad pictures by calling them "snapshots." But why make excuses when you know your real purpose was to capture something essential about these subjects and convey your feelings to the viewer?

Telephoto lenses are particularly good for photographing people, especially children, partly because these lenses bring subjects closer to the film without disrupting the subjects' psychological boundaries. In addition, the telephoto lens' flattened perspective is the

I had my camera with me when I came upon this farmer burning his field (opposite page). After mounting my 400mm lens and camera on a tripod, I waited patiently for his fire-breathing machine to move closer to me and fill the frame (above). Then I quickly fired off several shots of the tractor. Its size and the roaring heat from the fire create tremendous impact in the composition. In addition, the compression of picture elements caused by my telephoto lens adds bulk to the already brimming frame.

most flattering for facial details, which is why the telephoto is sometimes referred to as a portrait lens.

Cluttered compositions can be a problem when shooting landscapes, too. Most landscapes are made with standard or wide-angle lenses. These lenses offer a greater angle of view, as opposed to the telephoto lens, and thus allow more clutter to enter the picture field. So when you shoot with wider lenses, you need to be fully conscious of everything going on inside your viewfinder. My advice for shooting landscapes is to slow down! Unlike doing candids of kids or action photography, shooting landscapes should be pleasurable and relaxing and seldom requires split-second thinking. Why hurry yourself when that only results in ho-hum, so-so compositions?

From across the road where I'd just finished a midmorning snack and a cup of coffee, I spotted this roadside ditch of California poppies (opposite page, top). I decided it was a good place to practice changing lenses, shifting my point of view, and looking for tonal or color contrasts. First, using my wide-angle lens and a low viewpoint, I moved in very close and filled the frame with flowers (opposite page, bottom). The unique perspective created by the wide angle gives viewers the impression that I was shooting in a meadow brimming with thousands of poppies.

Next, I switched to my 200mm lens, and with the aperture set wide open I leaned against the side of the ditch and began focusing 6 to 8 feet into the scene, ever mindful of the other flowers and grasses in front of the lens (top). This selective-focus technique enabled me to separate just a few of the blooms from the crowded hillside. Notice how this effect also created tonal and color contrast in the picture.

Finally, with my 55mm macro lens I spied a single bloom (bottom). I chose to showcase the flower against a shadowed background that I created by hanging my jacket from my tripod. The flower's stark yellow-orange color is even more vivid and arresting with the addition of the dark-toned background.

BRYAN PETERSON

VERTICAL VERSUS HORIZONTAL

Perhaps it is because a camera is more comfortable to hold in the horizontal position, or perhaps it is because the viewfinder's information is easier to read when the camera is horizontal—whatever the reason, many photographers suffer from "horizontalitis," or an addiction to the horizontal frame. It isn't that using this format is bad, but the opportunities for vertical compositions are just as numerous and shouldn't be overlooked. Imagine both frames as hollow rectangles, and look at them side by side. If you could lie down inside either one, which would you choose? The horizontal rectangle, no doubt, since it offers more room to stretch out and relax. Conversely, if you were to stand up inside either one, which would you choose? The vertical rectangle, of course, since it offers more head room.

In terms of emotion, the horizontal frame evokes calm feelings of tranquillity just as a horizontal line does. In contrast, the vertical frame evokes feelings of pride and dignity. Quite often, subjects can be well composed in either format. Each conveys a different mood. I often find it critical to shoot a subject both ways since I market my work to a varied clientele. Some clients want only a vertical format—for instance, for magazine covers. No matter how wonderful my horizontal compositions are, they just won't work on most magazine covers.

Whenever you compose a picture, you should shoot in the format that calls the most attention to your subject. As you study each new opportunity, ask yourself whether the given subject could work equally well either way. There is no better time to decide than while you are at the picture site. After looking at the subject both ways, if you can't decide which looks better, take the picture both ways. I've learned over the years that film is very cheap compared to the trauma of having missed a wonderful shot.

86

On the last day of a five-day assignment in New York City, I was elated to hear that the weather forecast was calling for clear skies by nightfall. This came on the heels of four previous days of nonstop rain. I was determined to get a night shot of Lower Manhattan and the Brooklyn Bridge with a colorful sunset sky in the background.

After finding an ideal vantage point in Brooklyn, I mounted my 105mm lens on my tripod and decided on an exposure time of 8 sec. at f/16. I first chose to frame the scene horizontally (opposite page). Note the calm that prevails in the overall mood of this picture. Then I turned the tripod handles until the camera was in a vertical position (left). See how the mood of the city changes? Now the city skyline appears to be taller and prouder, an illusion created by your eyes having to travel a greater vertical distance in the photograph.

BRYAN PETERSON

EMPHASIZING TEXTURE

Even if you've never been thrown from a bicycle, the thought of skidding hands and face down across the pavement can still send chills down your spine. Evoking texture, or the way a surface feels, is a powerful stimulus for arousing old memories; so when texture dominates a composition, the picture invites a high degree of viewer response. As newborn babies, most of us discovered texture long before any other sensation. During our first years, we probably scurried and scooted across floors made of hardwood, concrete, tile, carpet, dirt, and gravel; and when mom wasn't looking (or chose not to panic), we may have sampled handfuls of mud, grass, paper, fabric, sawdust, and dry dog food. Some of these experiences with texture were pleasant; others weren't. We learned to prefer soft, smooth, and silky surfaces and to steer clear of rough, coarse, and jagged surfaces. As we grew older, these perceptions about texture were reinforced by a slew of positive and negative adjectives found in our daily language. For example, a woman's "soft" voice may arouse delicate feelings, but a man's "gravelly" voice may elicit aggression. A "hard"-nosed manager seldom wins the affection of his workers, whereas the "smooth"-talking manager usually does. "Sharply" dressed people "cut" good figures; "dull" appearances and "dull" movies don't "impress" us and "barely make a dent" in our consciousness.

There are many ways to use texture effectively. For example, you could lie down on a sandy beach or pebbled lakeshore and with your wide-angle lens fill the foreground with looming pebbles; the resulting pictures would immediately arouse the viewer's sense of touch. If you fill a picture frame with broken glass, jagged rocks, or soap bubbles from the kitchen sink, you'll reawaken the viewer's own experiences with these textures. The way you light a subject plays a major role in conveying its texture. Sidelighting is definitely the best technique to use for highlighting textured surfaces for the camera.

I love shooting in eastern Oregon during the winter months. The combination of snow, ice, and cloudy days sets up a monochromatic condition that speaks volumes about loneliness and solitude. An empty road seemed to sum up the mood I was after—cold, stark, and lonely (opposite page). But before moving on, I composed some closeups of the road's edge with my 200mm lens because I was intrigued by its texture and the feelings of caution it elicited (above). Imagine walking on this slippery, jagged surface—you would have to carefully plan each step in order to avoid falling on the hard ice.

BRYAN PETERSON

UTILIZING LINES

Lines are all around us, bringing direction to our lives. Some lines, such as the road to Grandma's house, lead us toward something wonderful; others, such as the road to safety, lead us away from danger. Lines evoke varied emotional responses; for example, sitting in long lines of traffic is irritating, but a long lifeline on the palm of your hand is a pleasure. Lines can symbolize wisdom and experience ("The many lines on the silver-haired man's weathered face spoke of his wisdom and experience"). A jagged line can symbolize fear ("Be careful with that broken pane of glass!"), or it can symbolize powerful energy ("Wow! Did you see the lightning storm last night?"). Curved lines represent nature, wind, water, the human body, and God's work.

The direction a line takes determines its symbolism. Horizontal lines imply tranquillity and are therefore considered the most stable ("from the bow of the ship to the distant horizon the ocean is calm"). Feelings of pride and dignity are reserved for vertical lines. Conventional wisdom tells you to "stand tall and firm" if you feel strongly about your convictions. Diagonal lines aren't calmly horizontal or proudly vertical but evoke feelings of movement or speed. For example, a ladder leaning against a house is a vehicle for up-and-down movement. Lines also have visual weight, and thick lines symbolize greater strength than thin lines. Being conscious of the hidden messages delivered by lines enables you to manipulate a photograph's emotional impact on the viewer.

I've been to Houston, Texas only once, but I'll never forget it. Downtown Houston is a treasure chest filled with visual design elements. One afternoon, I was working on the street with my 35-70mm and 200mm lenses when I was struck by the Pennzoil Building's multitude of lines and shapes, and the lines of the bus (opposite page). I quickly fired off several frames with the 35-70mm lens at the 35mm focal length.

Then I decided to do a closer study of line, so I switched to my 200mm lens and zeroed in on the white shaft of reflected light from the sky (above). Recorded in marked contrast to the surrounding darker tones, this strong line reminds me of a bolt of lightning breaking through the night.

BRYAN PETERSON

UNDERSTANDING DEPTH OF FIELD

No matter how well-composed a photograph is, if the wrong depth of field is employed, the picture won't be strong. But even the poorest of compositions can be commended when the right depth of field is used. So just what is *depth of field?* It is the zone or area of sharpness within a picture. Once you choose to focus on a particular subject, you'll notice that some sharpness exists in front of and behind the subject. As a general rule of thumb, this area of additional sharpness extends from one-third in front of and two-thirds beyond the in-focus subject. As you've undoubtedly noticed when looking at magazines, calendars, greeting cards, or oversized picture books, some photographs contain a great deal of overall sharpness while others have a very limited area of sharpness. You might be mystified by the "technique" professional photographers use to record extreme sharpness throughout an image—for example, from the flowers in the immediate foreground to the mountains in the distance. When you try to achieve overall sharpness with your camera, you may discover that when you focus on the foreground flowers, the mountains go out of focus; then when you focus on the mountains, the flowers go out of focus. In fact, one of my students felt quite confident that he couldn't render everything in a picture sharp because he didn't have "one of those professional cameras."

What exactly influences depth of field? Three factors come into play: the focal length of the lens in use, the distance between you and the subject you want to focus on, and the aperture you selected. I think that choosing the right aperture is the most important yet most often overlooked element. In general, the shorter the focal length of the lens, such as 28mm (wide angle), and the larger the aperture number, such as $f/11$, $f/16$, or $f/22$, the greater the area of sharpness. Conversely, the longer the lens is, such as 200mm (telephoto), and the smaller the aperture number in use, such as $f/5.6$ or $f/4$, the narrower or more shallow the area of sharpness in the image. For example, if I were to set both the 28mm lens and the 200mm lens at $f/22$ and then focus both on a particular spot, the 28mm lens would render greater depth of field. Why would a longer lens produce less depth of field than a shorter lens when they're both adjusted to the same f-stop? The answer relates in part to the diameter of the lens opening. Even though both lenses are set at $f/22$, the actual diameter of the aperture in the 200mm lens is larger than that of the aperture in the 28mm lens.

Also, as the focal length of any lens increases, the amount of light that reaches the film decreases. As light enters through a long lens, some of it might scatter or become absorbed before it reaches the film. To compensate for this loss of light, lens manufacturers determined that the opening should be a bit bigger on lenses with long focal lengths so that the cumulative effect of light would be equal to that of lenses with shorter focal lengths. Because an aperture of $f/22$ is in fact a smaller opening on a 28mm lens than an $f/22$ opening on a 200mm lens, less depth of field is rendered.

Focusing on a given subject also affects depth of field. When you focus a lens by simply rotating the focusing ring, you're actually moving the lens closer to or farther from the film plane. To understand this concept, pick up any lens you have. As you focus on an object near you, notice that the lens appears to "grow" longer. In effect, the glass elements inside the lens are moving farther away from the film plane. Remember: with whatever lens you use, the closer an object is to you, the farther away the lens elements have to be from the film plane in order for you to focus.

Choosing the Right Aperture

In theory, a lens is able to focus on only one object at a time; as for all the other subjects in a scene, the farther they are from the object in focus, the more out of focus they are. Because this theory is based on viewing a given scene through the largest lens opening, it is vital that you appreciate the importance of understanding aperture selection. Of course, the light reflecting off a subject makes an image on film, but the aperture in use dictates how well this image is "formed" on film. Optical law states that the smaller the opening in a given lens, the larger the area of sharpness or detail rendered on film. So a large lens opening, then, permits a huge blast of light to reach the film. In this case, the additional light in the scene—all the light except that reflecting off the single in-focus object—that passes through the lens splatters across the film, producing out-of-focus areas. Conversely, when the same object is photographed at a very small lens opening, such as $f/22$, the blast of light is reduced considerably. The resulting image contains a greater area of sharpness and detail because the light didn't splatter across the film plane; instead, the light was confined to a small, narrow opening.

The following illustration will help you understand this idea. Using a funnel with a very small opening, imagine pouring a one-gallon can of paint through it into an empty one-gallon container. Compare this process to pouring a gallon of paint into an empty one-gallon container without the aid of a funnel. Of course, the paint being poured without the use of a funnel will fill the empty container much more quickly, but there is a good chance that some paint will splatter. Clearly, transferring paint through the funnel results in a cleaner, more contained job.

Keeping this in mind, you can see that when light is allowed to pass through small openings, a larger area of sharpness and detail always results. Does this mean that you should always use small, "neat" apertures rather than large, "messy" apertures? Definitely not! But if you don't appreciate and understand the creative uses of the aperture, producing compelling imagery will always be just beyond your reach. Although there are countless situations in which choosing the right aperture is a priority, I'll share with you some common examples.

issue of
the arra
elements
frame. W
visually
arrange
static pio
place. Pl
in the fr
since a h
allow fo
moveme
tends to
going an

If you
arrange
and line
but usef
the tradi
tic-tac-to
dividing
vertically
strong p
importa
You hav
four in a
a vertica
won't w
photogra
these po
helpful f
unsure a

Wher
urge you
on your
that som
importar
happens
end up
regardle
use, ha
your sub
around
and sligl
Then or
perspec
set up y
carefully

Here is vi
formats.
where th
thirds pla
in the dir
a 400mm
for 1/50

I photographed this 7-foot-long alligator in a Louisiana preserve. After shooting the overall view (top), I decided to isolate the subject (bottom). With a 300mm lens and my camera mounted securely on a tripod, I moved a bit closer to the alligator. When I heard it hiss, I knew that I'd gone close enough and began to focus on its large, imposing profile.

To limit depth of field, I chose an aperture of *f*/5.6. Bringing the photograph to a close was a simple matter of adjusting the shutter speed until a correct exposure was indicated.

The first aperture-priority image is what I call the *storytelling composition*. Like any good book, this type of picture has a beginning, middle, and end. The "beginning" is a foreground subject that clearly pertains to the rest of the scene. For example, such an image might contain stalks of wheat in the foreground that lead the viewers' eyes to the middle of the scene where they see a farmer's combine and then to the story's end where they see rolling hills in the distant background.

Because wide-angle lenses encompass sweeping angles of view, they're often called upon to tell visual stories more effectively. Also, when wide-angle lenses are combined with storytelling apertures, such as *f*/16 or *f*/22,

an extensive sharpness, or depth of field, results. Although the 28mm lens is the most commonly used wide-angle lens, I prefer the 24mm and 20mm lenses. Because both of these lenses offer greater angles of view and a bit more depth of field from foreground to background, they can create storytelling compositions that include more information inside the frame. In effect, their "vision" enables these lenses to produce both a better "opening" and a somewhat longer "book."

Another kind of photograph that results in compelling imagery is the *isolation* or *singular-theme composition*. Here, sharpness is almost always limited to a single area, leaving all other objects in front of and behind the object

PART FOUR
EXPOSURE

CO

The f
photo
I've c
"Isn't
asked
talkin
answ
terms
The r
matte
verba
intere
to inc
your
Simp
comp
visua
pictu
inclu
tends

O
subje
majo
subje
withi
decid
how
sides
whet
horiz
defin
of the
came
shoot
tripoc
adds
of the
availa
study
wher
make
neces
impa

W
your
use a

Notic
in the
forma
shot c
105m
for 1/
the sy
135m
was 1

BRYAN PETERSON

UNDERSTANDING F-STOPS

Before you can master exposure techniques, you need to learn some basic concepts. The first of these is the *f*-stop. Pick up your camera and find the serrated ring located on the outside of the lens; this is called the *aperture ring*. As you turn the aperture ring from one end to the other, the series of numbers (2.8 to 22) click in and out of position. Each of these "clicks" is called a *stop*. The number of each stop corresponds to a specific lens opening and is referred to as an *f-stop*. This opening controls the amount of light that enters the lens and passes onto the film. For the technical-minded among you, an *f*-stop is a fraction that indicates the diameter of the aperture. The *"f"* stands for the focal length of the lens, the slash "(/)" means "divided by," and the number represents the stop in use. For example, if you're shooting with a 50mm lens set at *f*/1.4, the diameter of the aperture is 35.7mm. Here, 50 (the focal length of the lens) divided by 1.4 (the stop) equals 35.7 (the diameter of the lens opening). But all you must remember is that the *f*-stop determines how much light reaches the film.

The Halving and Doubling Principle

The primary function of apertures, also called *diaphragms,* is to control the volume of light that reaches the film during an exposure. This transmission of light can be compared to water flowing out of a faucet. If I were to open a faucet all the way and place an empty glass underneath it, the glass would fill with water in just a few seconds. On the other hand, if I were to open the faucet so that the water trickled out, the glass would take a longer time to fill. This same principle can be applied to light passing through an aperture. If you keep in mind that lens apertures are actually fractions—such as 1/2.8, 1/5.6, and 1/16—it should be easy for you to understand that an *f*/16 lens opening is smaller than an *f*/2.8 opening. Just as in the example of water coming out of a faucet, the volume or flow of light that passes through the lens openings is dictated by the aperture in use. Consider the following example. Imagine that the diameter of the faucet is equivalent to that of an aperture of *f*/2.8. The amount of water flowing out of this faucet, then, would clearly be greater than the amount of water coming out of a faucet whose diameter was equivalent to that of a lens aperture of *f*/22.

Each time you descend from one aperture setting to the next, or *stop down*, such as from *f*/2.8 to *f*/4, the volume of light is cut in half. Conversely, when you turn the aperture ring from *f*/16 to *f*/11 to *f*/8 and so on, the volume of light is doubled with each change. For example, if I set my camera at *f*/2.8 and you set your camera at *f*/4, the amount of light reaching the film in my camera is twice as great. But if you leave your aperture ring at *f*/4 and I move mine to *f*/5.6, the volume of light entering my camera is now half as much as that entering yours.

This relationship is called the *halving and doubling principle* and can also be discussed in terms of the shutter speed. Remember that the shutter speed controls the length of time the volume of light enters the lens and stays on the film. Going back to the water-faucet analogy, it would take me twice as long to completely fill a glass as it would to fill another glass halfway. If I then were to fill a third glass a quarter of the way, this process would take half the length of time needed for the half-filled glass and one-fourth the length of time needed for the full glass.

This halving and doubling principle can best be understood by referring to the shutter-speed dial. The numbers located there denote fractions of a second. For example, "1000" designates 1/1000 sec., "500" designates 1/500 sec., and so on, all the way to 1 sec. Each shutter speed corresponds to a predetermined amount of time and dictates how long the light that enters the aperture remains on the film. For example, if I shoot a picture at 1/250 sec., the light that passes through the aperture and onto the film does so for exactly 1/250 sec. If I shoot another picture at 1/15 sec., the light that passes through the aperture and onto the film does so for exactly 1/15 sec. Note that each number represents a fraction that is twice as large as that of the number on one side and half as large as that of the number on its other side. For example, 1/250 sec. is twice as long as 1/500 sec. and half as long as 1/125 sec. To simplify this concept even more, consider another analogy: think of these fractions of a second as pie slices. A 1/250 slice is clearly twice as big as a 1/500 slice and half as big as a 1/125 slice.

Like the numbers on the aperture ring, each of these fractions is referred to as a stop. When you change from one shutter speed to the next, you're changing from one stop to another.

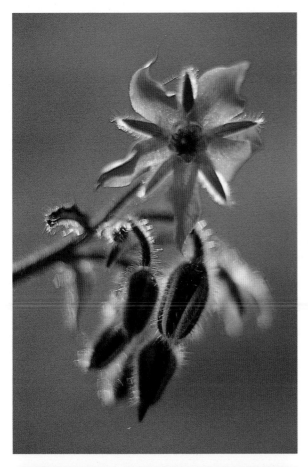

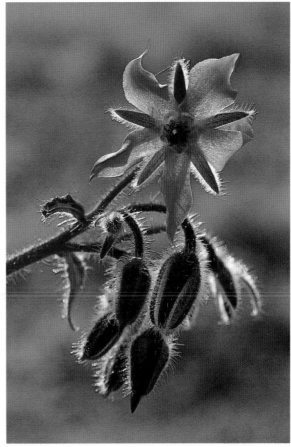

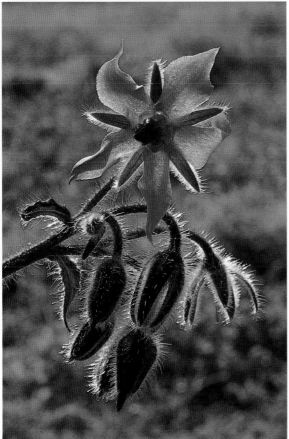

My students often say, "What difference does it make which aperture and shutter speed I use? All I care about is getting a good exposure!" For many photographers, exposure is simply the process of lining up the needles so that the diodes light up in the right spot inside the viewfinder. If a "correct" exposure is all you want, this approach is fine. But if you want a creative correct exposure, you'll need to choose the "right" *f*-stop and shutter speed.

These three photographs are correctly exposed, yet each one has a different depth of field. In the first image shooting at *f*/2.8 for 1/500 sec. produced an extremely shallow depth of field (above left). Next, I exposed at *f*/11 for 1/30 sec.; here, the green background is a bit more defined and the flower is sharper (above right). Shooting at *f*/32 for 1/4 sec. produced a very sharp flower and even more background detail (bottom).

The choice is yours as to which of these shots you prefer, but the point can't be overstated. Achieving a correct exposure is a task left to "snapshooters," while achieving a creative correct exposure is a challenge welcomed by true photographers.

DETERMINING EXPOSURE

At the center of the photographic triangle, which its three sides—aperture, shutter speed, and film—all revolve around, is the exposure meter. It is the "eye" of creative exposure. Without the vital information the exposure meter supplies, many picture-taking attempts would be similar to throwing mud on a wall and hoping that some of it sticks. This doesn't mean that you can't take a photograph without the aid of an exposure meter. After all, 100 years ago photographers were able to record images without one; however, they did have exposure tables or guides to lead them in the right direction. Fortunately, today's exposure meters are quite reliable and sensitive. For example, while shooting at night was a hit-or-miss proposition not too long ago, photographers are now able to continue shooting well past sundown with the assurance of achieving a correct exposure. If there is a tool that eliminates any excuse for not shooting 24 hours a day, it is the exposure meter.

Reflected-Light Meters

Exposure meters come in two forms. They are either separate units that you hang around your neck or hold in your hand, or, as with most of today's cameras, they're built into the camera body. Handheld meters require you to physically point the meter at the subject or at the source of the light falling on the subject and take a reading of the light. Once you do this, you set the camera and lens at an exposure based on this reading. Conversely, cameras with built-in exposure meters enable you to point the camera and lens at the subject while continuously monitoring any changes in exposure. This metering system is called *through-the-lens* (TTL) *metering*. These meters measure the intensity of the light that reflects off the metered subject. Like lenses, *reflected-light meters* have a wide or very narrow angle of view. Several less expensive SLR cameras have *averaging reflected-light*

meters built into them. Such a meter is useful when a scene contains areas of light and shadow because the meter can measure both and give an average reading. This reading usually provides adequate data that enables you to successfully set an exposure. However, in picture-taking situations in which the scene contains much more shadow than light or much more light than shadow, an averaging reflected-light meter tends to give exposure data that results in either overexposure or underexposure. Another type of reflected-light meter is a *spot meter*. This measures light at an extremely narrow angle of view, usually limited to one to five degrees. Seldom incorporated into the camera body, spot meters are separate units that look similar to compact hair dryers. As a result, you can aim the barrel of the meter at a very small area of an overall scene and get an accurate reading. Unlike averaging meters, spot meters zero in on the primary subject and aren't influenced by surrounding light and/or dark areas of contrast. But because spot meters are expensive (prices begin around $150) and are rarely necessary for picture-taking situations, most amateurs and some professionals—myself included—forgo buying one.

The type of reflected-light meter located inside most SLR cameras is a *center-weighted meter*. Unlike averaging meters and spot meters, center-weighted meters measure reflected light throughout the entire scene but are biased toward the central portion of the viewing area. To use a center-weighted meter successfully, you must center the subject or subjects in the frame when you take the light reading. Once you set a manual exposure, you can then recompose the scene for the best composition. On the other hand, if you want to use your camera's autoexposure mode but don't want to center the subject in the picture, you can press the exposure-hold button and then recompose the scene so that the subject is off-center.

The skyline in Portland, Oregon, lends itself to early-morning frontlit compositions. One spring morning several years ago, I arrived in the city before the sunrise in order to photograph this western view. With my camera and 50mm lens secured on a tripod, I set the aperture to f/8. Depth of field wasn't a primary concern because much of the composition rested at infinity.

As the sun came up behind my shoulder, I waited until it was high enough in the sky to cast its glow upon the buildings. When the light struck the buildings in the center third of the image and then was reflected in the water, I deliberately allowed this glaringly bright illumination to influence the camera's exposure meter. I proceeded to adjust the shutter speed, and the meter indicated a correct exposure of 1/500 sec. But as you can see, this was in effect an incorrect exposure (top).

Because my camera's meter is center-weighted, I can almost always expect frontlit scenes to record on film as underexposures when I don't intervene. To achieve a properly exposed shot, I simply tilted the camera up and metered the sky. At the same time, I adjusted the shutter speed until 1/125 sec. was indicated. I then recomposed and fired, creating the correct exposure (bottom).

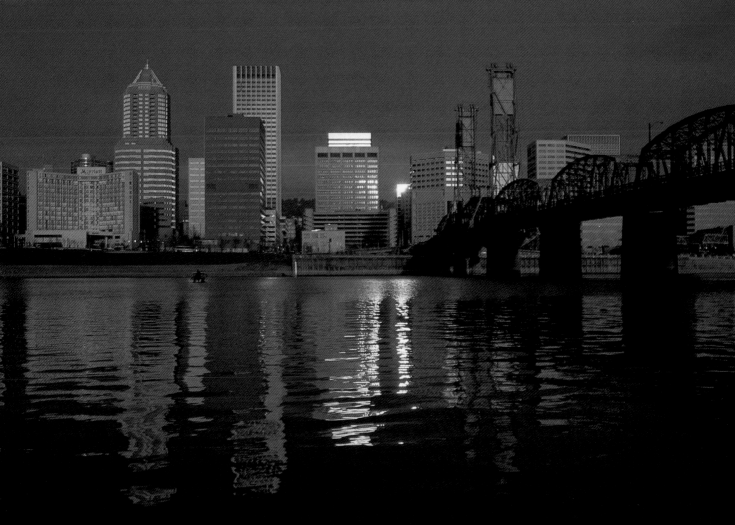

Whether you use an averaging, spot, or center-weighted meter, all three reflected-light meters are influenced by not only the amount and quality of light the subjects reflect, but also the reflective characteristics, or *reflectance,* of the subjects themselves. More often than not, the reflectance of a given subject creates "bad" exposures, not the light that strikes the subject. As an illustration of this important point, imagine that you come across a black cat asleep against a white wall. Both the cat and the wall are frontlit by the early-morning sun, illuminating them evenly. If you were to move in close and allow the meter to sense only the light reflected off the black cat, the meter would indicate a specific reading. If you were then to point the camera at only the white wall, the exposure meter would render a separate, distinct reading. This variation would occur because although the subjects are evenly illuminated, their reflective qualities radically differ. For example, the white wall would reflect approximately 36 percent of the light, while the black cat would reflect only 9 percent of the light.

Keeping this in mind, imagine that the world is completely neutral gray. Then, whether subjects are bathed in full sunlight or open shade, they always reflect 18 percent of the light falling on them. Although this is a fictitious description of the world, it is a very real scenario in terms of reflected-light meters. The built-in exposure meters in today's SLR cameras measure all reflected light as if it were bouncing off a neutral-gray surface. This isn't a problem because most subjects—whether they are frontlit in full sun or open shade and whether they are red, orange, blue, or green—reflect 18 percent of the light, just as a neutral-gray surface does. Consequently, meter readings taken with an averaging, reflected, or spot meter under these conditions are usually correct.

The only two exceptions to this principle are white and black subjects. Because white subjects tend to reflect 36 percent of the light, the meter inadvertently interprets the light as excessively bright and suggests giving the subject less exposure time. Conversely, the meter suggests more exposure time when it reads black subjects. In effect, white subjects record on film as an underexposure, while black subjects record on film as an overexposure. Interestingly enough, if you were to set an exposure based on the way the meter "sees" white or black subjects, you would end up with gray subjects in your pictures instead. This would happen because reflected-light meters tend to want to make all subjects appear average in brightness.

How do you successfully meter white and black subjects? Treat them as if they are neutral gray, even though their reflectance indicates otherwise. In other words, a white wall that reflects 36 percent of the light should be metered as if it reflected the normal 18 percent. Similarly, a black cat that reflects only 9 percent of the light should be metered as if it reflected the 18 percent standard. The halving and doubling principle can help you determine a correct exposure for white and black

subjects. A white wall might reflect 36 percent of the light, but you must expose for it as if it reflected 18 percent of the light. When the meter measures the wall, it will suggest one less stop of exposure because of the extra stop of bright reflectance. However, you must treat the white wall as having 18 percent reflectance and add one more stop of exposure to the meter reading.

A black cat, on the other hand, might reflect only 9 percent of the light, but you must expose for it as if it reflected 18 percent. When the meter measures the black cat, it suggests one more stop of exposure because of the one-stop reduction in reflectance. But once again, you must intervene and treat the black cat as having 18 percent reflectance; you must subtract one stop of exposure from the indicated meter reading.

When I first learned about the 18 percent standard, it took me a while to catch on. One tool that enabled me to understand it was a *gray card.* Sold by most camera shops, gray cards come in handy when you shoot bright scenes, such as white, sandy beaches or snow-covered fields. Gray cards can also be used effectively for metering dark subjects, such as black cats or shiny black cars. Rather than take a meter reading from such highly reflective subjects, you simply hold a gray card in front of the lens, make sure that the light falling on the card is the same light falling on the subject, and meter the light reflecting off the card.

Many cameras on the market today offer automatic exposure. Most of these have built-in meters that are center-weighted, although a few meters can function as a spot meter as well. But these "foolproof-exposure cameras" aren't foolproof—as perhaps you've already learned, particularly when you shoot scenes or portraits composed of white or black. Like a meter in a manual-exposure camera, an autoexposure camera's exposure meter is fooled by the 36 percent reflectance of white areas and 9 percent reflectance of black areas. As a result, without your intervention an autoexposure camera will record a bad exposure. This doesn't mean that you should never use an autoexposure camera in the autoexposure mode; it will perform well most of the time in straightforward available-light situations. But when you want to shoot excessively bright or dark scenes, you must alter the autoexposure.

You can do this one of two ways: either by switching to a manual-metering mode and measuring the light level with a gray card, or leaving the camera in the autoexposure mode and using the built-in autoexposure overrides that most autoexposure cameras offer. These overrides are designated as follows: +2, +1, 0, -1, and -2, or as 2X, 1X, 0, ½X, and ¼X. So, for example, to provide one additional stop of exposure when shooting a snowy scene in the autoexposure mode, you would set the autoexposure override dial to +1 (or 1X). Conversely, when shooting a black car in the autoexposure mode, you would set the autoexposure override to -1 (or ½X) to achieve one less stop of exposure.

Heavy snowfalls in Oregon's Willamette Valley are uncommon, but last February a pristine blanket of white transformed an otherwise dreary landscape into a beautiful vista. I photographed this lone oak tree near my farm. Using a 50mm lens on a tripod, I set the aperture to f/8 and then found that a shutter speed of 1/30 sec. was necessary. But this produced a dark, underexposed snowscape (top).

Why? Although white subjects reflect 36 percent of the light, they must be metered as if they were neutral-gray subjects; these reflect approximately 18 percent of the light. The meter understands this excessive reflectance to mean that less exposure time is necessary. The result recorded on film is an underexposed image.

One of the easiest ways to overcome this problem is to use a gray card. When placed in front of the lens, a gray card enables the exposure meter to measure the normal 18 percent of the light reflecting off it. So to properly expose this snow scene, I held a gray card in front of the lens, making certain to fill the frame with it, adjusted the shutter speed until 1/15 sec. was designated as the correct setting, and then removed the gray card. At this point, the meter responded immediately to the white landscape as an excessively bright scene and indicated that 1/15 sec. would produce an overexposure. But as you can see, f/8 for 1/15 sec. proved to be accurate (bottom).

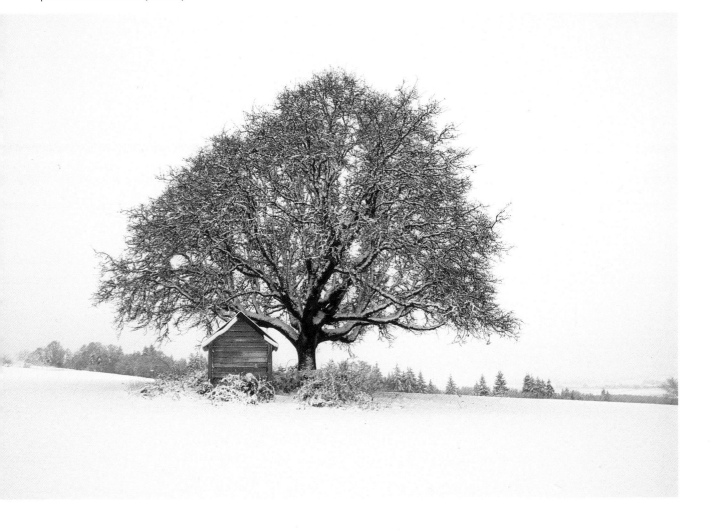

Incident-Light Meters

Unlike reflected-light meters, which measure the light reflecting off a subject, *incident-light meters* measure the light that falls onto a subject. To help you understand this distinction, think of an exposure meter as an arrow. A reflected-light-meter reading is achieved when you point the arrow directly at the subject, but an incident-light-meter reading is achieved when you point the arrow at the source of the light falling on the subject. For example, suppose you're shooting landscapes frontlit by the sun. As you compose, you decide to allow the camera's built-in reflected-light meter to measure the brightness of the scene, so you aim the meter (and, of course, the camera) at the landscape. If you then change your mind and decide to use an incident-light meter instead, you would point it toward the sun to measure the intensity of the sunlight falling on the landscape.

Incident-light meters have advantages and disadvantages. Small and compact separate units, they're easily handholdable. But incident-light meters can be expensive—good ones are priced about $150, and some cost around $500. Such an investment can seem unwarranted when you discover that these meters aren't needed for most picture-taking situations. I've never owned an incident-light meter, and only on the rarest of occasions have I used one. In fact, I've come to depend in large part on my camera's built-in exposure meter. The final decision, however, is yours.

Exposure-Meter Sensitivity

Every exposure meter on the market, whether it is built into the camera or is a separate unit, is capable of measuring the light on subjects that are bathed in daylight. This available light exists in various forms: full sun, open shade, and overcast conditions. But when your subjects are bathed in low light, you might think that your exposure meter isn't sensitive enough to record an accurate reading.

The easiest way to determine the sensitivity of your meter is to look at your camera's shutter-speed dial. If your camera offers slow shutter speeds of 8 sec. or longer, its exposure meter is quite sensitive. While photographic theory suggests that the more sensitive the meter is, the wider the range of picture-taking possibilities in low light, this doesn't necessarily mean that a less sensitive meter limits your options. With any long exposure, the primary goal is to record a starting exposure. So, using either a camera with a highly sensitive built-in meter or a precise handheld meter simply makes establishing a starting exposure a bit easier.

While photographing this woman, I realized that using an incident-light meter would be appropriate because the top half of her dress was white surrounded by a field of green and the bottom was dark blue. I knew that if I used my in-camera meter, I would end up bracketing this portrait of Daniela Sipkova-Mahoney, a Czechoslovakian artist.

I borrowed my assistant's incident-light meter (I don't own one) and set my 180mm lens to f/5.6 to limit depth of field. With the ISO 50 film speed programmed into the meter, I pointed it toward the bright, diffused light in the sky behind me. The meter indicated that f/5.6 for 1/250 sec. was the correct exposure, shown here. To satisfy my curiosity, I also took a reading with my camera's built-in meter. It indicated that an exposure of f/5.6 for 1/500 sec. was correct.

Many photographers forgo the opportunity to shoot at dusk because they aren't sure what part of a low-light scene to meter for. But determining exposure for such images is actually quite simple. The last traces of light in the sky 15 to 25 minutes after the sun sets require the same exposure time as this cityscape or rural landscape.

While on assignment in London, I photographed this classic scene that includes the Thames, Westminster Bridge, Parliament, and Big Ben. With my camera and 50mm lens mounted securely on a tripod, ISO 50 film, and the aperture set to f/2.8, I aimed the camera and lens at the darkening sky. At this point in the picture-taking process, the correct exposure was f/2.8 for 1/8 sec.

Because I wanted to emphasize the motion of both the river and any traffic on the bridge, I had to shoot at the longest exposure time possible. Switching from f/2.8 to f/32 produced a seven-stop decrease in light transmission, so I knew that a corresponding increase in shutter speed was necessary for a proper exposure: from 1/8 sec. to 1/4 sec., to 1/2 sec., to 1 sec., to 2 sec., to 4 sec., to 8 sec., and finally to 16 sec. Then by tripping the shutter via a locking cable release, I was able to achieve this appealing photograph of London at dusk.

FREEZING ACTION

The first photograph I ever saw in which the technique of freezing action was employed showed a young woman in a swimming pool throwing back her wet head. Clearly, the image was "frozen" because each drop of water and the woman's flying hair were recorded in crisp detail. Because the visual world seldom slows down enough to give us time to study its fast-moving pace, pictures that freeze action are often looked upon with wonder and awe. In fact, since that photograph of the woman appeared in a popular photography book many years ago, I've seen numerous others like it. (This is often the outcome when one photographer creates something "new"; many others rush out and try to repeat it. While trying a technique perfected by another photographer can lead to new and sometimes even more exciting discoveries, duplicating the image exactly is going too far.)

When freezing action is the desired effect, you wish to literally freeze a moment or slice of time for a much closer inspection later. More often than not, to freeze action effectively you must use fast shutter speeds. This is particularly critical when the subject is moving parallel to you, such as when a speeding race car zooms past a grandstand. In general, these subjects require shutter speeds of at least 1/500 sec. or 1/1000 sec. Besides race cars on a track, many other action-stopping situations exist. For example, the San Diego Zoo provides an

opportunity to freeze the movement of killer whales as they propel themselves out of the water from the depths below. Similarly, rodeos enable you to freeze the misfortunes of falling riders, and on the ski slopes, "hot-doggers" soar above the snow into the crisp air. When you wish to freeze any moving subject, you need to consider three factors: the distance between you and the subject, the direction in which the subject is moving, and your lens choice. First, determine how far you are from the action. Is the distance 10 feet or 100 feet? The closer you are to the action, the faster the shutter speed must be. Next, is the action moving toward you or away from you? Finally, which lens is the most appropriate? For example, if you're shooting at a distance of 10 to 20 feet with a wide-angle or normal lens, you have to use a shutter speed of at least 1/500 sec. to freeze the action of a bronco rider. If you were then to photograph the bronco rider from a distance of 100 feet with a wide-angle or standard lens, his size and motion would diminish considerably, so a shutter speed of 1/125 sec. would be sufficient. But if you were to shoot at a distance of 50 feet and use the frame-filling power of a 200mm lens, a 1/500 sec. shutter speed would work (just as if you were 10 feet from the action). Finally, a shutter speed of 1/1000 sec. would be needed if the bronco rider were moving parallel to you and filled the frame, either through your lens choice or your ability to move in close.

Whatever effect you want to achieve—freezing the action, panning, implying motion, blurring a subject, or making long exposures—it is imperative that you deliberately choose the "right" shutter speed.

While on vacation in Maui, I heard several voices screaming with delight. They were coming from six boys launching themselves and their bicycles off a homemade ramp. I rushed inside and grabbed my camera and 80-200mm zoom lens. I hoped to record the action even though I knew that the sun would be setting soon. Fortunately, I was able to shoot a number of exposures that captured the action at its peak. Like this image, many of the shots were backlit by the setting sun.

Here, I deliberately chose a fast shutter speed of 1/500 sec. With my zoom lens set at approximately 100mm, I took a meter reading of the bright sky above the sun. I then began to adjust the aperture until a correct exposure was indicated. I recomposed and told the boy to start up the ramp. Within a second or two, he soared through the viewfinder, and the fast shutter speed froze him in midair.

BRYAN PETERSON

BLURRING THE SUBJECT

When you intentionally blur a subject, the camera remains stationary—usually on a firm support, such as a tripod—and the moving subject passes through the frame while you trip the shutter. The resulting image shows the moving subject as a blur, while stationary objects in the composition are recorded on film in sharp detail. Generally, slow shutter speeds, such as 1/30 sec. and 1/15 sec., are called upon to create this deliberate blurring effect. However, objects that are moving very quickly, such as a race car, blur at 1/125 sec.

I deliberately wanted to create the blur effect when shooting an advertisement for an umbrella manufacturer. On the sixth floor of a parking structure, I mounted a 105mm lens on my camera, steadied them on a tripod, and pointed the lens straight down on the sidewalk. The two models were standing on the skeet, one holding a bright yellow umbrella, the other a bright red one. As the models stood very still, several cars turned the corner right in front of them. I shot a few exposures at a shutter speed of 1/4 sec. The resulting composition showed two sharply focused and brightly colored umbrellas in the lower third of the frame, while the top and middle thirds were filled with a curvilinear, streaked blur; this blur was a turning car.

Another blur-effect opportunity presented itself when I discovered my son and niece jumping off several bales of hay about 3 feet high onto a bed of loose straw. As the late-afternoon light filled this area of the barn with light, I positioned my camera on a tripod and set my shutter speed at 1/15 sec. The resulting image showed a blurred, almost ghostlike shape of a small child against the in-focus bales of hay.

Because most photographers still prefer sharply focused images, they seldom intentionally blur a subject. This is unfortunate since discoveries can be made only when you're willing to experiment. Consider just for a moment the creative possibilities when you deliberately blur subjects. Suppose you were shooting with your camera on a tripod at a shutter speed of 1/15 sec. Imagine how these subjects would look; a person who uses hand gestures, a dog shaking itself dry after a dip in a lake, a large Vermont sugar maple assaulted by a 30 MPH wind. Intentional blurring is one technique in which many waters remain uncharted.

Of all the discoveries I've made during my 21 years of shooting, my favorite is creating "rain"; it has provided me with hours of joy-filled photography. This technique has also resulted in numerous stock sales with calendar and greeting-card companies.

The effect is easy to achieve. On clear mornings in the spring and summer, I set up an oscillating sprinkler so that the water is backlit as it cascades down. I then select and arrange the blossoms. I use a small vase for single stems and a large narrow vase for bunches of flowers. To effectively produce the look of falling rain, I set the shutter speed to 1/60 sec. Next, I move in close to the backlit flower and adjust the aperture until the meter correctly exposes for the light reflecting off the subject. At this point, I back up, recompose, and shoot.

I almost always choose a 200mm or 300mm lens for "rain" shots, not so much because they have a shallow depth of field, but because they enable me to fill the frame with the flower from a distance that allows me to keep dry. I photographed these "rain" images at f/11 for 1/60 sec. (left and top right).

To achieve this blurred image of an oak tree, I deliberately zoomed in on the tree during the short exposure time of 1/8 sec. After setting the shutter speed, I adjusted the aperture until a correct exposure was indicated for this frontlit scene. With my camera and 35-70mm lens mounted securely on a tripod, I was ready to start zooming. I began with a focal length of 35mm and immediately zoomed to 70mm after I pressed the shutter-release button. Not all of the exposures worked out, however; I zoomed too slowly for some and too fast for others. This photograph is one of the seven good shots I managed to record on a roll of 36 exposures (bottom right).

BRYAN PETERSON

DELIBERATE OVER- AND UNDEREXPOSURE

This exposure technique is seldom practiced by slide shooters with much enthusiasm; however, the effect can be arresting. Several years ago, I came across a book written by New York photographer Robin Perry. Although I don't remember the title, I do remember that it was amply illustrated with "tricks" and techniques to which I'm indebted. One such technique was overexposure. Perry included variations of an image of a model: intentionally thrown out-of-focus, intentionally shot at $f/26$, and intentionally overexposed by four or five stops. The overexposed result showed the model as a striking stick figure that reminded me of old pencil drawings of fashion models. Nudes, busy and colorful street scenes, and fields of flowers look wonderful when overexposed by four or five stops, whether they are in-focus or out-of-focus. It is important to note when shooting deliberate overexposures that you must choose a subject or subjects that are sidelit. The combination of light and shadow that sidelighting provides enhances the effect because of the different tones.

Unlike deliberate overexposure, deliberate underexposure is practiced by experienced slide shooters worldwide. The purpose behind this technique is to increase color saturation of the overall scene. Both backlighting and sidelighting provide opportunities for deliberate underexposure. One of the most common scenes—used without fail by two well-known nature-calendar companies—is a backlit autumn leaf against a pitch-black background. Amateur photographers often think that the darkness of the background is an effect achieved with electronic flash. Although this is possible, nothing compares with natural light and deliberate underexposure.

When you see photographs like that of the leaf, do you ask yourself how they were shot? Here is another example of how your vision can actually impede your progress toward making creative exposures. If you'd been there when the photograph of the leaf was taken, would you have seen anything that resembled a black background? Most likely, you would have seen only open shade, branches, leaves, and twigs behind the much brighter, backlit leaf. You might have advised the photographer to change viewpoints to prevent ending up with a busy composition. But the photographer didn't switch positions, as the finished picture proves. So what happened to the open shade and the busy background? They never had a chance to record on film because the exposure was set for the much brighter highlight. When an exposure for a high-

light is at least three stops greater than that for surrounding open shade or shadows, these areas fade to black.

Consider another example. Suppose you come upon a cotton-candy stand at a local fair. As you face the vendor and his colorful display of pink "clouds," you notice that he is illuminated by sidelighting. Directly to his left is a large circus tent that casts a large area of shadow behind him. With a telephoto lens and a "who cares?" aperture where depth of field isn't a concern, you move in close and take a meter reading off the vendor's sunlit clothing or skin tones. (If you want to shoot a candid, place the back of your hand in front of the lens so that the sunlight falls on it and take a meter reading off your hand. It doesn't have to be in focus.) Make several exposures at the indicated reading as well as several others underexposed by one stop. Even though you can see behind the vendor and into the area of open shade, the underexposed film will record it as very dark or black. To ensure that the scene will contain a dark or black background, take two separate readings: one from the highlight area and the other from the area of open shade. How far apart are these stops? If there is a difference of three or more stops, the final image will contain the darker background.

You're probably wondering, "If I can record bright, vivid subjects in front of black backgrounds, can I also record them behind black foregrounds?" Sure! For example, suppose that you are on vacation in Paris. From inside your hotel room, frame the Eiffel Tower with the window. Move up to the window and set the exposure for the much brighter light outside. Next, scoot back a bit from the window and frame it around the tower. The result: a black shape in the form of a window in the foreground frames the distant tower. Now suppose that you're vacationing near Rapid City, South Dakota, and want to shoot Mount Rushmore, one of the most photographed monuments in the United States. Unfortunately, most amateur photographers pull into the main parking lot, raise the camera to their eye, and shoot the "postcard" image. To achieve an inventive shot, you need to move away from the crowds. As you continue driving on the main road heading south, you pass through one of the area's many tunnels and notice the mountain in your rearview mirror. You pull over and take a meter reading of the mountain. With your exposure set, you walk a few feet into the tunnel until its oval shape frames the mountain. Your photograph of Mount Rushmore reveals a new and exciting point of new, complete with a black foreground.

Although I'm not a fan of typical Oregon winters with all of their rain and rather mild temperatures, I rush out the door when I see a heavy frost on the landscape. Several years ago, I woke up to such a morning and without any hesitation, I meandered across several fields near my farm and photographed more than seven rolls of film over a few hours. The strong backlight that fell on the field produced some wonderful compositions as well as some great opportunities for creative exposure.

This photograph of a blackberry vine is one example. I focused my macro lens on just several leaves on the vine. What intrigued me most was the area of open shade behind the leaves. As I moved in close to fill the frame with only these two backlit leaves, I adjusted the shutter speed until 1/30 sec. was indicated as correct.

To further emphasize the dark background, I changed the shutter speed to 1/60 sec. in order to underexpose the scene by one stop. I then recomposed and fired the shutter, assured that the background would record as black.

BRYAN PETERSON

BRACKETING

If you have any doubt about determining a correct exposure, bracket. *Bracketing* is the practice of photographing a subject at exposures other than the exposure recommended by the meter, such as two stops overexposed, one stop underexposed, and two stops underexposed. However, you might be wondering, "Should I bracket with the shutter speed or the aperture?" This valid question is often the source of confusion.

The first question you should ask yourself is, "What creative effect do I want to achieve?" Do you want extensive depth of field (for storytelling imagery), limited depth of field (for singular-theme shots), or "who cares?" apertures? Do you want to freeze action, pan a moving subject, intentionally blur a subject, or imply a subject's motion by shooting with your camera secured to a tripod? Obviously, if you want a great deal of depth of field, you use an aperture of either $f/16$ or $f/22$, so the shutter speed plays the primary role in completing the exposure. Conversely, if you want to use the shutter speed creatively, such as by panning, you set the shutter speed and rely on the aperture to bring the exposure to a close. In the first example, bracketing is performed by the shutter speed: shooting at the indicated exposure as well as at one or two shutter speeds faster and one or two shutter speeds slower than that exposure. In the second example, bracketing is performed by the aperture. Here, you shoot at the indicated exposure as well as at one and two f-stops larger and one and two f-stops smaller than the indicated f-stop.

Not every scene, though, needs to be bracketed to such extremes. For the most part, extreme bracketing is reserved for compositions of sharp contrast, such as bright sunlight filtering through trees in a forest. Because the scene is composed of bright shafts of light and deep shade and all of the tones in between, bracketing in this situation enables you to record a range of exposures. Then, after you have the film processed, you can better decide which exposure is best. Don't feel discouraged because you had to bracket. It takes many months, if not years, of experience to know which single exposure is correct in a case like this. Even so, many experienced professionals still bracket around the indicated reading just to be safe.

More conservative bracketing is reserved for scenes that are fairly evenly illuminated. Just think of the beauty and softness of the light created by a bright, overcast sky. Whether you're shooting portraits, flowers in your garden, or candids of your children at a local park, no harsh shadows or areas of bright sunlight exist. Under these conditions, slide shooters can photograph at the indicated exposure as well as at one stop under if they want a bit more color saturation. Print shooters, on the other hand, can shoot at one-stop overexposure in addition to the correct exposure indicated by the exposure meter. The overexposed negative is then custom-printed, which results in a greater saturation of color on the finished print. Because deliberately underexposing color-print film produces a "thick," or dense, negative, which is difficult to print, this is seldom done. Like an unusually dark pair of sunglasses, a thick negative doesn't permit enough light penetration to all areas of the image when it is printed in a color enlarger at the lab.

Bracketing simply means shooting a scene at various exposures. First, you determine the indicated exposure and then shoot several exposures above it to overexpose the scene, and then several below the indicated reading to underexpose the scene. While people suggest bracketing whenever you are in doubt, I don't agree wholeheartedly with this advice. I believe that you should bracket only when extreme contrast exists:

While on assignment in Cancun, Mexico, I noticed that the swimming pool at my hotel was designed in such a way that when viewed from the west looking to the east, it seems to merge with the distant ocean. One morning, I decided to shoot a pleasing composition with a 35mm lens. I chose a low viewpoint from the west end of the pool and composed the rising sun. This ensured that the pool and its mirror image would reflect the various colors of the early-morning sky. But because of the wide range of tones in the sky as well as the reflection in the pool, I decided to bracket the exposure. After shooting at the indicated exposure of $f/16$ for 1/125 sec. (bottom left), I shot at $f/16$ for 1/60 sec. for a one-stop overexposure (top right), at $f/16$ for 1/30 sec. for a two-stop overexposure (top left), and at $f/16$ for 1/250 for a one-stop underexposure (bottom right). I prefer the image that was overexposed by two stops.

BRYAN PETERSON

DELIBERATE DOUBLE EXPOSURES

Shooting double exposures can be fun and rewarding. To achieve this effect, you photograph two separate scenes or subjects on the same piece of film. Keep in mind that double exposures often shock and surprise viewers; also, too many double exposures can make each one less dramatic. One of my first attempts at making a double exposure included the American flag. In one composition, an elderly man was sitting on his front porch directly under a flag. I photographed the man and his dog, lying at the side of his chair, first and then made another exposure of the flag alone on the same piece of film. I could have shot a single exposure of the man, his dog, and the flag, but the man's patriotism seemed so intense that I thought it was appropriate to "drape" the flag over the entire frame.

Another double exposure I remember fondly is of a friend. Although this woman lived in the city, she spent almost every waking moment dreaming about the ocean. Her apartment was decorated with seashells and driftwood, and paintings and photographs of the sea covered the walls. One day when my friend and I were at the beach, I decided to photograph her at sunset. I positioned her so that I could shoot a profile of her head and neck against the much brighter, backlit sky. By using a 200mm lens, I was able to completely fill the frame with her silhouetted profile. I quickly switched to a wide-angle lens and shot the surf, surrounding rocks, and sun so that this image fit inside her profile. When the processed film came back, the photograph showed my friend with the ocean filling her head. We both loved it.

Check your camera right now to see if it has double-exposure capabilities. Unfortunately, not all cameras do. The purpose of the double-exposure feature is to enable you to shoot two (or more) exposures on the same piece of film. Remember, however, that when you shoot a double exposure, you must pay attention to how the images will overlap. Many compositions are ruined by the misalignment of the two exposures. For example, when I made the double exposure of the elderly gentleman and his dog, I was careful not to cover his face with the stars on the flag.

Despite the need to be careful and precise, you'll find that creating a double exposure is easy. You shoot the two compositions at one stop under the indicated reading; this is true for both print- and slide-film shooters. The list of subject matter is endless, but I encourage you to consider several of the following ideas. Cityscapes are popular with amateur and professional photographers alike. If you are fortunate enough to live near a city that faces east and if you plan ahead, you can be out shooting the skyline at night with the full moon rising between or above the many skyscrapers. Some ideal cities for this once-a-month event (weather permitting) are Seattle, Dallas, and Houston. You might be wondering how there can be so many shots of American cities including a full moon when most buildings are too tall for a natural moonrise over the city skyline. The answer is simple: the magic of double exposure. I prefer this treatment because I can then decide exactly where I want the moon to be in my compositions.

As I reached the top of an incline on the highway, I saw this brightly illuminated nightscape. I quickly pulled over and mounted my camera and 300mm lens on a tripod. With my aperture set wide open to f/4, I adjusted the shutter speed until 1/4 sec. was indicated as correct. Then I engaged the camera's self-timer and tripped the shutter release (top left).

Next, while pressing the double-exposure button, I advanced the shutter without advancing the film. I was ready to take the second exposure, using the same f-stop and shutter speed. But for this shot, I deliberately close-focused the 300mm lens; the result shows out-of-focus circles of light (top right).

For the bottom shot, I tripped the shutter again using the self-timer. The out-of-focus circles were then recorded on the same piece of film as the in-focus buildings. The effect of this double exposure is a city that promises glittering riches.

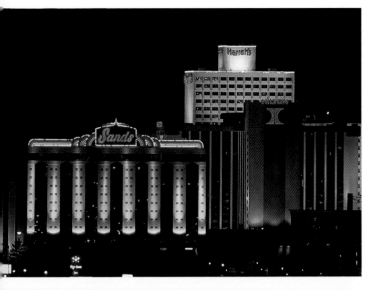

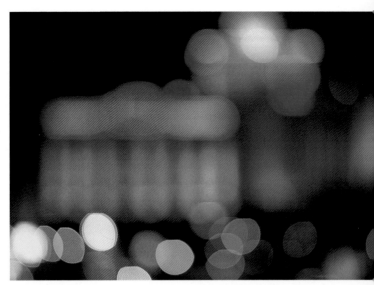

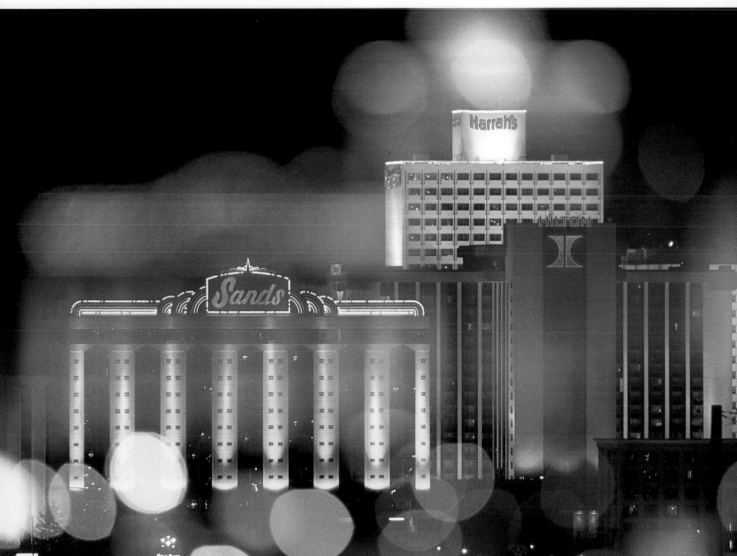

JOHN SHAW

CALIBRATING A METER

Having built-in TTL metering is without a doubt a godsend for photographers. Cameras with TTL meters are so common today that they're taken for granted; indeed, a 35mm camera without a built-in meter is a real rarity today. But taking a meter reading or letting the camera set the aperture and shutter-speed based on its metering is no guarantee of correct exposure regardless of what the camera advertisements say. A meter doesn't think, and there is no reason to assume that the meter always gives the correct exposure values for any scene. Before I discuss how you take meter readings for correct and consistent exposures, there are some preliminaries I want you to understand.

Proper exposure can be determined two ways: you can estimate the light level, or you can take a meter reading to measure it. Estimating the light isn't usually very practical for field work since the natural light is always changing. There is, however, one situation where the light is at a constant level, and that is when you're working in bright sunlight. From about two hours after sunrise until two hours before sunset on a bright, clear, pollution-free day, it is far easier to shoot using an estimated exposure than to meter the light. In a bright, sunny situation, the correct exposure anywhere in the world for a middle-toned frontlit subject larger than a breadbox is expressed by the sunny f/16 rule. A middle-toned subject is defined as being photographically average in tonality. It is neither light nor dark, but halfway in between. In terms of black and white, it is a medium gray. According to the sunny f/16 rule, the correct exposure for

this tonality is f/16 at the shutter speed with a number closest to the film's ISO number.

In other words, a sunny f/16 exposure is 1/ISO at f/16, or any equivalent exposure. Suppose you're shooting Kodachrome with an ISO of 25. The sunny f/16 rule says that correct exposure is 1/30 sec. (30 is the number closest to 25) at f/16, or it could be any equivalent. An exposure of 1/30 sec. at f/16 is exactly the same as 1/60 sec. at f/11, 1/125 sec. at f/8, 1/250 sec. at f/5.6, and 1/500 sec. at f/4. The sunny f/16 exposure for Fujichrome 50 starts at 1/60 sec. at f/16; for Ektachrome 200, 1/125 sec. at f/16; for Ektachrome 400, 1/500 sec. at f/16.

When you use Kodachrome 64 at ISO 64, you must modify the sunny f/16 rule just a little. You know that there are 1⅓ stops between the ISO film speeds of Kodachrome 25 and Kodachrome 64. If Kodachrome 25 is properly exposed at a sunny f/16 exposure of 1/30 sec. at f/16—and believe me, that is the proper exposure—then Kodachrome 64 should be 1 1/3 stops faster. But the sunny f/16 rule for Kodachrome 64 suggests an exposure of 1/60 sec. at f/16, which is only one stop different. So with Kodachrome 64 when you're estimating the light and shooting nonmetered sunny f/16 exposures, you must stop down 1/3 stop more. In other words, for Kodachrome 64

The wet beach sand here is a perfect middle-toned area to meter. However, the exposure won't be correct unless the meter is calibrated to read a middle-toned value. For this shot of a sand dollar on a beach, I exposed Kodachrome 25 for 1/2 sec. at f/16 and used a 135mm lens.

Once your meter is calibrated to a middle-tone value, it will give the proper exposure values for any middle-toned subject, such as this sycamore bark. I simply metered and shot with my 50-135mm zoom lens. The exposure was 1/4 sec. at *f*/22 on Kodachrome 64.

This is the lighting in which to calibrate your meter by using the sunny-*f*/16 exposure value. Make sure you select something middle-toned to meter, such as the sky in this photograph—not the yellow foliage of the autumn maple tree. Here I used a 35mm lens and exposed Kodachrome 25 for 1/30 sec. at *f*/16.

the rule changes to "sunny *f*/16 and one-third," or "sunny *f*/16 and a smidge down."

Before you can confidently take an exposure-meter reading, you must first calibrate your meter. For some reason many people think that just because they've bought an expensive camera, the meter is perfectly adjusted. Don't assume this. In fact, I would urge you to assume the exact opposite.

Consider the fact that when you buy a car (and a car is a lot more expensive than a camera), you don't believe that the gas gauge is 100 percent accurate. You learn from experience that perhaps when the gauge says "1/4" you better look for a gas station immediately, or that when it says "E" you really have several gallons left. All you're doing is calibrating the car's gas meter, and you think nothing of doing this. You must be able to do the same with your camera meter.

You'll want to calibrate your meter so that it gives you a correct reading whenever you point it at a middle-toned subject. Why a middle-toned one? Because there are many more natural subjects of average tonality than unaverage. Middle-toned subjects include the tonality of green grass, most foliage, dry tree trunks, or the clear north sky in the middle of the day.

The way to calibrate a meter is based upon the one correct exposure you already know, the sunny *f*/16 exposure. Just go outside on a clear, sunny day and meter something middle-toned with a standard or longer lens set at the infinity focusing mark. Adjust the ISO dial until you get the right sunny *f*/16 reading for whatever film you're using.

Suppose you want to calibrate your meter for Kodachrome 25 film. Proper exposure, according to the sunny *f*/16 rule, is 1/30 sec. at *f*/16 or any equivalent. With your camera on manual, set your shutter speed and aperture to this exposure. Now meter your middle-toned subject leaving the lens set at infinity. Change the ISO dial until the meter indicates that 1/30 sec. at *f*/16 is correct. It doesn't matter what number you end up with on the dial because those numbers are just reference marks. You know what the right answer should be, so get your meter to tell you this answer. Whatever setting you come up with is now the number you'll use whenever you're shooting Kodachrome 25 in that camera body. (I've always thought that meters would make more sense if, instead of ISO numbers, the marks were labeled A, B, C, and D, and the instructions said, "Pick the one that gives you the results you like.") All you've done is correct the camera's film-speed dial. Now you can go out and photograph as usual.

Most TTL meters are set on the overexposure side by the manufacturer. In my summer workshops I have all the participants set their meters to the exact same ISO number, and then meter the same subject in the same light. Usually, there is at least a two-stop variation in the meters' answers, but there should be only one correct exposure if they're all using the same film.

You must calibrate your own equipment because the ISO setting on your camera has no relationship to any other camera. You might have heard someone say, "Always rate Kodachrome 25 at an exposure index of 32." This isn't valid information, and is similar to saying that because your car's gas gauge reads "1/4" when in reality its tank is empty, then all gas gauges must read this way. Not true! You must test your own equipment. My Kodachrome 25 camera is set at the ISO 50 mark because that is where its meter gives me the correct answers. But that isn't necessarily where another meter will be set. I have several camera bodies, and no two of them are set at the same number for the same film. However, what is important is that they all give me the same exposure information.

With my calibrated camera, I carefully metered the middle-toned green needles for this shot of raindrops. With my 105mm lens, I exposed Kodachrome 25 for 1/2 sec. at *f*/22.

METERING

Once you've calibrated your meter to a middle-tone placement, you have to learn how to use the meter properly. Exposure meters don't think, but photographers do. Being a slave to your meter and taking its suggested exposure values literally is a sure way of turning your quality camera into a glorified box camera.

All TTL meters are *reflected-light meters*; that is, they measure the light reflected from whatever subject you point them at. Reflected-light meters assign tonality to what you meter according to the tonality for which they've been calibrated. In other words, if you've calibrated your meter to a middle-toned value and you photograph using an exposure that the meter suggests, then whatever you metered will be middle-toned in the final slide.

So if your subject is middle-toned, all you have to do is meter it directly and shoot. If the subject isn't middle-toned, there are several solutions to achieving proper exposure. One way is to intentionally meter something besides the subject. Find a middle-toned area in the same light as your subject. Focus on your subject, then swing the camera to the middle-toned area, and meter it without refocusing. Now return to your subject, but use the exposure settings you found from the middle-toned area to take the picture. As long as there is a middle-toned expanse in the same light as that illuminating your subject, this is

This grizzly-bear track was fresh—I watched and then photographed the bear with a 55mm lens as it walked past me in this freshly fallen snow. I took another shot about five minutes later, after the bear literally went over the mountain (top). The exposure here, 1/125 sec. at f/16 on Kodachrome 64, was two stops open from that indicated by a direct meter reading of the snow. To capture these raindrops on an autumn tulip-tree leaf, I exposed Fujichrome 50 for 1/4 sec. at f/11 using a 105mm lens. In this shot, the exposure was one stop open from what the meter indicated (bottom).

probably the easiest way to obtain an exposure value.

What can you do if there is no middle-tone to read? You could carry a middle-tone with you by purchasing an 18 percent reflectance gray card. Then you simply meter the card in the same light as your subject. However, even the best gray cards have a little sheen to them and tend to be too reflective for metering. I would buy one to use as a visual reference point; I like the ones made by Unicolor (called "The Last Gray Cards" since you supposedly won't need to buy another) because they have a suede finish and aren't so reflective.

Lacking a gray card, you can meter a known substitute. Find something such as your camera bag that you'll always have with you in the field. Meter it, and compare that reading with one from a middle-toned subject in the same light. Suppose a reading from your camera bag is 1/15 sec. at *f*/8, and a reading from a middle-toned area is 1/15 sec. at *f*/11. You now know that your bag is one stop darker (yes, darker since the meter says the bag needs even more light to be placed as a middle-tone value) than middle-tone. To use this information in the field, focus on your subject and then meter your bag in the same light. Take the bag's meter reading, and stop down one stop to get back to a proper exposure for your subject.

One known substitute that is very handy, so to speak, is the palm of your hand. You'll always have it with you, and if you can't find it, you probably shouldn't be out trying to photograph. The skin on most people's palms is about one stop lighter than middle-tone. To make sure of this, meter your palm, and compare it against a middle-tone reading. It will definitely be lighter than middle-tone. To take a picture, repeat the procedure with the camera

The silvercrown, shot with a 55mm lens, was exposed at the meter reading, 1/2 sec. at *f*/22 on Kodachrome 25 (top), while the sumac was one stop down from what the meter indicated: 1/4 sec. at *f*/22 on Kodachrome 25 (bottom). For this autumn shot, I used a 105mm lens.

bag, only this time open up from a reading off your palm. It might seem like you should stop down, but if you shoot at what the meter says, your palm would become middle-toned in the final slide. It isn't; it is lighter in value so you must add light. A little memory aid I learned may help. You have to open your hand to take a meter reading, so you have to open your lens. One hand, one stop.

You can meter anything you want as long as you know either what its tonality is—that is, how many stops it is away from middle-tone (as in the camera bag or your palm)—or more important, what tonality you want to make it appear in the final image. The final photograph doesn't have to be a literal rendition of your subject;

it can be an accurate representation of what you see, or it can be lighter or darker to create a particular mood. You don't have to reproduce colors exactly as you can see them, but you do want to reproduce them as you envision them.

Color-slide film has a total exposure range of about five stops from textureless white to detailless black. Middle-tone falls halfway in between these two extremes. Proper exposure means that all the important parts of your photograph are reproduced in the tones that you envisioned them to be, while improper exposure means that they aren't. Correct exposure is a matter of your controlling the color rendition. The terms *overexposure* and *underexposure* simply mean that the important colors are either too light or too dark compared to what you wanted. These terms don't mean that you shot at an exposure value different from what your meter suggested, since you must often adjust a meter reading to reach your correct exposure. Remember, don't be a slave to your meter!

Whatever you meter with a reflected-light meter will become middle-toned if you shoot at what the meter suggests (assuming it has been calibrated). I've heard many people say that a meter makes everything a middle gray. No, it makes everything a middle-toned placement. If you meter a green area, it doesn't become middle gray in the final slide; it becomes middle green. The meter makes whatever color you meter into an average or medium value: for example, medium green, medium blue, medium red, or medium yellow. So what you have to do is decide what value you want a color to have in your photograph. Do you want that green area to be a dark green, a medium green, or a light green? Metering it would place it as a medium value, and you could either open up from that meter reading to lighten the color or stop down to darken it.

This shot of a blood star on kelp at the ocean's edge was two stops down from what the meter indicated. Using a 105mm lens, I had time for only three frames before another wave washed the blood star away and left me with soaked boots. The exposure was 1/4 sec. at f/16 on Kodachrome 25.

If you work in stops, this becomes much easier. Color-slide film has a tonal range of about 5 stops altogether, or 2½ stops on either side of middle-tone. One stop open makes a color appear light, and two stops open makes it almost white. One stop down makes it a dark color, and two stops down makes it almost black. Half stops fall in between. For example, take green and see what values result as you open up in half stops from the meter's middle-tone:

Meter reading—	medium green
1/2 stop open—	dark light-green
1 stop open—	light-green
1½ stops open—	light light-green
2 stops open—	whitish green
2½ stops open—	burned-out, detailless whitish green

Now do the same but stop down:

Meter reading—	medium green
1/2 stop down—	light dark-green
1 stop down—	dark green
1½ stops down—	dark dark-green
2 stops down—	blackish green
2½ stops down—	blocked-up, detailless blackish green

Of course, this works with all colors. Now you can pick any portion of your frame and choose how you want it to appear in the photograph. Meter that area, and adjust in stops to reach the color rendition you want. You can also compare areas to see how they'll record by metering them and then comparing the readings. This, at last, is control.

JOHN SHAW

SHOOTING THE WHITE SUNLIT SUBJECT

When you're working in bright sunlight, photographing white subjects that fill a good part of the frame, the basic sunny *f*/16 exposure rule doesn't work. Highlights and details on the white surface become washed out, and the resulting slide is overexposed. A similar problem occurs when you shoot in bright sun and include such highly reflective surfaces as sand and snow in the frame. With slide film, it is especially important to keep details in the highlights. Once they're lost, there is no way you can recover them.

Taking a meter reading isn't the solution to this problem, however; a meter can also be misled by the situation. The answer is to base your exposure on the sunny *f*/16 rule, but cut your light by one stop. This will give you the correct exposure for keeping all the details of your white subject intact. Under these conditions, then, the correct nonmetered exposure becomes "sunny *f*/22." Suppose, for example, that you're using Kodachrome 64. Your proper bright sunlight exposure time is still 1/60 sec., the shutter speed closest to ISO 64 in number. But your proper *f*-stop is now *f*/22. As always, you can pick any equivalent combination of shutter speed and *f*-stop that you need for your subject. In this example, you could use 1/125 sec. at *f*/16, 1/250 sec. at *f*/11, 1/500 sec. at *f*/8, or 1/1000 sec. at *f*/5.6.

I strove for detail in the white fur of this mountain goat and for the brilliant blue sky. This was a tall order, but satisfactorily filled: my exposure kept the goat properly exposed and increased the color saturation in the sky. Shooting with a 300mm IF lens and Kodachrome 64, I exposed for 1/250 sec. at *f*/11.

JOHN SHAW

HANDLING THE BACKLIT SUBJECT

One of the most difficult lighting situations to meter when you shoot is backlighting. Here the light, coming from behind the subject, inflates the meter reading, and the usual result is an underexposed slide, lacking detail in the shadowed side of the subject, which is toward the camera.

Since your subject is being underexposed, what you need to do is open up about one or two stops. If your subject is set against a bright sunlit scene, you know the exposure for the sunlit background, the sunny *f*/16 exposure. To correctly expose for your subject, all you have to do is open up one or two stops from that exposure. For example, if your sunny *f*/16 exposure with Kodachrome 64 is 1/60 sec. at *f*/16, you would open up to *f*/11 or *f*/8. Actually how much you open up depends on how you like your backlit shots. To find out, test it before you go out in the field.

If you can get close enough to your subject, taking a closeup reading of the subject that doesn't include the backlight is the easiest way to actually get a meter reading. Often you can't approach that closely, so a spot-meter reading of the important areas is the answer. You don't own a spot meter? Actually you do—just put a long lens on your camera or rack your zoom lens out to its longest focal length. A 300mm or 400mm lens on a center-weighted metering camera such as a Nikon gives a very precise spot-meter reading. Take your reading this way, then switch back to the actual focal length required for the picture.

If you own a hand meter, another solution is to take an *incident reading*. Hold it so that the incident sphere is toward your camera position, and it will read the light filling on the shadowed side of the subject. Like all meters, an incident meter wants to make everything a neutral middle-tone. Use this reading as a starting point.

A meter reading wasn't necessary for this photograph since I knew that the standard exposure for a white subject with Kodachrome 64 is 1/500 sec. at *f*/8. However, I allowed for the backlighting by opening up two stops.

WHEN THERE IS NO MIDDLE TONE TO READ

I photographed these cattails and reeds at sunrise with a 105mm lens. I wanted the water area around the reeds to appear as it actually was—lighter than middle tone. So I metered for this area and then opened up one stop. The exposure was 1/8 sec. at f/11 on Kodachrome 25.

As long as you have a middle-toned area anywhere around you that is in the same light as your subject, you'll have no problem taking a meter reading. But what do you do when there is no handy middle-toned area?

One solution is to carry a middle-toned area with you in the form of an 18 percent gray card. All you have to do then is meter the card in the same light as your subject. But gray cards, in my estimation, don't work very well outdoors because they have a slight sheen to them and can be too reflective. Find something else that you always have with you. The object doesn't even have to be middle-toned, as long as you know how many stops off middle-toned it is. As discussed earlier, one very useful reference is the palm of your hand. With most people, the skin of the palm is one stop brighter than a middle tone. To check the tonal value of your palm, meter it and a known middle-toned subject like green grass; and compare the two readings. Make sure that both are in the same light, and don't refocus while making the two readings since that would affect exposure values. Now,

assume your palm is one stop more reflective than a middle tone. To take a picture, first focus on your subject. Then without refocusing, meter your palm in the same light as your subject. Using the settings the meter indicates, open up one stop. Why open up? Shouldn't you stop down since your palm is brighter than neutral? If you were to shoot at what the meter says, your palm would be middle-toned in the final slide. But it isn't; it is lighter. To get it back to the correct value, you must add light.

Another way to handle a scene with no middle tones is to decide how you want the tonal values to appear in the final slide. You can meter any part of your subject, and then decide if you want that part to be middle-toned, or lighter or darker. If you want it to appear as a middle tone, shoot at what the meter says. Otherwise, compensate for the meter reading by working in stops. Color-slide film has a very limited range, about six stops, from washed-out white to blocked-up black, so in general you'll be metering an area and changing the reading by only a stop or two at the most.

JOHN SHAW

COPING WITH THE LOW-LIGHT SITUATION

When relying on your camera's TTL meter in very dim light and using small *f*-stops, you'll often be unable to get a meter reading. But these times of marginal light—the very edge of light—create very beautiful conditions for photography. Suppose you've found a scene you want to photograph. By studying the composition through the viewfinder, you decide you need to use *f*/16 for adequate depth of field. But with the lens set at *f*/16 and the shutter speed all the way down to 1 sec., you can't get a meter reading. Short of buying a sensitive handheld light meter, what can you do?

The answer is to work in stops. You don't have to meter at the *f*-stop you plan on using. Instead, meter with the lens fairly wide open and then figure out what the shutter speed would be at your shooting aperture. Suppose that you meter 1 sec. at *f*/4. What is the correct shutter speed for *f*/16? Remember that stops are doubles and halves; for every one *f*-stop change, the shutter speed must double. Here, the progression of changes would be 1 sec. at *f*/4, 2 sec. at *f*/5.6, 4 sec. at *f*/8, 8 sec. at *f*/11, and 16 sec. at *f*/16. In practice, you simply count the shutter speeds off as you change the *f*-stops on the lens.

If you shoot for 16 sec. at *f*/16, though, you'll discover that the final slide will be underexposed. For very long exposures you must be concerned with *reciprocity failure;* in this shooting situation the reciprocal, interchangeable relationship between *f*-stops and shutter speeds doesn't hold. If you think of exposure in terms of drawing a gallon of water, one possibility is turning the tap on just a trickle for a long period of time. Well, in time, some of the water evaporates and you must add a little more to get your gallon. Films at long exposure times act the same way. You must add a little light for correct exposure. Since this problem is compounded by an increase in exposure time, it is best to add light by opening up the aperture, not by increasing the shutter speed. Some films also shift color balance and must be filtered back to their original balance. Most of my long exposures are on Kodachrome 25. And I don't believe it shifts color, even though Kodak says it does. I open up ½ stop at 1, 2, or 4 sec.; 1 stop at 8 sec.; and 1½ stops at 16 sec. Returning to my original example, I would be shooting at 16 sec. at 1½ stops open from *f*/16, halfway between *f*/8 and *f*/11.

I photographed this old apple tree at twilight during late winter with a 105mm lens. For this low-light scene, I exposed Kodachrome 25 for 30 sec. at *f*/4.

PART FIVE
LIGHT

BRYAN PETERSON

THE QUALITY OF LIGHT

How important is light in terms of your subjects? Experienced photographers often want you to believe that you can shoot only on clear days under low-angled lighting conditions. I am the first to agree that the quality of light during the early morning and late afternoon is truly dynamic. But the enthusiasm for these two times of day seems to eliminate the possibility that any other lighting condition can be favorable.

Many amateur photographers today mistakenly assume that they can't capture light on film as well as professionals can. I've never understood this assumption because light is readily available to all who can see. Firsyt you must explore the changing light. On your next vacation, discover for yourself that frontlighting provides even illumination, sidelighting creates a three-dimensional effect, and strong backlighting produces striking silhouettes. After some experimenting, you'll reserve the midday sun for relaxing by the hotel pool.

You should also become familiar with the "color" of the light. Although early-morning light is golden, it is a bit cooler than the much stronger golden-orange light that begins to fall on the landscape an hour before sunset. Weather, especially inclement weather, also affects light quality. The soft, almost shadowless light of a bright overcast day can impart a delicate tone to many pastoral scenes as well as to flower closeups and portraits. Because snow and fog are monochromatic, they call attention to such objects as a long red barn or a pedestrian with a bright blue umbrella. Finally, you should follow light through the seasons. The harsh, direct summer sun differs sharply from the low-angled winter sun. During the spring, the clarity of the light provides delicate hues and tones for buds on plants and trees. The same clear light enhances the stark beauty of the autumn landscape.

One of the best exercises I know can be done near your home. Select any subject: for example, the houses and trees that line your street or the city skyline. If you live in the country, in the mountains, or at the beach, choose a large, expansive composition. With a wide-angle or standard lens, document both the changing seasons and the continuously shifting angles of light throughout the year. At the end of your 12-month exercise, spread out the pictures on your desk or kitchen table, or if you shoot slides, place them in a projector. Then carefully study the seasonal changes in the light as well as the light's direction: frontlighting, sidelighting, and backlighting. I did this exercise years ago in my own neighborhood. I took several pictures a week (usually on the weekend), shooting to the south, north, west, and east at different times of the day. I paid no attention to the photographs' content or to the weather, shooting whether it was sunny, foggy, raining, or snowing. Even before the year was over, I was miles ahead of other amateurs in my ability not only to see the light but also to predict its quality and tone on film. Was I gifted? No, the light itself is the gift. By putting myself in the position to perceive and appreciate the quality of light, I gained a tremendous amount of understanding and improved my photography.

I made my first attempt at shooting London's Tower Bridge at dawn on an overcast day (above). The illumination at that time was soft yet somewhat cool. The results of my other attempts are shown on the opposite page. I returned later that same morning after the sky had cleared and rephotographed the scene (top left). With the promise of a clear sky again at sunrise, I went back the following morning and recorded the same composition. As you can see, the scene was sidelit by the early-morning sun (top right). When I returned at sunset, I decided to photograph the bridge from a different vantage point—50 feet east of my original position—with an orange filter (bottom left). I waited half an hour before I continued to shoot, knowing that the bridge lights would turn on just before the last light of the day disappeared into darkness (bottom right).

Under the overcast light at dawn, Tower Bridge appears cool and distant. On the other hand, the golden light at sunrise makes the bridge seem warm and inviting. In late morning, it appears cheerful and stable; at sunset, its graphic shape creates a sense of dignity; and right before nightfall, the bridge's artificial illumination makes it look quite regal. Because every subject is influenced by the quality of light, it is essential for you to explore the effects of various times of the day and the year.

BACKLIGHTING

This photographic term, which is used to describe a direction of light, can be confusing. Beginning photographers assume, as I did when I first started shooting, that backlighting means the sun is at your back. However, the opposite is true: the light, or the sun itself, is behind the subject in front of you. Of the three primary lighting conditions—frontlighting, sidelighting, and backlighting—backlighting continues to be the biggest source of both surprise and disappointment. Do you remember shooting your first silhouette? If you are like most other photographers, you probably achieved it by accident. During many assignments in the Hawaiian islands, I've watched countless bridegrooms shoot unintentional silhouettes. Rather than photograph a detailed portrait of his wife standing under a palm tree with backlighting from the setting sun, the well-meaning husband will in fact record a silhouette. (For those of you thinking that the groom might have intentionally shot a silhouette, please explain why he told the bride to smile before he pressed the shutter release.)

Although silhouettes are perhaps the most popular creative exposures, many photographers find them frustrating to shoot because the pictures don't always turn out well. This inconsistency is usually a result of what lens is chosen and where the meter reading is taken. For example, when you shoot with a telephoto lens, such as a 100mm lens, you must meter carefully. The telephoto lens increases the image magnification of the very bright sunrise or sunset in the background. The exposure meter sees this magnified brightness and suggests an exposure accordingly. If you were to shoot at this exposure, you would end up with a picture of a dark orange or red ball of light, with the rest of the frame fading quickly to dark, if not black. Furthermore, whatever subject you want to silhouette would merge into the surrounding blackness. So whenever you shoot a silhouetted composition with a telephoto lens, *always* point the camera and lens to the bright sky to the right of, to the left of, or above the sun, and *never* include the sun in the viewfinder. Manually set the exposure or press the exposure-hold button if you're using an automatic camera in the autoexposure mode.

On the other hand, when you shoot scenes with a sunrise or sunset in the background with a wide-angle lens, such as a 24mm, 28mm, or 35mm lens, you can simply point, compose, and shoot most of the time. Wide-angle lenses diminish the intensity of the sun's light: in effect, the angle of view of this type of lens merges the sun with the surrounding expanse of sky. However, when you shoot sunrises or sunsets at the coast and wish to include the wet, sandy beach and small rocks in the foreground, you must take a meter reading from the light reflecting off the sand. This is because the wet sand, which reflects the colors of the sunset or sunrise in the sand, is about two stops darker than the sky. If you exposed for the large expanse of sky and sun, the wet, sandy foreground would record on film as a two-stop underexposure. In this situation, that is a bit too dark. In any effective storytelling photograph, foreground interest is essential. When the foreground of a photograph isn't correctly exposed, it is like a book in which the print in the first few chapters is muddled and unclear. Although overexposing the foreground in a sunset shot by two stops means that the large expanse of sky and sun will also be overexposed, any foreground subject will remain colorful if perhaps a bit on the pastel side.

If you're photographing a backlit subject but don't want to make a silhouette, you can use flash to achieve a correct exposure. Because I'm not a fan of artificial light, I think that there is a much simpler way to both get a proper exposure and create a stag effect. Returning to the honeymooners in Hawaii, if the groom wants a photograph that clearly shows his bride's face as well as her Hawaiian print dress, he must set an exposure exclusively for the light reflecting off her, regardless of his lens choice and composition. To do this, he should walk toward her and fill the frame with only her dress and face. She wouldn't even need to be in focus at this point. Then he should take a meter reading and either set the exposure manually or press the exposure-hold button if he is using an automatic camera in the automatic-exposure mode. Finally, he should return to his original shooting position, focus, recompose the scene, and shoot. The result will be a perfectly fine exposure, no matter which lens he uses.

To achieve a truly glorious image, the groom should use a telephoto lens and choose a viewpoint that places the bright sun directly behind the bride's head. Exposing for his wife's skin tones and dress will then create "a ring of fire" around her hair. This *rimlighting effect* is a type of backlighting; it is the result of an overexposure of the sun that in this situation illuminates the hair from behind.

Backlighting always provides two exposure options. You can either silhouette the subject or subjects against the backlight or meter for the light on the subject against the strong backlight. Although both choices require special attention, the results are always rewarding. Like so many exposure options, successful backlit scenes result from a conscious and deliberate metering decision.

Shooting deliberate silhouettes is one of the most popular exposure techniques because the results are so dramatic. This is particularly true when subjects are photographed against a beautifully illuminated sky. Unfortunately, silhouettes look much easier to execute than they actually are.

After photographing an assignment in eastern Washington for five days and witnessing an equal number of sunrises and sunsets, I had time to do some shooting for myself. Earlier in the week, I'd spotted a hill lined with old locust trees and planned to return there because I knew that the scene would make a wonderful silhouette. But I hadn't planned on numerous thunderheads—a stroke of luck.

I mounted my camera and 400mm lens on a tripod, got into position, and proceeded to fill all but the bottom portion of the image area with this dramatic sunset. Because depth of field wasn't a primary concern, I set the aperture to f/8. Next, I allowed the meter to determine what the shutter speed should be: 1/500 sec. As you can see, however, this resulted in a too dark image (top left). Because I was using a telephoto lens, the exposure meter interpreted the magnification of the sunlight as greater than it actually was.

To prevent this problem, I find it beneficial to meter the area above or to the left or right of the sun. So I exposed for the sky above the sun and adjusted the shutter speed until a correct exposure was indicated; this was f/8 for 1/250 sec. (top right). I then recomposed the scene. The resulting image was a far more pleasing silhouette (bottom).

BRYAN PETERSON

SHOOTING IN LOW LIGHT OR AT NIGHT

Suppose I'm standing on a hotel balcony several hours after sunset, looking down on the strip in Las Vegas, about to start shooting. With my camera and 85mm lens securely mounted on a tripod, I am ready to establish a starting exposure. The first "rule" is to set the aperture at wide open. For my 85mm lens, that is $f/2.8$. Next, I adjust the shutter speed until a correct exposure is indicated. In this situation, I find that 1/30 sec. is needed. So my starting exposure is $f/2.8$ for 1/30 sec. But this is merely one of many different exposure options. When I glance quickly at the scene below, I see the moving headlights and taillights of many cars and realize that this is an opportunity to convey motion. The only trouble is that I'll never succeed if I shoot at $f/2.8$ for 1/30 sec. The starting exposure won't produce the creative effect I'm seeking: streaking headlights and taillights surrounded by the bright, colorful stationary signs on the strip.

To achieve this effect, I know that the exposure time must be at least several seconds. If I stop the lens down one stop to $f/4$, I must increase the shutter speed by one stop to 1/15 sec. to maintain a correct exposure. From $f/4$ I switch to $f/5.6$, then to $f/8$, $f/11$, $f/16$, finally ending up at $f/22$. How many stops did I reduce the lens opening? Moving from $f/4$ to $f/5.6$ is one stop, $f/5.6$ to $f/8$ is two, $f/8$ to $f/11$ is three, $f/11$ to $f/16$ is four, and $f/16$ to $f/22$ is five. Now, once again, in order to maintain a correct exposure, I must increase the shutter speed five stops: from 1/15 sec. to 1/8 sec., to 1/4 sec., to 1/2 sec., to 1 sec., and finally to 2 sec. But my shutter-speed dial doesn't provide a setting of 2 sec. What can I do? Use the "B" (Bulb) setting. When shooting at "B," I take out my trusty old cable release and count: 1001, 1002. By doing this, I am sure that I'm recording this motion-filled cityscape on film.

There are other scenes that call for revealing motion through long exposures and enable you to make some creative images. Along many coastlines in the United States, the pounding surf releases its fury against large rock outcroppings. During the day, photographers have many chances to freeze this thunderous action. On countless occasions, however, I've seen many photographers put their equipment away immediately after sunset. This is unfortunate because exposures of the smashing waves made after the sun goes down seem calm and ethereal.

Unlike shooting a city scene from the safety of a balcony, photographing such landscapes requires you to seek out a location to shoot from before the sun goes down. Obviously, you don't want to begin to hunt for an ideal spot in the dark. After hiking through some rather rough terrain, I arrived an hour before sunset on a bluff along the Oregon coast. As I shot to the south, my camera and 105mm lens recorded the surf pounding against large boulders. During this hour, the sidelighting imparted not only great contrast, but also a golden glow on the water and wet rocks. I shot most of my exposures at shutter speeds of 1/250 sec. and 1/500 sec. in order to freeze the action of the surf. Once the sun set, the light level began to diminish rapidly. As a result, my interest shifted to implying the motion of the crashing surf. For a starting exposure with my camera and 105mm lens mounted on a tripod, I set the aperture to wide open at $f/2$. I then began adjusting the shutter speed until a correct exposure was indicated. At 1/4 sec., the meter "said" to take the picture. So in this situation, $f/2$ for 1/4 sec. is my starting exposure—and merely one of many different exposure options.

Although it was possible that $f/2$ for 1/4 sec. would have revealed some motion, I wanted an extreme effect. So I stopped the aperture down one click at a time, remembering to double the shutter speed each time to keep the exposure constant. The exposure settings changed from $f/2$ for 1/4 sec., to $f/2.8$ for 1/2 sec., to $f/4$ for 1 sec., to $f/5.6$ for 2 sec., to $f/8$ for 4 sec., to $f/11$ for 8 sec., to $f/16$ for 16 sec., and finally to $f/22$ for 32 sec. Because the amount of light was cut in half with each f-stop reduction, I had to get that light back to maintain a correct exposure. I did this by doubling the amount of time with each click. Then I set the shutter-speed dial to "B" and with the locking cable release, tripped the shutter for a count of 16 seconds.

I hope that you can now appreciate why the road to photographic boredom is paved with the shutter speed of 1/125 sec. Choose any subject, animate or inanimate, and you can make a great photograph through the creative and deliberate use of different shutter speeds. Even a building, which is obviously stationary, can be "moved" with a creative shutter speed. When you combine a zoom lens with a shutter speed of 1/4 sec., you can "explode" the building; while firing the shutter at 1/4 sec., zoom the lens from its widest focal length to its narrowest focal length. Why not stop right now and just look at motion-filled opportunities around you? Make a list of scenes starting with the motion created by your putting this book down. From there you can add the motion created by coffee being poured from the pot as you refill your cup. Now as you look outside, you can add the wind as it moves through the branches of an elm tree, and then you can add

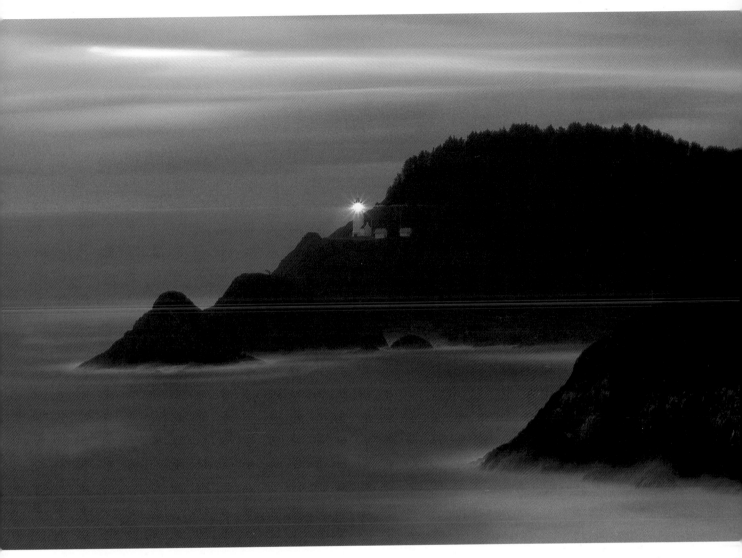

While long exposures can seem intimidating, they can also lead to exciting—and challenging—photography. The question my students always ask is, "How long should I expose the scene?" I remind them that first they need to establish a starting exposure.

I photographed this lighthouse near Heceta Head on the Oregon coast. Following a day of heavy rain, I waited for the storm to pass in order to make this long exposure. I mounted my camera and 105mm lens securely on a tripod and then composed the scene at dusk, minutes after the rain stopped. Next, I set the aperture to f/2.5 (wide open) and tapped the shutter-release button to activate the exposure meter. As I adjusted the shutter-speed dial, I found that 1/2 sec. was the correct setting.

But because I wanted to render the distant, pounding surf on film as a calm sea, I simply started to stop the lens down. I doubled the shutter speed with every f-stop decrease. By the time I got to f/32, the corresponding exposure time was 1 minute. Realizing that this wasn't long enough, I placed a two-stop neutral-density (ND) filter on the lens and added two full stops of exposure time to compensate for the two-stop decrease in light transmission. This took me to 4 minutes at f/32. Then I added another full stop of

time to allow for the sky getting progressively darker during the 4-minute exposure. I was now at 8 minutes at f/32. Finally, I added another full stop of time to correct for reciprocity failure; all films suffer a one-stop underexposure when the exposure time exceeds 4 sec. Now the exposure was f/32 for 16 minutes. With the shutter-speed dial set to "B" and the aperture set to f/32, I locked the shutter open with the locking cable release.

The last concern: how to render the light from the lighthouse on film correctly. It was much brighter than the surrounding sky and water, so if I exposed it for the full 16 minutes it would "burn a hole" in the film. To solve this problem I took a reading of my car headlights from a distance of about 50 feet at f/2.5 and determined that a shutter speed of 1/30 sec. was adequate. I then estimated that f/2.5 for 1/8 sec. was correct for the lighthouse illumination 1000 feet away. This two-stop difference enabled me to proceed with the first 4 minutes of the exposure time as intended but caused me to put my hand in front of the lens (for less than a second) every time the roving light swung around into the viewfinder during the last 12 minutes. My patience paid off. This image has sold quite well as a stock shot.

JOE MARVULLO

SHOOTING AT SUNSET

The sun was a mere compositional element in this shot of seagulls on a shimmering southern California shoreline. The personality of the scene—a warm, tranquil mood—was captured through the film's response to this low-light situation, photographed at sunset. The depth of field was shallow. The birds were sharp whereas the background blurred out of focus until the sun was a small, familiar shape, too weak in strength to influence the overall color temperature of the panorama. I used a telephoto-zoom lens set at a medium focal length.

The most glamorous, moving photographs of daylight can be made as the light leaves at sunset. The sky becomes a canvas of continuously changing, sometimes aggressive color, as the red light waves take over. This is the realm of impressionistic color and reciprocity failure, so be prepared for surprises when you view the finished film. Lenses of all focal lengths work with a sunset: telephoto lenses produce huge sun disks and cloud closeups, and wide-angle lenses compress subjects and landscapes. Beautiful sunsets happen in every season in every locale; some of the most spectacular effects are visible in pollution-clouded city skies. Also, this is the last time of the day for long, handheld exposures.

I was fascinated by the splendor of this particular sunset in Hawaii because of the pastel colors that were prevalent. The long red wavelengths of the spectrum combined with the sea mist to influence the color balance of the scene, while the long exposure time (1/2 sec. at f/5.6) stretched the limit of the film's ability to record colors accurately. The result was a striking, surreal combination of "off-color" waves and surf.

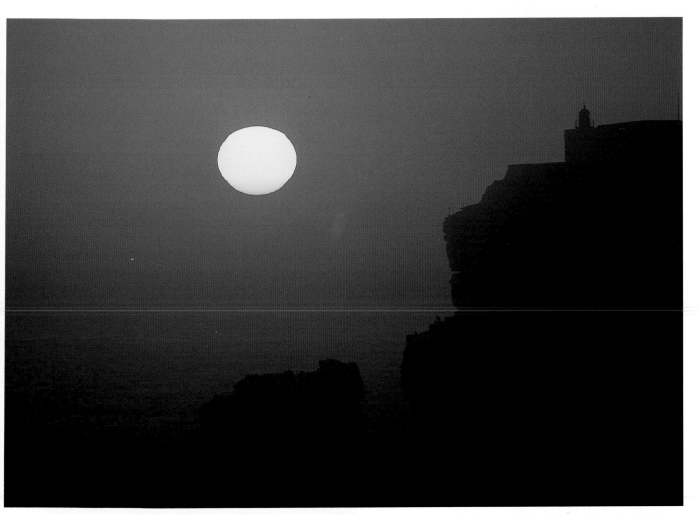

The bending of waves in the visible spectrum was evident in this summer seascape photographed on the southern coast of Portugal. The light waves scatter less at sunset. This, combined with the heavy sea mist, created the warm, diffused light that gave this scene its drama. "Moodscapes" like these are directly related to natural phenomena that occur only at certain times in certain places. In any climatic condition, however, the special directional light of sunset creates atmospheric conditions photographers can exploit. Here, I used a 400mm lens on a tripod in order to pull the sun and the cliffs together and enlarge the sun's disk.

I had only a minute to shoot this spectacular example of last light over the water one fall evening in Bermuda. The scattered beams of the setting autumn sun, the weak sun shrouded by clouds, and the natural haze of the sea produced an unusual combination of warm and cool colors that made the sky dazzling. I used a 50mm F1 lens handheld at 1/15 sec. here.

LOU JACOBS, JR.

OVERCAST LIGHTING

There are pictorial differences between certain related lighting conditions. A bright overcast sky, usually bright clouds or open shade, can make beautiful light, may soften color into pastels, and can give you detailed shadows. A heavily cloudy or rainy day can help make a moody subject, but such days are usually irritating when you're traveling. And sunlight reflected into a shady area may have soft brilliance and satisfying contrast.

Hazy, sun and shade or reflected sunlight are beautiful for portraits and can create atmospheric pictures. Many of the portraits in magazines, both editorial or advertising, are either shot outdoors with indirect or reflected light, or in studios with carefully controlled reflected electronic flash. Large studio reflectors and clusters of diffused flash units create the effect of a slightly overcast day, which is perfect for softer and more saturated colors. Studio photographers imitate natural lighting without having to wait patiently for weather to change or without being dependent on chance discoveries of beautiful light.

The color temperature of the light in shade and on a cloudy day or rainy day is cooler than in sunlight. If you're shooting slide film, be sure to use a skylight filter to tint the light and warm your pictures. The effect of a skylight filter is subtle and makes color look "healthier." Don't worry about variations in color-negative film; the color can be warmed easily when prints are made. If you are lucky to find a shady location where the sun is reflected onto the subject to fill in the darker areas, the results can be lovely. This is the type of light that studio photographers create with electronic flash and large diffusers. Around home, you can use a sheet of white illustration board as a portable reflector. Ask someone to hold it at the right angle, or mount it on a lightstand by piercing a hole at one end of the board. A photographic umbrella handheld or clamped to a lightstand is also a good reflector. On the road, you might carry a folding sheet of white cardboard or you might find natural reflection in a shady area. Try shooting portraits in overcast or indirect light; this light, which is much softer, often makes the subject look terrific.

Quiet light from an overcast sky helped Angelo Lomeo, a veteran professional photographer, give a Model A Ford the air of nostalgia he saw in this evocative scene. Lomeo and his wife, Sonja Bullaty, work together, but each brings a distinct vision to travel and nature photography. Lomeo is a great admirer of painter Edward Hopper and says Hopper's use of light was a strong influence on him. He sees any landscape as a challenge simply because of the continually changing light.

LOU JACOBS, JR.

45-DEGREE LIGHT

For strong scenic pictures, try to catch the sun at a medium-high, 45-degree angle. In a studio, 45-degree lighting is popular for portraits, with fill light usually reflected into the shadows. The same applies outdoors if the light isn't too harsh. There are endless variations in nature, in the city, or in rural situations. When you have choices about camera position, try as many as you can. If you have time—and no alternate viewpoint—and you want 45-degree light, wait for the light to change. Pictorial impact varies as light and shadows change. If you come upon a scene in midday hours and realize that the light at 4 P.M. will have more of an impact, wait around and shoot other subjects until then. As the light approaches a 45-degree or lower angle, the scene will probably change drastically, warming in color and tone and becoming more dramatic as the shadows grow longer.

A mountain in Nepal not far from Mt. Everest was in bright sun when photographer Tom Atwood arrived with his SLR, a 70-210mm zoom lens, and Fujichrome 100 film. He stated that he "was fortunate to find thin clouds blowing through because this area is often so cloudy that you can't see mountains." Light from one side gave beautiful form to the jagged peaks.

In Colorado, photographer Bud Kennedy found an ancient mining structure surrounded by pines bathed in 45-degree sunlight and made a lovely scenic using Ektachrome 64 in his SLR. He used a 200mm lens with a 2X extender in order to obtain a focal length of 400mm. Kennedy used a tripod for this image because even the slightest camera movement can blur an image when you shoot with a long lens.

COLOR VERSUS BLACK AND WHITE

JOE MARVULLO

COMMUNICATING THROUGH COLOR

Color has an enormous effect on you, emotionally and physically. You have, of course, heard about being "green with envy" or having "the blues." And you guide yourself through the physical world by using a combination of senses. Because the environment is defined by the visible spectrum—the wavelengths of light—sight is your most important faculty in terms of orientation and perception. It is light that enables you, in part, to see, and where there is light, there is color. You're enveloped by it. The sky and the ocean, the grass and the buildings, rocks and metals, all appear to have color. But objects actually have no color at all; the colors you see are simply reflected rays of colored light bouncing off the objects themselves.

Since you view life in varying degrees of color, color is vital to the creation of any photographic idea. This makes color photographers unique among artists in that they deal with a natural element (light) and an unnatural one (film). Light's profound influence on the environment and film's ability to record it, as well as the psychological and emotional effects of perceived colors, convey messages through one of the pictorial languages of visual thinking, the photograph.

Photographers who shoot in color have to be able to imagine what the final photograph will look like. They have to carefully consider the camera angle, the balance of the color composition, the focal length of the lens, the correct aesthetic or technical exposure, and the texture of the photograph. All of these various components will determine both the meaning and the impact of the picture. In order to translate a photographic idea into an

The earthy gold color of the walls, photographed in midafternoon in open shade, give a uniform brightness to this scene, a detailed abstract of a uniquely Portuguese street. The color red was used as the key element here. This closeup view, which I made with a 28mm lens and Kodachrome 25, is representative of how a photographer can select a small portion of a scene to tell a color story.

effective, successful image, photographers must appeal to the viewer's sensibilities and establish an awareness of a place in space and time that never actually existed. The transformation of a three-dimensional live scene into a two-dimensional artificial colorization on film, frozen at a millisecond and seen and recorded through optics alien to normal human vision, is the framework in which modern photographers work.

The camera meets an image filled with color and responds to the photographer's vision of both. This is what I call *color vision*. The word "photography" comes from the Greek and means "to write with light." As a photographer, this is what you do. You follow the magical metamorphosis of light throughout the course of the day and night and make photographs accordingly. Light, color, and subject are the fundamental components of an image, while the photographer's understanding of exposure, lenses, and ideas are the tools used to convey a personal interpretation of a living scene.

The personality of color is determined by two distinctly different characteristics. The first is the "soul" of a color, its hue. There are hundreds of hues of the color red. However, when the other component of a color, its *saturation* or lightness, is added, a seemingly endless number of combinations become possible. Saturation describes the amount of hue in a color. For example, crimson red or vermilion have large amounts of red in them, while there is very little red in pink. The lightness of a color indicates, obviously, how light or dark a color is. Pink is a light color because it contains a great deal of white. The terms *value* and *chroma* stand for the amount of lightness or saturation in any given hue. Photographers primarily react to these millions of colors and how the brightness or absence of natural or artificial light affects them from an aesthetic viewpoint.

Just after sunrise and sunset, there are mild variations of light, and soft, serene colors are uniformly calm, neither jumping out nor screaming for attention. Even the strongest color contrasts are merged in the limited palette of pastels joined by the muted lighting. Afternoon's bright sunlight, with its deep shadows high contrasts, and explosive colors, reveals colors at their peak. Distinct outlines and unmistakable detail create well-defined, powerful color renditions. Also, an uneven distribution of shadow and light can mean uneasiness, even color tension.

To fully understand the nature of color, you should visualize it by "seeing" the colors of the spectrum bent into a circle, with the red and blue ends meeting, since the spectrum blends one color into another, from violet through blue, green, and yellow, to red. Red, blue, and green are the primary colors of light; by mixing them, you can form any color in the visible spectrum. White light is what you get when you put them together. Each of these primary colors has a complementary color. Yellow is the complement of blue, magenta of green, and blue-green

(cyan) of red. Complementary colors are opposite each other on the color wheel. Color by subtraction, or subtractive color mixture, forms the basis of almost all color photography.

And keep in mind that the color, intensity, and angle of light determine the brightness of a photograph. Saturation increases the depth of feeling of a color. The essence of the color lies in its saturation, which is accomplished by letting less light in by slightly underexposing. Light is a photographic design element as well as the basis for temperature in a photograph. It controls the density of color.

Whether you create personal portraits, photojournalism, or still lifes, it is color that will bring your vision home. Color, like light, is a potent force. People respond to it intellectually, emotionally, and physically. Color lives. It has moods: it is aggressive—hot reds—and passive—cool blues. Colors can seem harmonious or at odds with each other, thereby creating tension. A fresh look at light and color is important to all photographers who want to work well with color and have greater control over it.

The communications revolution has hurled the world into a new dimension of perpetual, artificial color. People now have a mirage world of illuminating symbols and signs that send glowing, flashing, coded messages by the millions. In this new age of information, the way those millions of messages are sent means that light and color play the most significant role: they constitute the means for relaying visual signals instantaneously and with a "high-tech color punch." Today, more colors are available for the human eye to behold than ever before. True color and artificial color have become blurred.

Each person may, in the course of a single day, see hundreds or even thousands of color signals in every degree of intensity, shape, and size. Some are deliberately designed graphics, such as neon signs and advertisements designed to catch the eye and make a certain impression that color-identify a product; these may be sought after, but they may also be forced onto an unsuspecting viewer.

The harmonious conformity of colors and shapes is the strength of the quiet composition of this image, taken with a 35mm lens. The natural curve of the California coastline is balanced by the diagonals of flowers and shrubs. The feeling of space is conveyed by the brighter colors and details in the foreground as well as by the cooler, soft colors of the coastline and sea in the background. Adding to this depth is the gentle sweep of the curve in the upper third of the image.

The colors of television commercials are clear examples of this visual assault. Reds and yellows scream color alerts over and over through the tube; reds and blues—powerful signals—thrust viewers into prearranged color scenarios: red is hot and sexy and not to be confused with amber-yellow, which is for good times and sun; blue is tranquil and comforting; green represents menthol, fresh and outdoors. This is intrusive color, identifying moods and messages and mounting a color-assault on the senses, an assault that the people of the twentieth century contend with, create, digest—and prosper by.

Colors are also the visual "feelers" through which people, as communicators, relay our thoughts and information. Everyone speaks the language of color. In daily, recurring encounters with color, lights, and reflections, people react in accordance with atmospheric levels set by light and color: the natural colors of landscape, the artificial colors of cities—everything is alive with combinations and harmonies that will change progressively during the day from the light and color of morning through countless gradations of tints and shades. Bright light and low diffused light make their presence felt as color shifts and moods change; long shadows and precise highlights, even the absence of light—all these affect the "personality" of color. This continual movement of color wavelengths and the effect it has on our human psyche are the essence of what I call color vision.

The harshness of the midday sun in New York City acted like a giant spotlight to bring out the incredible detail and intense color saturation of this red metal door. I used a 90mm lens and took a light reading directly off the door. Closeups of inanimate objects can be rewarding when you shoot them in the early afternoon because the strong colors and heavy shadows and outlines that are seen under this light add a stark realism to subjects.

I photographed this emergency signal in graphic action on a side street in New York City. I froze the bright glow of the flashing yellow arrow by exposing Fujichrome 50 for 1/125 sec. with my 28mm wide-angle lens wide open at f/8. The intensity of the red and orange lights in focus, contrasted against the slightly cooler colors of the out-of-focus background, emphasizes the sharp "Alert!" of the yellow arrow and lights of the foreground.

JOE MARVULLO

THE POWER OF A DOMINANT COLOR

The color blue has a special place in the psyche of the Western world. It can mean royalty—people or objects that look regal. It is tranquil and self-assured. A major color, it signifies the sky and the sea; it represents the world above and around you. The reliability of blue, as manifested in a police officer's uniform. The serenity of blue, as manifested in a calm ocean. The color blue conveys stability, truth, loyalty, authority, so it is no small wonder that it is used successfully in advertising to illustrate themes stressing these points.

In this shot of low-light blues, the early-evening sky provided just enough light for me to be able to use a 75mm lens and ISO 100 film to handhold a shot of this graffiti-covered metal door. The low light level and the "unnatural" colors of the spray paint make this a study in urban blues.

The contrast between the rich sky and the white and black horizontal and diagonal lines brings a fierce quality to this image of a torn billboard in Hollywood. Shooting Fujichrome 50, I used a 90mm lens to pull the sign framework in as close as possible. Against a deep blue sky, the stark whites of the billboard turn into a graphic outline.

The receding tendencies of the color blue are evident in this photograph of a painted plaster wall. The dark shapes anchoring the corners of the picture are abstract puzzles of color that are rich in texture. For this shot, I used a 35mm lens and Fujichrome 100.

Yellow is a strong advancing color. It signifies loyalty and honor and the heat of summer. Yellow is the color of alertness, as well as of the sun, buttercups, gold, canaries, lemons, corn, bananas, the *Yellow Pages*, and, of course, Kodak film boxes. Yellow surrounds and assaults you everyday.

The color of the yellow flowers, shot close in San Francisco with a 35mm wide-angle lens, advances and gives an impression of three-dimensional composition. These are flowers, but they are aggressive because of their color, as well as focus, tight cropping, and a slightly overhead angle of view. Filling the frame with closeups offers endless opportunities to work with shape, form, and color.

Here, the lemon yellow of the plaster walls and the greenish yellow of the aged wooden door are striking in their chromatic vibration. The pure intensity and contrast value of the hues, saturated by slight underexposure for effect, give the image its power. I chose a 24mm lens and used Fujichrome 50 for this study in aggressive color taken in a small highlands village in Guatemala.

GEORGE SCHAUB

THE BEAUTY OF BLACK AND WHITE

Although most people focus on color photography, there is also a wonderful world of black-and-white photography for you to explore. No one can deny the power and glory of this medium; in fact, some "serious" photographers won't shoot anything but black and white. Black and white is quite flexible and inspires different photographers in different ways. Some perceive it as an accurate reflection of the world: no distracting colors get in the way. Other photographers regard black and white as highly interpretive because they can take a negative from black-and-white film and make it into almost anything they want, from a high-contrast graphic to a moody, glowing, silver-rich print.

A few black-and-white films are fine for most outdoor shooting. These films are ISO 100, 125, and 400. All produce good results, but ISO 100 film has finer grain and better sharpness. Keep in mind, however, that ISO 400 film works quite well for outdoor photography. This is because it has an edge over the slower films in terms of bridging brightness ranges and because its inherent contrast is slightly lower. In bright lighting conditions with deep shadows and brilliant highlights, ISO 400 film gives you the greatest chance of recording all the tonal values in a scene. All of these films are extremely "smooth"; each has an exquisite gradation of tones.

When shooting black-and-white film on dimly lit days, use ISO 400 film. It provides a great deal of leeway in exposure settings. There are times when you can *push,* or raise the ISO black-and-white films beyond their nominal speed. This comes in handy when you want to shoot an entire roll at a higher speed.

I captured these ladies on parade with a 35mm lens on ISO 400 black-and-white film.
The exposure was 1/125 sec. at f/8.

For this stark rendering of an abstract adobe scene, I used a 28mm lens and ISO 400 black-and-white film. The exposure was 1/125 sec. at f/11.

JOSEPH MEEHAN

USING CHROMATIC FILTERS WITH COLOR FILM

Chromatic filters affect color films to render distinctive changes. The guiding principle here is that these emulsions are made with specific amounts of colored materials that match certain light sources. Between them is the filter, which can alter the proportions of color wavelengths in the light in order to produce the specific effects on film that you want.

Color-Conversion Filters

Color-conversion filters are the strongest filters available for changing the Kelvin temperature of a light source, enabling you to use daylight film under tungsten light or a tungsten film outdoors. These filters are intended to affect shifts of more than 2000K and fall into two categories, the 85 yellow series and the 80 blue series. When used correctly and under the right circumstances, color-conversion filters should, theoretically, provide the results that would be expected if the correct film were exposed to its designated light source. In practice, however, many photographers find that conversion filters actually produce a result that is a little warmer or cooler than expected,

particularly with transparency films. It is very difficult to generalize about this because of the different ways modern films render individual colors. Some films are warmer than others, while others favor hard light and still others favor soft light. Nevertheless, it is definitely worth testing a particular pairing of film and filter before trusting the results as theoretically correct. I suggest you shoot a roll of "converted" film under a variety of lighting conditions appropriate to the Kelvin temperature and then shoot the film without filtration under the light for which it is intended.

Color-Compensating Filters

Color-compensating (CC) *filters* extend the principle of subtractive color correction beyond the general warming and cooling effects of conversion and balancing to control individual colors. In fact, the weaker warming and cooling filters have their counterparts among the yellow, orange, and blue CC filters. Once again, the idea is usually to achieve as correct a rendering as possible. Photographers

Color-correction is sometimes a matter of personal interpretation, as shown in these cave photographs. First I shot the scene unfiltered (left) and then used a CC20 red filter to achieve what I think is a more natural rendering (right).

You can also use CC filters when the subject is in low light surrounded by a monochromatic setting. For this serene shot of a waterfall, which was in an outcropping of dark rock, I chose a CC20 green filter to "lift" the green color of the plants to give the scene more chromatic contrast. I used a very slow shutter speed of 6 minutes, so that the white water would show a color shift.

use them most frequently to fine-tune two types of illumination. In a controlled, standardized lighting situation, the need to correct color comes from variations in the film's response to the illumination, such as a studio strobe. Shooting under *nonstandardized lighting,* such as fluorescent light, requires contending with too much of a particular color in the light source itself; here, there is an abundance of green. A variation of the film response scenario also occurs when long shutter speeds are used in time exposures. The film's normal response curve is altered, so that it fails to properly record colors.

Employing CC filters to correct for unusual light sources, especially fluorescent light, is probably what photographers most frequently use these filters for. So prevalent is this difficult problem that some manufacturers have put out a special fluorescent filter that is based on the subtractive color principle. In fact,

I've never met a photographer working in color who didn't hate fluorescent lighting because it is a *nonstandardized* light source. What do I mean by "nonstandard"? Unlike white light with its continuous spectrum, fluorescent tubes have a discontinuous spectrum of color. This produces a difference in the proportions of the colors present. Despite these differences, manufacturers use such terms as *daylight* to describe their products and rate them by Kelvin degrees; however, this isn't very helpful to photographers looking for critical color reproduction. A more useful scale for rating fluorescent light is the *Color Rendering Index* (CRI), which uses daylight (the light at noon) as a standard with a top rating of 100. So, for example, a Vita-Lite tube rated at CRI 91 has 91 percent color accuracy when compared to daylight. The higher the CRI, the more correct the color rendering.

JOSEPH MEEHAN

USING CHROMATIC FILTERS WITH BLACK-AND-WHITE FILM

When it comes to black-and-white film, many photographers devote their attention to controlling the relationship between exposure and development in order to capture the brightness range of a scene on film. They rely on the darkroom manipulations of different paper grades to change contrast; to add light to areas they wish to darken, or *burning in*; and to hold back light from parts of the print that are too dark, or *dodging*.

What many photographers fail to exploit is the ability of chromatic filters to control how colors and certain subject matter, such as water and the sky, are translated into tones on the gray scale. It sounds odd to say that when photographers work with monochrome materials, they should think in terms of color as well as black and white. Nevertheless, this is true. And it is critical for photographers to use this dual mindset to translate scenes with correct tonal representations, or to translate scenes into ones that they want to depict creatively.

Controlling Color Translation

The first step to having greater control over the translation of color to monochrome is to know how this change takes place without filters. Once you grasp this which colors produce which tones, the next step is to see how chromatic filters change this process. Complementary colors are blocked most, so they appear darkest. You then have to compensate for this light loss by adjusting exposure according to a filter factor. While these conditions apply to all chromatic filters, the effect of some filters on black-and-white images is hardly noticeable. This includes all of the very weak CC and light-balancing filters. The filters designed for black-and-white work are specific to that medium, and their colors—red, orange, yellow, green, and blue—are so intense that if they're used with color film, they'll produce very strong color casts. These chromatic filters are numbered within each color group to indicate their strength. For example, a 23A red filter is lighter than a 25A red filter, which in turn is lighter than a 29A red filter.

Controlling the appearance of tones in a black-and-white print is usually done to separate subject matter. This increases contrast between tones as it renders a scene in a natural gradation. So it is difficult to label the effect of a particular filter as "corrective" versus "contrast producing." In practice, both mechanisms are commonly at work. It is more appropriate, therefore, to think of the ways tonal separations prevent the merging of similar gray tones and control the brightness range of a scene as the rough equivalents of correction and contrast.

Suppose that you're shooting a dark red barn and deep green foliage with a green or a red filter, and that the scene also contains significant areas of clear, blue sky and puffy, white clouds. These will show up as an overall bright area in an unfiltered print: because of the film's sensitivity to blue, the sky will expose at about the same density as the white clouds. If you use the green filter, the sky will become dark since the green will block some of the blue of the sky. But using a red filter will really darken the sky, almost to black.

Obviously, very often you have to make decisions about corrections and contrast concurrently. Unfortunately, you may not always understand this if your thinking is couched in such oversimplifications as "Colored filters increase contrast" and "Use a yellow filter to bring out the clouds." This kind of circumscribed reasoning can lead to many missed opportunities.

The more desirable approach, therefore, is to apply the specific principles of color filtration to the characteristics of black-and-white materials. Base your decision about filter use on the need to separate the tones that comprise your centers of interest. In a portrait the key factors are: skin tone and lip color for lighter-skinned individuals (darker-skinned individuals show fewer changes); hair color for people with blond, red, and silver-blue hair; and eye color for people with light blue or green eyes. Be aware of the natural red tint in many faces, and watch out for tonal mergers between hair, backgrounds, and clothing when filtering for a person. Yellow and yellow-green filters provide about the best tonal correction for moderate separation in the facial features of light-skinned individuals, but they darken silver-blue hair.

When you shoot landscapes, pay particular attention to the colors that dominate the scene, regardless of their relation to the center of interest. These colors have the potential to become strong, secondary attractions with their own visual center that will compete with the main subject if they're translated too dark or too light.

Skies, with or without clouds, play a major role in most landscapes. Unlike a clear sky with its predominance of blue, a completely clouded-over sky doesn't respond to filtration because all colors are present. White skies near the horizon and white areas around the sun respond little if at all to chromatic filtration, which very often produces an unevenly graded shading from light at the bottom to dark at the top.

However, chromatic filters excel in their ability to penetrate haze. The colors remove the excess blue and are able to bypass the UV effect. To penetrate the foglike effect of UV radiation, use a progressively darker filter for stronger results; for example, proceed from yellow, to green, to orange, to red. Generally the longer the photographic distance and the longer the focal length of the lens, the stronger the filter must be. Telephoto lenses cover a narrow angle of view but compress subject matter through magnification. When photographing clouds, avoid overexposure, which builds up density in the negative.

Chromatic filters have no effect on white, black, or gray areas, so you'll find that the problems associated with neutrals don't occur with monochrome work.

Besides varying exposure and development, the primary mechanisms for controlling tone and contrast in black-and-white photography are using camera filters and altering the contrast grade of the printing paper. Both the separation and contrast between this red building and the sky were influenced by the use of filters. Unfiltered, the building appears moderately dark against a light-gray sky (top). Then I used a 23A red filter to lighten the building in the sunlight (center) but it darkened the sky. So then I switched to a 47 blue filter that rendered the building almost black and the sky white (bottom).

SUBJECTS AND SPECIALTIES

PATRICIA CAULFIELD

CAPTURING WILDLIFE ON FILM

Every photographer using a manual 35mm SLR has essentially the same camera controls for manipulating exposure, and many of the same potential compositions are accessible to everyone. The basic elements of photographing wildlife are universal: you choose a shutter speed to stop or blur motion. You select an aperture, which is an important part of controlling the depth or field, or area of sharp detail, in the photograph. You either hold the camera rock steady during the exposure, or pan it along with the action, thereby keeping the subject sharp and blurring the background. You select the focal length of your lens, the camera angle, the camera-to-subject working distance, the time of day, and how you place the subject elements in the frame. The compound of all these choices adds up to your personal style, something that distinguishes your pictures from those of all the other photographers in the world.

Showing Motion

One of the most important decisions to make about photographing a moving subject is what shutter speed to

use. A fast shutter speed, such as 1/500 sec., arrests motion; a slow speed, such as 1/30 sec., renders it blurred. How fast a speed is needed to stop an action depends on several factors: the speed of the action, its distance and angle in relation to the camera, and the focal-length lens you use. Under the following circumstances, you should usually employ the fastest shutter speed possible to freeze an animal's action on film: your subject is moving fast and close to the camera, the direction of its motion is practically parallel to the film plane, or you're using a long-focal-length lens. Obviously, deciding on the ideal shutter speed isn't always easy. And a shutter speed can't be considered in isolation because it must be combined with one particular aperture to deliver the right exposure.

Accumulated experience will ultimately be your best guide. In the meantime, you can use the following table showing the shutter speeds necessary for stopping a subject's motion as it crosses your view parallel to the film plane. This table is for 200mm lenses. For longer lenses, use the next-fastest shutter speed each time you double the

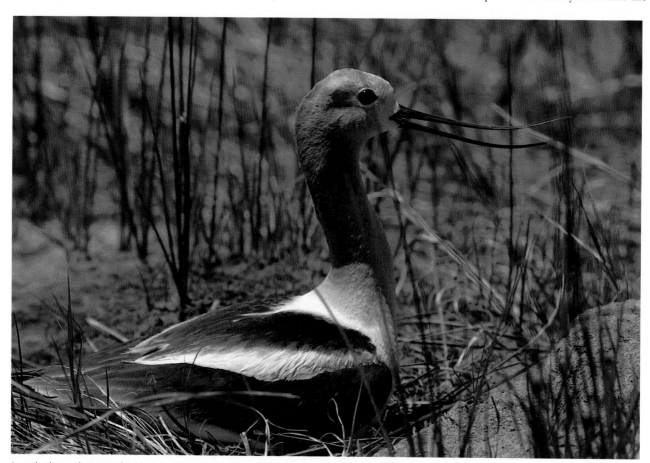

I made these photographs of an avocet on its nest with the smallest and largest apertures possible on my 300mm lens. I shot one picture for 1/8 sec. at f/32 on Kodachrome 64 to create the greatest depth of field possible (above). Then I exposed for 1/250 sec. at f/5.6; this rendered everything but the bird out of focus (opposite page). I didn't shoot with the lens totally wide open because that usually degrades image sharpness.

focal length of the lens. For shorter lenses, use the next-slowest shutter speed each time you halve the focal length.

**Shutter Speeds to Stop Action
That Is Parallel to the Camera**

| MPH | Camera-to-Subject Distance in Feet | | | |
	10	25	50	100
	Shutter Speeds in Seconds			
2	1/1000	1/500	1/250	1/125
4	1/2000	1/1000	1/500	1/250
8	1/4000	1/2000	1/1000	1/500
15		1/4000	1/2000	1/1000
30			1/4000	1/2000
60				1/4000

At first glance, the high speeds indicated in this chart might seem discouraging, but when you consider that 1/500 sec. was the highest shutter speed I used for any of the birds in motion that you see here, you should be able to take heart.

The conditions surrounding wildlife photography often make aesthetics take a back seat compared to the difficulty of simply capturing the animals on film. Nonetheless, you must still make some critical choices.

Depth of Field

Chief among these is your decision about *depth of field,* or how much of the picture will be in sharp focus. To achieve maximum depth of field, use a small aperture. This will bring distant as well as nearby objects into sharp focus. For a more selective range of focus, open the lens up, which means use a wide aperture. Sharp detail will appear around your point of focus only.

Camera Angles

Exploring different camera angles is also very important and is one of the easiest ways to start taking better pictures. Finding a new camera angle is often the solution to what may seem like a deadend problem in composing a photograph. Unfortunately, many beginning photographers overlook this simple step. And when you're working around water, don't ignore the possible reflections of your subjects; try to angle your camera to include some of these fantastic shapes if they are present.

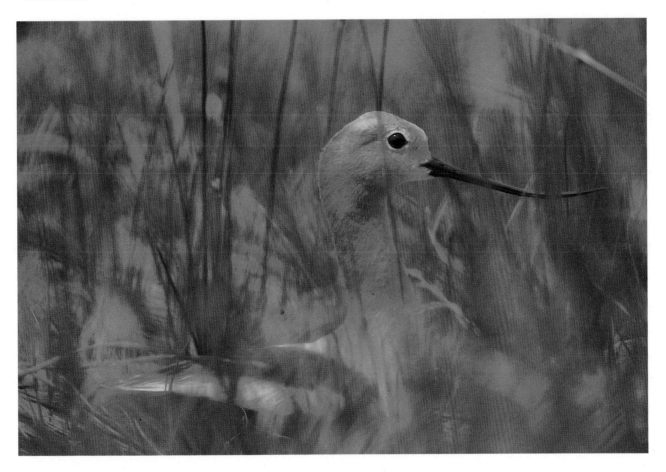

PATRICIA CAULFIELD

USING A BLIND FOR CAMOUFLAGE

Avian eyesight is remarkable. Birds can see in color, and they see far more sharply than we do. Think for a moment about the feeding behavior of such birds as hawks and buzzards. Both species cruise high in the sky, riding air currents thousands of feet above the ground as they scan the scene below them for food. From this height they can spot carrion or potential prey that are camouflaged in color and pattern. Now *that* is good eyesight.

Compared to most mammals, birds have an inferior sense of smell, and their hearing, while acute, is quite different. Birds seemed tuned in to the calls of other birds, and yet, unlike mammals, frequently ignore artificial noises.

Out of Sight Is Out of Mind

Because birds see so extraordinarily well, they've evolved relying on their eyesight to protect them from danger. What they can't see doesn't bother them, which is most fortunate for people interested in studying and photographing them. Serious wildlife photographers use *blinds* to camouflage themselves from their subjects when doing bird photography. Broadly defined as any lightly built structure that hides a photographer or hunter, blinds are the bird photographer's best friend.

Most birds will accept almost any structure or device that completely hides the photographer as long as the blind doesn't flap or bend in the wind, and as long as the birds don't know that anyone is inside. And, in fact, sometimes photographers don't need to use blinds in the formal sense; instead, you can use such natural cover as dense bushes or tree branches. You can also make a casual blind by lying beneath a length of camouflage cloth or by placing the cloth over a bush or a natural formation. Another option is to build a blind on the spot, using natural materials with or without additional camouflage material. And sometimes a portable blind or a tent is most useful in wide open spaces or other places where no natural cover already exists.

Portable Blinds

There are several factors to consider when building or buying a blind or a tent to use as a blind. First, regardless of the lighting conditions, from the outside you should never be able to see anything moving inside the blind. This makes canvas material preferable to burlap, even if the burlap for the blind is several layers thick. Another factor to be conscious of is your own comfort. You should have enough room inside the blind to stretch and even to stand upright if possible. A third consideration is the blind's stability in the wind. Birds are frightened by motion, so make sure all of your equipment is stationary. Nothing on the outside of the blind should ever flap. In windy country, I stabilize my blind or tent with guy wires.

I've owned several different portable blinds over the years. The first blind I used extensively was a special pop tent, manufactured by Thermos, that had many strategically placed zippered openings for camera lenses or observation. Thermos no longer makes these tents, but pop tents are still available. A pop tent has a vertical frame of nylon ribs that pop up when depressed, giving the tent a rigid form. If you want to customize a pop tent for picture-taking, you can cut slits in the tent and sew in heavy-duty zipper flaps with fasteners made of Velcro. Before you begin altering the tent, decide what constitutes eye level when you're seated in the blind. Put your camera on a tripod, set it up the way you intend to use it in the blind, and mark the blind material where the lens would intersect it. You'll want to have eye-level openings on opposite sides of the blind or possibly on three or four sides.

You'll also want to use different camera heights. In addition to the eye-level openings for ground seating, you may want to make openings at ground level or at the level of a camera mounted on a tabletop tripod. In practice, vegetation may preclude using the lowest vantage points even with ground-nesting birds. If your blind is tall enough, you might opt to cut some lens portholes at eye level when you're standing.

When You Need a Platform

Sometimes you may need to construct a platform to support your blind, for example, when the birds you want to photograph nest in high treetops. The tree you choose for your platform must be near the nest tree and be able to accommodate the platform at a level slightly higher than the nest to give you a clear view of it. Without such a tree, some photographers build towers of metal tubing for their blinds.

Putting a platform and a blind in place is tricky because it must be done when the birds are absent, preferably before the nesting season. Some bird species return to the same nests year after year. Constructing a platform near their nests is relatively simple since it can be erected any time other than during the nesting. For other birds it should usually be done after the eggs hatch, a time when the platform is unlikely to cause the parent birds to desert their young.

Don't undertake such elaborate preparations unless you can consistently spare enough time to photograph the birds, or if there is any possibility that the birds' safety will be compromised. Be absolutely certain that the nesting birds you want to photograph aren't endangered or threatened. Nest photography constitutes harassment and shouldn't be undertaken with rare or endangered creatures.

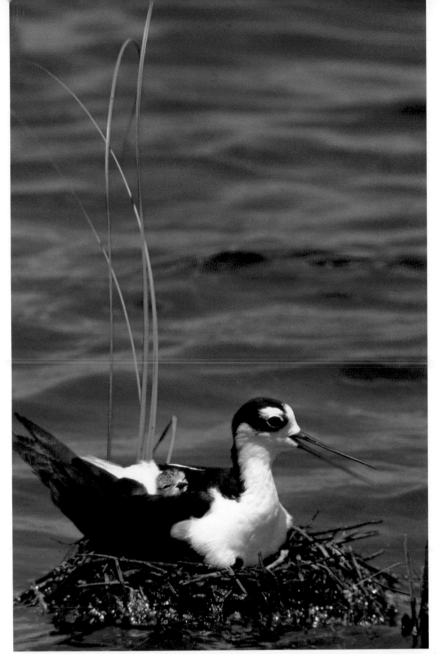

Building a platform for my blind was an essential first step in my photography of these black-necked stilts nesting deep in the Everglades. They build their nests right in the swamp water by constructing a foundation of vegetation that supports their eggs above water level.

The water during the stilts' mating season was about 18 inches deep. I expected to work from my blind for several weeks and knew that setting it up and then sitting in the water would be a disaster: every time I moved, I would have risked dunking my cameras and other equipment. So a friend built a platform for me from 2 x 4s and boards. The platform was about 3½ feet from the ground and had an area of 4 x 4 feet.

I was transported to the blind twice a week for several weeks until it became evident that the eggs were ready to hatch; then I went out every morning for a few days. Stilts are *precocial,* which means that as soon as they're hatched, they are active, down-covered, and able to swim. A stilt nest is empty the day after the eggs hatch, so perfect timing is imperative for capturing the newly hatched offspring on film.

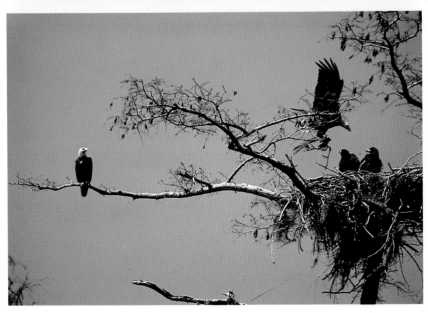

I waited for four days to frame this entire eagle family in one photograph. I used a 500mm mirror lens for its reach, and I exposed Kodachrome 64 for 1/250 sec. at f/8.

JOE McDONALD

GAME CALLING

Two types of natural or simulated animal calls are good for attracting some species of mammals, birds, and amphibians to you. A *mouth call* is a device that attracts predators by imitating the cries of an injured rabbit or similar prey animal. Using a mouth call properly requires practice. *Electronic calls* are easier to use because they are tape recordings of real animals calling or screaming. Electronic callers are used to attract predators, owls, and certain species of birds. Johnny Stewart Wildlife Calls of Waco, Texas, offers a large variety of animal sounds specifically designed to attract animals for photography.

Screech-owl tapes attract other screech owls, as well as many species of songbirds. Many songbirds have an almost human sense of hatred of owls and harass any that they discover. A variety of songbirds have been known to gather around a hidden speaker for as long as 20 minutes as they seek out the calling owl. Screech owls, of course, usually respond and investigate only at night. Game calling doesn't work with every species or every individual; however, it can be a useful way to attract active species that are wary, nocturnal, or difficult to find. Coyotes, bobcats, foxes, hawks, and owls often respond to the dying-rabbit and squealing-woodpecker tapes. In Africa, I've even attracted lionesses with the rabbit tape when I was calling jackals and caracals. This isn't surprising because many predators are opportunistic and will steal a meal from a smaller animal.

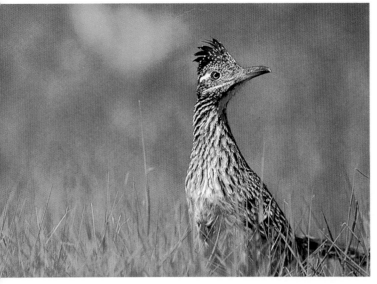

At New Mexico's Bosque del Apache National Wildlife Refuge, I played a tape of a screaming woodpecker to attract this shy roadrunner within camera range. I wore complete camouflage and a headnet, and sat alongside one of the thick bushes surrounding a clearing. It took less than 5 minutes to bring in the bird. I shot Kodachrome 64 at f/5.6 for 1/500 sec. and used a 500mm F4.5 lens.

However, using any type of game call can be stressful or even harmful to your subjects. Predator calling is perhaps most effective in winter when food is scarce, but this ploy costs your subject valuable energy as it follows your false leads for food. Late summer or early autumn is a better time for game calling because food is abundant then, and any animal that investigates is probably doing so out of curiosity, rather than because it is starving. For similar reasons, don't use an owl call to attract songbirds during the nesting season. Although most songbirds spend only a few minutes hunting for the owl, this is time the birds could be using to find food for their young or to search for real predators. The period before the nesting season begins, and in late summer and autumn after nesting is completed, are better times because it is unlikely that you'll harm your subjects by calling.

Many birds also respond to tapes of their own species, especially before or during the nesting season. In fact, bird watchers often use tapes to lure rails or other elusive species into view, but they generally don't play a tape as long as a photographer might because they're trying only to see the bird. Many people have expressed concern that using bird tapes can stress animals and drive a bird from its nesting territory. This is a valid point. And using tapes or game calls is prohibited in most parks and refuges because they alter the normal routine of an animal or bird. If you must use bird songs to attract your subjects, don't use any recording of a songbird at high volume because this can drive the species you seek off its territory, and never play an owl or other bird tape during the nesting season for longer than five minutes.

Tree frogs, toads, and true frogs also call in the spring to attract mates. Although the expanded vocal sack of a singing frog or toad makes an attractive photograph, many amphibians stop calling when you approach them. Tapes can coax these shy amphibians to resume singing. Unlike the possible harm caused by tricking birds with recordings, amphibians aren't affected in the same way because they don't set up territories. You won't stress amphibians by playing a tape. Instead, you might help them to draw in mates by coaxing them to resume calling.

When you're game calling for birds and mammals, wear camouflage clothing and remain absolutely motionless while waiting for game to approach. Remember, any animal you attract is looking for the source of the call, and its senses are far superior to yours. A songbird's vision is so acute that it can see you blink from more than a dozen feet away, even when you're completely camouflaged. However, a face net and a camou-net covering that drapes over you and hangs a few inches out in front of your face help disguise any facial movements you may make.

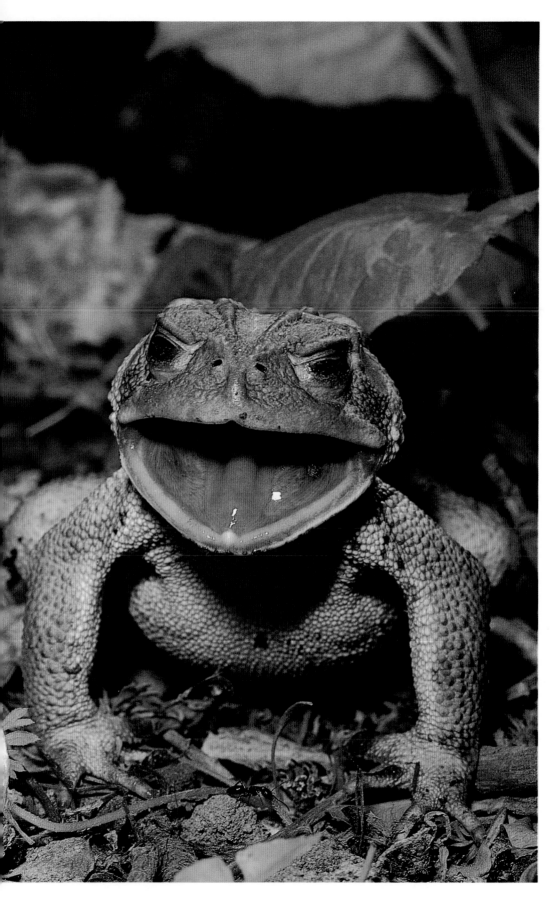

Don't overlook wildlife in your own backyard. American toads are common woodland and garden animals that are frequently ignored because many photographers seek more exotic fare. Although this toad, which I found in my own backyard in Pennsylvania, appears to be laughing, it was actually attempting to gulp down the last of three huge night crawlers I'd provided. Here, I used a 100mm F4 lens and manual flash.

JOE McDONALD

RECOGNIZING THE DECISIVE MOMENT

For wildlife, a fast lens, a fast-speed film, or an electronic flash unit is often necessary to photograph under heavy-overcast or low-light conditions. But these accessories aren't required if your subject is still. Surprisingly, most mammals, reptiles, amphibians, insects, and many larger species of birds can be virtually motionless for varying lengths of time, ranging from the briefest instant to quite a few seconds. For example, even a walking deer or a preening egret may pause momentarily, and if you anticipate that moment, you can use a slow shutter speed.

In many wildlife photographs, there is a *decisive moment,* either a point of peak activity or a momentary lull. Using a motor-driven camera doesn't guarantee you'll capture that moment, but a state of awareness and a sense of anticipation may. Sometimes an animal telegraphs its action. A change in expression, a tightening of muscles, a sense of alertness—any of these may warn you that action is imminent. Although it requires patience, try waiting for an activity to take place rather than coaxing it along. In other words, don't make a bird flush that might have flown if you'd waited.

Impatient photographers may obtain one action, such as flight, but miss another, such as preening, stretching, or yawning, that may have occurred if they'd waited. Besides, frightening an animal to make it run or fly, or teasing it to catch an eye highlight, is unfair to the animal. It is also a disservice to other photographers who may find a formerly trusting animal now skittish.

Animals and birds can be photographed in very low light with slow ISO films if they are still. A bit of luck and a sense of timing and anticipation can help you catch an ordinarily active bird during a brief second of stillness. I photographed this stellar's jay in Yosemite National Park with a 300mm F2.8 lens, exposing Kodachrome 64 for 1/125 sec. at f/2.8.

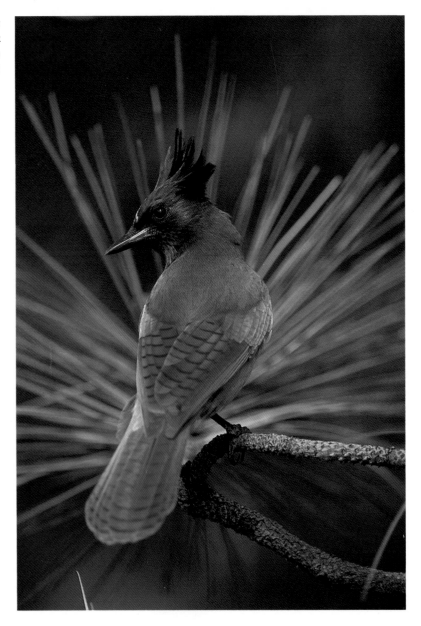

Steam or fog adds an interesting contrast to many scenes. To silhouette your subject, base your meter reading on the steam, as I did here, and then open up one *f*-stop to bring back the brightness. To record this quiet moment, I photographed this coyote at Yosemite National Park with a 300mm F2.8 lens and exposed Kodachrome 64 for 1/250 sec. at *f*/8.

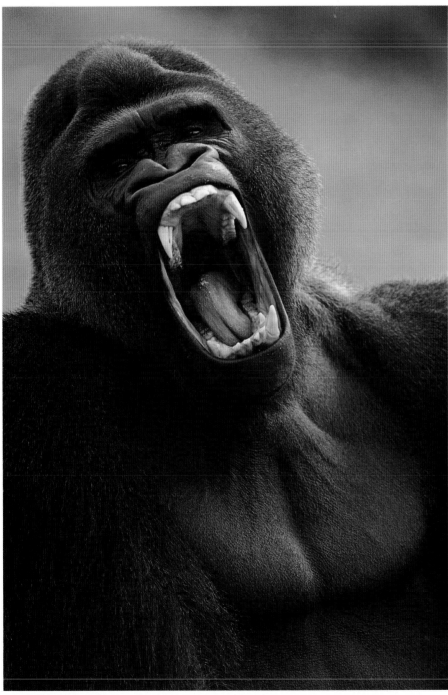

Because the sun was obscured by light clouds, I couldn't use the wildlife equivalent of sunny *f*/11 for this shot of a lowland gorilla at Florida's Miami Zoo, taken with a 500mm F4.5 lens. Instead, I took a meter reading off the grass behind the gorilla, then opened up one *f*-stop. As you can guess, my camera's meter indicated that I was underexposing the image. The exposure was 1/250 sec. at *f*/4.5 on Kodachrome 64.

JOHN SHAW

PHOTOGRAPHING THE PASSING MOMENT

Some events are here today and gone long before tomorrow is even a conscious thought. Change and variation seem to be the only constants in life. You can't take the time to look at something twice; you'll have already missed it. The late light has faded, and the lark has finished its song.

Some happenings are so quickly over that their occurrence each year marks a special page on the seasonal calendar. Such is the case with mayflies. These insects spend most of their lives as completely aquatic forms, living as long as four years in ponds and streams before emerging from the water in the last stage of metamorphosis. Adults last a few days at most. Some don't even make it through one day, emerging in the early evening

to mate, lay eggs, and die before dawn. When they emerge, however, the numbers can be staggering. These mayflies were the result of an incredible overnight hatch from a large inland lake. Not a mayfly was to be seen the night before but by morning my truck was so covered with them, it seemed to have changed color and gained texture. Mayflies were everywhere.

I found this pair of adults clinging to opposite sides of a dandelion. In order to maximize depth of field, I needed to keep the camera back parallel with the plane of the insects. This meant I had to position my tripod as low as it would go. I used my 200mm macro lens both to narrow down the background and at the same time to isolate this small area.

I photographed these mayflies on a dandelion with my Nikon F3, a Nikon 200mm macro lens, and Fujichrome 50.

One of the best lights in which to shoot autumn foliage is when the entire sky is overcast. It creates a high, soft-white-light tent encompassing the scene. The contrast is low, and colors become saturated. I love this light so much that I almost hate to see sunny days in the autumn. Bright sunlight builds contrast, produces harsh shadow lines, turns leaves into a mass of confusing shapes, and tints the scene with blue from the open sky.

Overcast days do, however, have one major drawback. If a photograph includes any sky, it will record on film as a featureless, washed-out, dull expanse. This isn't the look you want to achieve when the explosion of colors cries out for the exact opposite. One solution is easy: don't include the sky in your composition. Long lenses, with their narrow angle of view, enable you to eliminate the sky. If you use a standard lens, its angle of view will include the sky regardless of where you place your tripod. Pick up your telephoto lens. I often find myself using focal lengths in the 100-300mm range in the autumn to focus in on certain parts of the landscape.

I shot this group of sugar maples with my 300mm lens. Shooting into the woods, I was able to isolate a section that included all the autumn colors. And because I backed away from the trees rather than looked up at them, I was able to keep the tree trunks parallel to the sides of the frame. If I'd used a short-focal-length lens and tilted it upward, all the tree trunks would have appeared to converge toward the top of the frame, in a "keystoning" effect. Combining overcast light, peak fall color, and a long lens leads to dynamic photographic opportunities.

For this shot of autumn colors of a sugar maple, I used my Nikon F3, a Nikon 300mm lens, and Fujichrome 50.

To record the fleabane and the quaking aspen trunk, I chose my Nikon F4, a Nikon 50-135mm zoom lens, and Fuji Velvia.

I was exhilarated to find this fleabane meadow as I was poking along a back country road. The only problem was that it was 10 A.M. on a bright, sunny, cloudless day. I knew that any photograph of the meadow would look absolutely terrible in that light. Luckily the meadow sloped downhill to the northeast, so late in the day while there was some light left for photography, the meadow would fall in shadow.

I returned too early. Like every other photographer, I've done my share of waiting but I haven't gotten any better at it. I figure out some shots, play with the equipment, explore the area—and wait, and wait. Some photographers claim they can previsualize exactly what a composition will look like in different lighting situations. I can't. I can tell if a scene has potential, but in the end I need to see the actual lighting. Here, the light made the difference. As shadows fell across the hillside, I came alive, madly shooting film. I started with large sweeps and slowly narrowed my vision until I finished with this tight shot. I kept the aspen trunks in the frame to provide a textural contrast to the fleabane and to add an environmental anchor, hinting to the viewer about the flowers' location.

The burst of blooming spring flora in the eastern hardwoods is always too brief. For a few days or at most a few weeks, spring flowers are everywhere. Then for a very short time, the flowers and budding tree leaves coexist. And for an even shorter time, both are in perfect condition, not yet showing the effects of the weather or insects. At this exact moment when spring is at its peak, when everything is new and unfolding, lush colors that I don't see at any other time abound. They are intense but not extreme, warm but not blistering, saturated but not syrupy thick. Then the canopy of budding leaves forms overhead, preventing light from reaching the forest floor, and the season is over.

I found these wild geraniums under the sweeping lowest branches of a spreading sugar maple. Some of the blossoms are hidden deep behind the tree's new leaves; others, like the ones you see here, peek out tentatively yet expectantly.

I made this shot of wild geraniums and sugar-maple leaves with my Nikon F3, a Nikon 105mm macro lens, and Fujichrome 50.

For just one moment, this moorhen glanced over at me. I was photographing it along a drainage ditch through the mangroves near the Ding Darling National Wildlife Refuge exit. While these birds are fairly common throughout the southern Florida ecosystem, they're often overlooked simply because they are such a familiar sight. Sometimes people forget to look at what is right in front of them.

Whenever I can, I try to photograph birds and mammals from close to their eye level. Too many pictures of them are taken from about a 5-foot-high point of view, which is human eye level. Birds and animals exist in their own special worlds and have their own ways of looking at their surroundings. Try to photograph them from their own perspective.

Shooting at bird's-eye level, however, meant locating my tripod almost in the water. I used my 400mm lens in order to crop tightly on the bird. Luckily, the moorhen wasn't moving around much, so I could take the time to carefully maneuver my tripod and camera into the exact shooting position I needed for this image. I wanted to isolate the bird against the dark green reflections of the surrounding mangroves.

For this photograph of a common moorhen, I used my Nikon F3, a Nikon 400mm lens, and Fujichrome 50.

To shoot these Columbia lilies, I used a Nikon F4, a Nikon 20mm macro lens, and Fujichrome 50.

I was photographing in Olympic National Park when I found these Columbia lilies early one wet morning. They were in perfect condition. Their petals were curved tightly and their stamens covered with pollen, and as of yet, they hadn't been ravaged by insects or the weather. I wanted to isolate the two blossoms against the uniform green background, provided by trees 20 feet away, and at the same time to shoot slightly up at the blossoms in order to see into them. I chose my 200mm macro lens although any lens of this focal length or longer would have worked just as well. I simply needed a focal length long enough to enable me to narrow the background coverage and to exclude the sky.

A slight breeze persisted in annoying me as it caused the blossoms to sway. I poked a dead stick into the ground, angling it so that it gently touched the flower stalk just outside the picture frame. This cut down on some of the worst movement. Next, I used the depth-of-field preview button to determine which *f*-stop would provide just enough depth of field. I wanted to cover the flowers, but I didn't want the background in focus. I metered the blossoms and the background and discovered that they were exactly one stop apart. I placed the blossoms as a medium orange and let the green background fall one stop darker. Finally, I framed the picture very carefully. I wanted to include not only the two blossoms in opposite corners, but also the junction of their stems as well as the small leaves at that point. Then it was just a matter of waiting for a perfectly calm moment.

APPROACHING POTENTIAL SUBJECTS

Sometimes I wonder if cameras shouldn't be licensed. I can always tell where hordes of cameras have come before me. I'll put my camera to my eye and people immediately cringe, duck, or flee. This is a completely opposite reaction to the friendly curiosity I notice in places where few foreign cameras travel. Of course, having one person in six months come along and photograph you is very different from 16 people approaching you in one day.

Newcomers to travel photography are led to believe that only a combination of stealth and long lenses can guarantee the travel trophies they want. My guess is that most people feel guilty taking photographs of other people; they feel that they're being obtrusive and invasive, so they use a long lens to shield themselves. Still, even with a 200mm lens you need to be as close as 15 feet to your subject for a portrait from the waist up.

All photographers develop their own distinctive manner and style with other people. Some are pushy, some are silent, and some are flamboyant and loud. All kinds of approaches work.

I've seen some wonderful shots made by photographers who fit in each of these categories. I have a simple approach. I rarely use a telephoto lens; I prefer direct photographic contact with people. Since I enjoy a personal exchange, I go right up to someone and engage in a conversation or make some kind of contact.

Success in photographing people is the result of the manner of your approach. Suppose you are in a village market, and you see an intriguing woman selling beautiful red tomatoes. The light is perfect. You know the best shot is a candid shot, so you quickly hold up your camera and you snap the picture. Suddenly, she senses you and looks up. If you meet her gaze with a guilty look and scurry around the corner, you're sending a message that you've done something wrong or you've violated something. I've seen this happen far too many times.

Don't slink furtively away. Instead, put down your camera, smile, and wave. Go over and shake the woman's hand in gratitude. You might even buy a tomato from her. After you establish good, friendly terms, take out your camera, put on a wide-angle or macro lens, and continue shooting. I find that people love this approach, and that the person in the next market stall may also be willing to pose for you. By then you have the market on your side and have shown that being photographed can be fun. Be open and flexible. What you first envisioned might evolve into something better. For example, the woman's twin sisters might come out in pink-checked dresses and stand on either side of the tomatoes.

Sometimes, though, you'll find that a person notices you, becomes annoyed, and waves you away. With experience you learn to tell the difference between people who are sincere in their wish to be left alone and people who say "No, no, no!" but mean "Yes, yes, yes!" Often these individuals wave you away, saying, "Oh, I'm not dressed in my best clothes" or "I'm not pretty enough." I laugh and dismiss that assertion, which is usually exactly what they want me to do. Most often they agree to have their picture taken. I never patronize people or talk down to them, but I do reassure them and try to put them at ease. However, if people give me an obvious, abrupt "No!" in response to my request or ignore my pleasantries, I smile, thank them, and walk away. I never sneak a photograph. It is their choice whether they want their picture taken or not. There is always another photographic opportunity. No picture is worth irritating someone over.

Don't spend too much time photographing one person in front of their family or friends; it begins to embarrass them. Often I'll intensely photograph one person, then leave or turn to his or her neighbor. Later I'll return and continue photographing the person who initially interested me.

Photographing people isn't for the shy at heart. You need a certain amount of impudence to overcome natural reserve. You have to be friendly and forthright and have a lot of panache in order to approach people. Confidence and friendliness open the gates to communication. People are as curious about you as you are about them, and often all that is necessary to unlock this curiosity is a friendly word or two. And it doesn't matter if you don't speak the same language. I have the longest conversations with individuals who don't speak English. I talk in my language and they talk in theirs. None of us, of course, can understand anything that's being said, but we have a wonderful time.

Sometimes it helps to have a local with you, whether the person is a paid guide or someone who befriends you on the street. I've worked with guides from the Foreign Press Center in Vietnam and local agencies in China, as well as with guides assigned to me in Africa and even little boys who tugged on my shirt in the temples of Nepal. Frequently you find people who are happy to walk with you because they want to practice their English. In Vietnam a teenager who wanted to speak English approached me, so we walked together around the streets. As we visited his friends in local cafes, he set up photographs for me, pointed out shots, and dragged me over to likely subjects. I had a wonderful time, and the locals saw me with a neighborhood kid who was also having fun. He broke the ice and paved the way for others to relax with me. The teenager certainly wasn't shy, and he felt very proud that he was showing a foreigner around his town. But you should be wary when you travel. Sometimes people want more than friendship.

And I always wear jewelry that I think might interest the local women. For example, when I am around Tibetans, I wear some turquoise rings or necklaces. The women and I inevitably end up admiring and comparing each other's jewelry. Then when the time feels right, I ask

if I can photograph them. When dealing with a shy woman, I might ask to take a photograph of her earrings or necklace; this minimizes the emphasis on her face. You may have to do some conventional overall shots and tactfully see if you can work your way in closer. It is rude to immediately zoom in on a subject's chest. And be sensitive when using a flash. Remember how blinding it is to have a flash go off directly in your eyes.

Make your camera a bridge rather than a barricade. If your subjects are unfamiliar with a camera, you might let them look through the viewfinder. Sometimes I even have them take a photograph of me (make sure you put the motor drive on single-frame exposure). You might get an interesting portrait of yourself.

Many photographers prefer not to use a motor drive when photographing people. I can certainly understand the sentiment. Motor drives can be noisy, obtrusive, and confusing. However, they are invaluable for catching fleeting expressions and a sequence of action. After I've reeled off a series of motor-driven shots, I usually drop the camera from my face, laugh at its antics, and then

begin photographing again if necessary. It helps to have a quiet camera. The Nikon F3 with a motor drive is one of the worst in terms of noise: it sounds like a submachine gun. A Leica is a great stealth camera because it is one of the quietest on the market.

At times you have to distance yourself from an emotional situation while remaining empathetic, which isn't always easy. In Vietnam I waited at the Hanoi National Cemetery for a funeral; I wanted to photograph the mosquito-net clothing worn by the family. Even though I knew I was there specifically to photograph a funeral, I was unprepared for how intensely their grief affected me. When a group of mourners arrived at a burial site, at first I stayed back. But I soon realized that I wasn't capturing the impact of the occasion, so I asked my interpreter if I could go closer. When he said yes, I moved to the front of the grave and photographed until I felt that my presence was becoming intrusive. With my Nikon N8008 and a 35-70mm zoom lens, I exposed for 1/125 sec. at f/8 on Kodachrome 200.

One day while I was photographing the ethnic hill tribes in Son La Province in northwestern Vietnam, a young Black Thai girl walked by carrying two bundles of Lau flowers used for stuffing mattresses. The sun was shining from behind, dramatically backlighting her and her load. I motioned to the girl to stop, metered off my hand, and shot a series of photographs. For this image, I used my Nikon F4 and a 24mm lens. The exposure was 1/60 sec. at f/5.6 on Kodachrome 64.

CHARLES SEABORN

SHOOTING UNDERWATER SUBJECTS

What makes the underwater world so intriguing, and why does it inspire rubber-clad individuals to dive into the sea, dragging with them cameras, lenses, flash units, and film? First, it truly is another world—a world of motion, weightlessness, and virtual silence.

The underwater world also appeals to us because its natural state seems so foreign to ours. Land environments abound with plant life while underwater environments are dominated by animal species. When people describe land environments, they refer to grasslands, redwood forests, and oak tree groves; when people describe underwater environments, they refer to coral reefs, oyster flats, and mussel beds. In addition, the animals encountered underwater often have unusual, if not bizarre, shapes and colors providing a never-ending supply of photographic subjects.

Although the fundamentals of land photography—measuring light, calculating exposure, focusing, framing, and composing—are essentially the same when applied to underwater photography, the challenge of capturing images on film underwater lies in dealing with the constraints of the underwater environment. First, you need to learn a new skill, scuba diving. And because the quality and quantity of light are altered as light penetrates water, you have to change your photographic technique. You also have to become familiar with the collection of special equipment designed for underwater use so you can handle it easily. At any level, underwater photography can be challenging, exhilarating, and rewarding if you have a basic understanding of the photographic process and the underwater world.

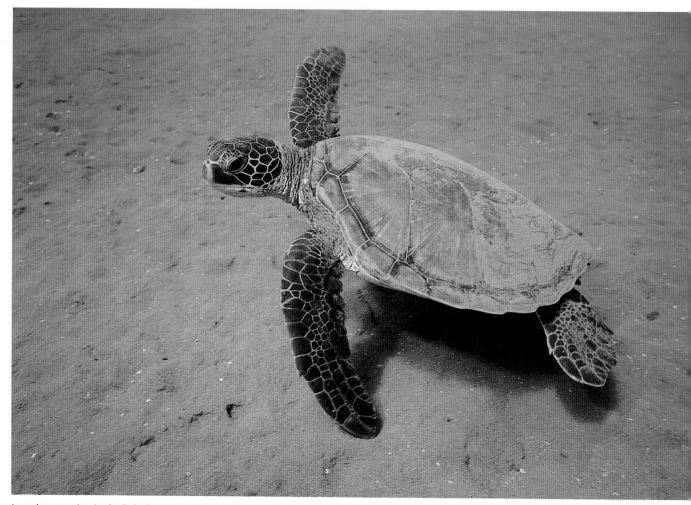

In order to maintain the light background, I had to use available light as the key light in this picture, taken in Maui (above). By using my Nikon SB-102 Speedlight at quarter power, I was able to enhance the detail in the sea turtle's head and shell. With my Nikonos V and a 20mm lens, I exposed for 1/90 sec. at f/5.6 on Kodachrome 64. The camera-to-subject distance was 3 feet.

Working in Roatan, I decided to stack these blue-striped grunts vertically in the branches of the soft coral and let it frame them (opposite page). Shooting from a camera-to-subject distance of 3 feet, I used a Nikonos V, a 35mm lens, a Nikon SB-102 Speedlight aimed almost directly at the grunts, and Kodachrome 64. The exposure was f/11 for 1/90 sec.

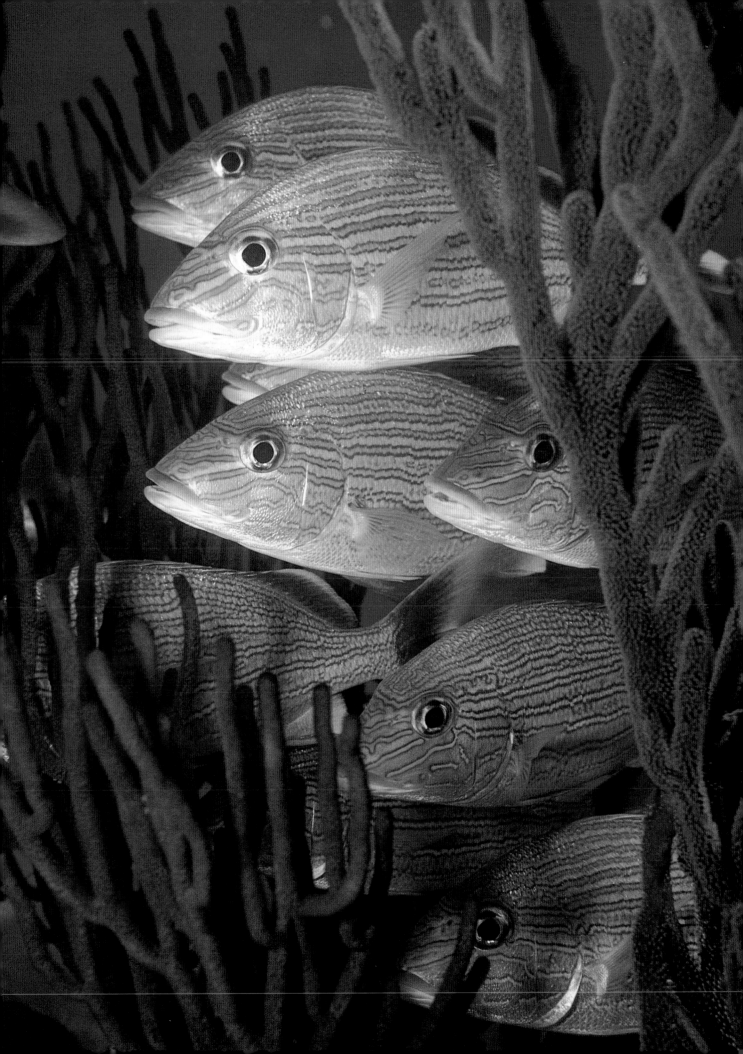

CHARLES SEABORN

SELECTING A FORMAT AND FILM

Essentially, all underwater photography is done in the 35mm format. Using medium-format camera systems underwater is complicated because of the difficulty in designing and constructing waterproof housings for them. But 2¼-format camera housings are available for Rollei and Hasselblad systems.

Another reason for the dominance of the 35mm format in underwater photography was the development of the Nikonos 35mm format system. Its widespread popularity in both the consumer and professional markets has had a big influence on the technological research, design, and construction of underwater camera equipment. While the size of the consumer market for underwater camera equipment is growing, it is still quite small in comparison to the market for cameras used on land. As a result, the development of underwater gear is slow. However, a major breakthrough came in 1992 when Nikon introduced the Nikonos RS, the first underwater SLR camera, complete with three autofocus lenses, matrix metering, and complete TTL integration with Nikon's SB-104 electronic flash.

Within the 35mm format, film selection for underwater photography is determined by both light sensitivity and color characteristics. Although print film gives you more leeway in regard to exposure during the developing process—which can be particularly helpful in underwater use

where measuring ambient light is often difficult—slide film seems to be preferred for two reasons. First, it is less expensive than print film. Given the amount of film you go through underwater, price can become an important consideration from a budgetary point of view. Second, if your images will be used commercially, transparencies are preferred: they reproduce better.

In addition, black-and-white film is used very little underwater; getting good shade contrast is difficult in most underwater situations. Because of this, black-and-white images usually appear dull and extremely monochromatic; they lean toward a fairly even gray tone, and everything

in the picture blends in with everything else.

With the limited levels of ambient light underwater, "fast" color films are generally more useful for images in which ambient light is key. Some photographers use films with ratings of ISO 100 and higher despite the inherent problems of graininess and loss of resolution with the faster films. These include films with ISO ratings of 200 and 400, whose grain quality has been improved recently. With ambient light, your images will lean heavily toward a monochromatic combination of blue and green—a result of water's color-absorption properties. Because of this tendency, I prefer to use Kodachrome film for

The 35mm film format enables you to work with both vertical and horizontal picture areas. This gives you more creative control. In this vertical image of strawberry anemones, the space between the groups creates two parallel diagonal lines and divides the groups into distinct units. The anemone in the upper left corner balances with the anemones in the lower left. The central cluster of anemones contains a bit of a curve, which adds to the overall radial pattern. Shooting in British Columbia, I exposed Kodachrome 25 at f/16 for 1/60 sec.

available-light shooting in order to try to bring out whatever red and/or orange there is in the water. I don't use Ektachrome or Fujichrome film with ambient light because it tends to enhance the blues and greens. With color-print film, warm colors can be enhanced to a certain degree during the printing process. This can also be done with slide film if an internegative is made and a print produced from it.

For closeup work, most photographers choose films with ISO ratings of less than 100. This is because a great deal of light is given off by electronic flash units at small flash-to-subject distances (usually less than 18 inches). The films most often used for such work are Kodachrome 64 and Kodachrome 25. Their ability to accentuate warm colors, such as reds and oranges, can be particularly effective with many small marine subjects: these tend to be brightly colored. In addition, Kodachrome 64 needs less flash power for exposure than Kodachrome 25 while it provides a high degree of sharpness.

However, even Kodachrome 25 can be used if the power output from the electronic flash unit can make up for the loss of about 1½ stops. I use it almost exclusively for closeup flash work because I find its sharpness to be unmatched.

Recently, however, Fuji's Velvia film has become nearly as popular, providing photographers with not only sharp images, but also the advantage of E-6 processing. This is a real bonus when you check to see if your equipment is working properly at the beginning of a location shoot. By being able to shoot and develop a test roll, you can find out if your equipment is faulty before you shoot hundreds of feet of film on that once-in-a-lifetime trip.

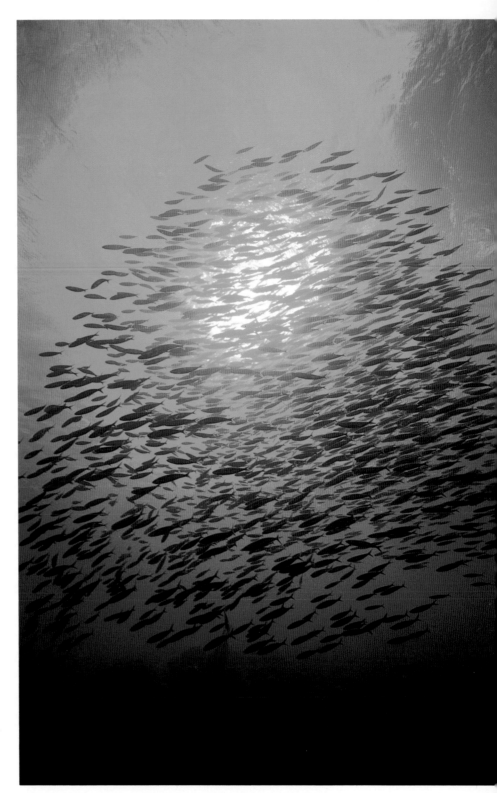

Ektachrome 64, which I used for this photograph of a school of mullet, picked up and accentuated the blue hues in the tropical waters in Bonaire, in the Netherland Antilles. With available light, I set my Nikonos III, fitted with a 15mm lens, for 1/60 sec. at f/16; the camera-to-subject distance was 10 feet.

BEAUTY PHOTOGRAPHY

Professional beauty photographers blend many factors to provide viewers with a page stopper, whether it is an introduction to a specific product, a hairstyle illustration, or a new makeup look. In order to make this come off expertly, you start with a concept or idea, fit the model to the image in mind, and then tailor the model to create that image. While all the parts are of relatively equal importance, good hairstylists and makeup artists can greatly influence the outcome of a photograph. Each of these people brings a different approach to the concept or desired end result, and it is up to the photographer to know which people to use for which project. For the most part, I work with individuals who do both hairstyling and makeup. This arrangement also makes sense because of the bottom-line concerns of agencies and clients. However, some jobs require both a makeup artist and a hairstylist, particularly ones where you photograph several models for one shot.

The wardrobe stylist is another member of the team whose taste and understanding of the desired end product, the photograph, are crucial to the result. The stylist should be able to interpret your desired effect within the parameters of the job. When you look at a potential wardrobe stylist's portfolio, ask how much input he or she had. Was there any freedom involved, or was there a layout with specific directions that had to be followed? I want stylists who listen to the client's requirements, make suggestions, are imaginative, and have contacts. I count on the stylist to be aware of fashion trends and directions that lend themselves to the photograph being produced. This is essential since better hairstylists and makeup artists always want to see the wardrobe colors beforehand, so that they can coordinate skin-tone and makeup colors to complement the look. Stylists not only take care of the wardrobe for the shoot, but also are sometimes required to fill in as the producer and bring all the loose ends together.

Although I rely on the makeup artist and stylists for both their skills and their opinions, a shoot is something like a democratic dictatorship. At some point, it is up to the photographer to make the final decisions and to get the show on the road. Regardless of all of the invaluable help—your own staff included—that surrounds you when producing beauty shots, you must have a complete grasp of the lighting variables necessary for creating a beautiful image. If you don't, all the help in the world isn't going to matter. The photographer's input is by far the most important factor in terms of realizing the end result for a number of obvious reasons, such as lighting, exposure, film choice, set or background, and attitude or expression. The impact of all of these elements can be easily weakened or destroyed by bad lighting technique. Before

For this shooting for head shots, I planned about 15 hairstyle and wardrobe variations of this clean-cut, blonde, Midwestern look. The idea behind a shooting session like this is to maximize the end result. I accomplished this by pre-lighting, testing the exposure, and shooting two or three changes per roll of 35mm film, not by bracketing. Simple, clean lighting lends itself to a multitude of illustrations for both editorial and product-oriented advertising.

the shooting, you need to have a clear picture in your mind of how to light the scene in order to pass this information on to both the hair-and-makeup artist and the wardrobe stylist for color selection. For example, if you're going for a very high-key effect, the makeup and wardrobe should mirror that look.

Yet all of the planning involved with a shoot shouldn't prevent you from suddenly deciding on the set to experiment with the lights, such as by changing an angle. Illuminating a scene in order to shoot from one direction doesn't mean that shooting against the light is taboo. Cover what looks good to you at the moment. After all, there is always more film. Just follow your instincts, and you'll create your own "hot shots."

When this model came to the studio for a "go-see," the light was perfect. To achieve the dramatic feeling that I wanted, I simply added a 2K spotlight and used the window light as fill. By walking around the model and shooting from various angles, I was able to capture a series of striking images. The lighting produced different effects from opposite angles; here you see edge lighting. I pushed Fujichrome 100 two stops and handheld the camera.

For this photograph shot during the late afternoon, I added a 2K spotlight as a back light to enhance the warm lighting. The spotlight actually functioned as the main light, and the available light coming in the window served as the fill light. By using Fujichrome 100 pushed two stops, I was able to handhold the camera and to shoot close to wide open. I chose this particular Fuji film because it tends to render warmer skin tones.

CLASSIC BATHING SUITS

Thanks to *Sports Illustrated,* bathing-suit photography has been raised from the pinup calendar to an art form that is in great demand by many national magazines. However, except for the fashion magazines, most of them don't do nearly as nice a job as *Sports Illustrated* because they don't have the funds required to take top models to some of the most exotic beaches in the world. And, needless to say, a beautiful model in a gorgeous bathing suit looks even better when she is photographed on a deserted beach in Seychelles than at Coney Island. But with a little ingenuity and a bunch of long lenses, you can usually transform any beach—within reason, of course—into an acceptable background.

The single most important factor in photographing bathing suits is the casting. The client, the art director and/or editor, and the photographer usually collaborate on the choice of models. If you're starting with a model who has a specific problem, you'll have to spend most of your time working around this part of the body instead of having the freedom to shoot from any angle. However, don't let anyone talk you into using any type of body makeup other than one of the newer toner/moisturizer products—unless you want to see someone photograph orange. The few times that I was forced into using body makeup were disasters. Not only did the makeup look too orange, it streaked and ran if any water got on the model, and it stained the garment. It also took about three hours to apply.

You also need a little understanding of anatomy. Does the waist look smaller when the model is standing or lying down? Is there a good hip line? Do the arm muscles or shoulder blades look awkward? A little knowledge in this area goes a long way toward transforming a mediocre shot into a beautiful image.

The fit and color of the bathing suit are also very important. A suit that looks great on one model may not look good on the next. One-piece suits that are cut high on the hip provide the most flattering look overall, although suits with string bottoms are very popular. Depending on their skin tone, some models look better in a specific color range. Most of the time, models have pretty strong opinions about which suits look good on them. Nevertheless, fittings are a must for any swimwear shoot.

When planning this type of shot, you also have to consider the lighting. Early-morning light and late-afternoon light are the most flattering for these shooting situations. But you must pay attention when you shoot at both times during the course of a day. Too often, photographers forget to remove the warming filter that they use in the morning, as a result, their subjects turn very orange-red in the late-afternoon light. The use of a polarizing filter enhances saturation, but it can also create problems. With some films, in a fully polarized shot a highlight can disappear or almost look solarized. When using a polarizer, move it a quarter or a half turn to carry part of the highlight. This provides more depth or *modeling.*

Photographs of models wearing bathing suits call for careful lens and film selection. Long lenses can do a lot for swimsuit shootings. I usually use lenses that range from 180mm to 500mm, but my 300mm F2.8 lens is the workhorse. It not only enables me to control the backgrounds to the point of completely dropping them out, but produces a flattening perspective that flatters the body. Film selection, of course, is very personal. Fuji Velvia is quite popular because it offers enhanced saturation. You might want to do a series of tests with this film. This is especially true late in the day when it renders skin tone a bit reddish. I still prefer using Kodachrome KPA 25 to achieve a neutral yet fully saturated look.

And, of course, locations for bathing-suit shots are obvious. The prettier the color of the water and the sand, as well as the number of swooping palm trees, the better the shoot will be. Don't overlook this fact or skimp in this area. Despite all the tricks in your camera bag, you still can't do the old "sow's ear, silk purse" routine if everything isn't working for you. For example, I can't make a painted backdrop and a ton of sand in the studio look like St. Bart's. Find the right location before you start shooting, or at least make the most of the circumstances.

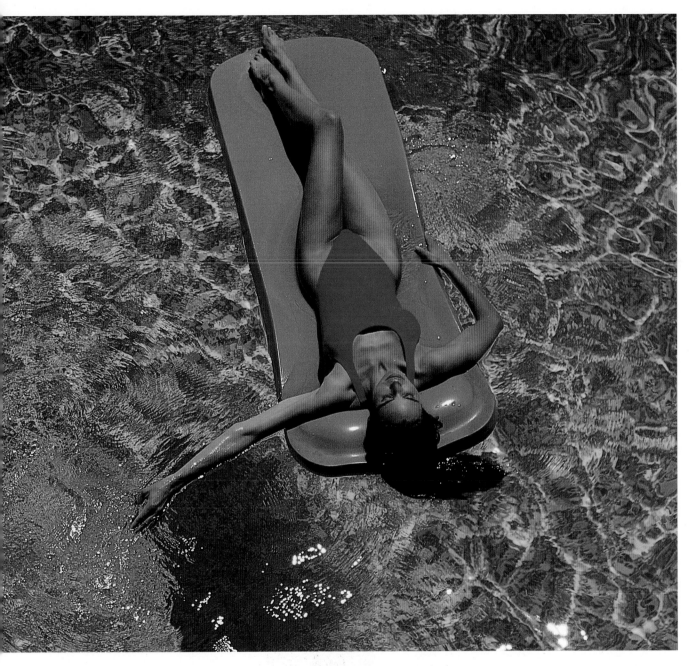

I made this photograph while standing on a 10-foot ladder and used a 50mm lens and Fuji Velvia. I purposely shot at midday in order to work with the sun overhead. Although the model's hand seems relaxed, she was actually making ripples with it on the water's surface. This added more interest to the interplay of highlights.

FASHION PHOTOGRAPHY

Like most other photographers, you may wish to enter the field of fashion because you're drawn to its prestige and glamour. Attractive faces and alluring garments are part of the make-believe world from which models seduce their audience. But this business also involves long hours, continual rejection, intense pressure, and explosive temperaments.

If, after weighing the pros and cons, you remain convinced that this is the field for you, then you are on your way to an exciting and potentially lucrative career. As a fashion photographer, you'll play a role in constructing images that not only sell products, but also create a fantasy world of ideal beauty and style. The boundaries of that world will be determined by only the richness of your imagination. The garments you photograph will be delineated by the variables of color, form, line, and movement, but your own imagination will govern these elements from the moment you accept an assignment to the last click of the shutter.

As a fashion photographer, you'll always have to be alert to trends—preferably not after they happen, but just before. You'll need to anticipate the next significant step in fashion. You'll have to be sensitive to the prevailing attitudes that shape such trends. For a good fashion photographer, these skills are second nature.

Fashion exists in and of the moment. Days of preparation and planning come together for one brief instant. How you capture that instant and what you instinctively register on film are what will make your work unique. This special personal style makes one fashion photographer different from any other. Before you embark on a career as a fashion photographer, you must come to realize that it won't always be an avenue for self-expression. If you are like many other fashion

In this photograph, the model looks relaxed, not stiffly posed. Editorial photography often conveys a mood but doesn't necessarily show every line of a garment. Here, the bright existing light adds a crisp feeling to this photograph.

photographers, you will hope that 25 percent of your assignments will be ideal and end up in your portfolio. But you may find that you'll accept 75 percent of your assignments just to pay bills.

Understanding the Markets

To enter the field of fashion photography and become successful, you first need to know that fashion photography is divided into three broad areas: editorial, advertising, and catalog. Each specialty has its own specific requirements. The editorial market enables photographers to express themselves rather freely; however, the corresponding fees are low. Beginning fashion photographers often must decide which is more important to them: creativity and exposure, or a substantial income. The advertising field offers photographers just the opposite. While the fees are usually quite high, photographers must subjugate their personal vision to the ideas and instructions of the client and the art director. In addition, photographers rarely receive a credit line for their efforts. Finally, the catalog market falls in between the editorial and advertising fields. Fashion photographers aren't allowed much flexibility when shooting catalog assignments as they follow the guidelines established by the client. Also, photographers can rely on this market for steady income.

The editorial pages in fashion magazines consist of articles and columns illustrated with photographs; they represent the fashion editors' point of view. If you remove the advertisements, these pages form the core of the magazine. They showcase the fashions the editors have decided to show to their readers that season. The term *editorial photography* applies to all the photographs that accompany articles and columns. Although these photographs aren't specifically meant to sell specific garments, the outfits get welcome publicity. Editorial sections have a particular style that reflects the tastes of the fashion editor. As a photographer, you'll be chosen for editorial assignments based on your style; obviously, you won't be selected for an assignment if your individual style is incompatible with the style of the magazine.

Despite the modest fees, photographers are eager to do editorial work for prestigious magazines because they usually receive a credit line: that is, their name appears alongside their photograph. This assures them of a great deal of valuable exposure. Everyone in the advertising business scans the major fashion magazines to keep abreast of the latest trends. As a result, credit lines help build a photographer's reputation.

The purpose of photographic advertisements is to sell a product. The products that often call for fashion photography are large in number and include cosmetics (lipstick, eye and face makeup, nail polish, skin-care treatments), fragrances, and hair products. Photographic advertisements are also used by department stores to sell various items or to be included in in-store product promotions. Because advertisers use the latest fashions to sell a variety of products, your clients might not be limited to the fashion business. Even some advertisers of products that aren't

For an advertisement featuring Denaka vodka, the client requested a black female model who could convey a slightly haughty attitude. To complement the copy for the ad, the model was to seem as if she had it all and wanted only the best. This model was perfect: she looks beautiful, sophisticated, self-assured, and wealthy.

fashion-related may require fashion-oriented advertising: appliances, cigarettes, liquor, furniture, and real estate.

While the advertising field is both glamorous and lucrative for fashion photographers, it also requires a great deal of responsibility. And, credit lines are rare. However, if the client's budget is small and you are expected to work for less than the standard rate, you could probably negotiate for a credit line. Only such top photographers as Avedon, Horst, Scavullo, and Penn are paid handsomely and receive a credit line, too. These photographers are chosen because the client or the agency feels that the photographer's name lends prestige to the advertisement.

When you're hired as a catalog photographer, you'll be shooting for mail-order houses, such as Spiegel, or for department stores, such as Macy's and Bloomingdale's. These businesses ship their catalogs to thousands of people on their mailing lists, including charge-account customers. The ultimate objective for any catalog is to sell product. In fashion catalogs, the garment is always the focus of attention, and the presentation is crucial. Today there is also an interesting trend toward an "editorial" feeling in catalog work: the clothes are enhanced by a certain mood and atmosphere.

Some assignments are more challenging than others. You have to be good, and you have to be fast. Working on catalogs might not be as glamorous as editorial or advertising photography, rates aren't as high, and credit lines are rarely given. However, you may get consistent bookings from the same client, and often several days and even weeks may be booked at a time. Many fashion photographers think of catalog assignments as bread-and-butter accounts.

WORKING WITH MODELS

What makes a good model? Nature has a great deal to do with it, since the primary prerequisites for a female model are that she be fairly tall and slender and have strong bone structure. She must also have charisma, that indefinable something that makes her interesting and not merely pretty; she must have one of those faces that the camera "loves." Male models must be taller than average because they must be taller than the women they're photographed with. The term *good looking* is more loosely defined when applied to male models. They can look rugged, carry a little extra weight, and don't need to have perfect features.

Some models are good for fashion shots, while others are good for beauty shots. Some models carry garments well and are best suited for full-length fashion layouts; others have perfect features and make their living doing closeup beauty shots. Some models move freely but can't hold a pose for long; others are more static but can strike a pose and stay that way for hours. Models who do catalog work know how to move correctly for this particular type of assignment: unlike other kinds of fashion photography, catalog assignments require static positions that reveal the details of the garments.

I believe that talent is definitely involved. Top models reach the height of their profession because they know how to "turn on" in front of the camera and relate to it on cue. The best models also have personalities that capture the viewer's imagination. Experienced models know how to move. They also know how to deliver a variety of looks and convey a wide range of emotions. They take direction. When you work with an experienced model, you can relax a little and do your job. I've worked with some top models who were so skilled at turning on in front of the camera that I could use almost every frame I shot.

To be successful, models have to be attractive, as well as have a strong presence and striking features. The natural lighting and the shadows it created draw attention to this model's well-defined chest, but his intense, brown eyes are compelling, too.

This model was a pleasure to work with. She is beautiful and dramatic looking, and she is able to strike a variety of poses in spontaneous, fluid motions, making her a successful model.

I photographed this classic design at the Christian Dior showroom in Paris. The model was chosen because her presence and sophisticated look reflected the company's image.

Although this technique contradicts photographic convention, I find it to be one of the most successful ways to enhance a product's appearance. The mellow effect of Old Master light is especially appropriate for decorative objects: the illumination produces a sense of warmth and simplicity. As a result, I thought that it would be ideal for this atmospheric image of a vase and a candleholder.

Having decided on the film for this photograph, I turned my attention to composing the image. I thought the existing composition was perfect because it was stripped of all extraneous elements. As such, I felt that its uncomplicated nature complemented the beautiful quality of the Old Master light. I did, however, like the shape created by the tungsten lamp and deliberately kept it in the frame. This light also accentuated the curve of the vase and highlighted the vase's texture. The long, slender candleholder helped to provide scale, making it the prominent subject. Against the canvas-like background, the painterly light created by the daylight-balanced film reinforced the image's spare but exquisite design.

Experimenting with different lighting techniques—particularly Old Master light—requires patience and precision. With too little light, the image becomes obscure. With too much light, the effect loses delicate tonal value. Be prepared to shoot an entire pack of test Polaroids just to get the light balance correct. However, if there you don't have enough time for Polaroid tests, shooting a tight selection of bracketed exposures is critical.

The Beauty of a Natural Setting

After steadily photographing products in my studio for an extended period, I often feel the need to shoot on location. I've found that breaking out of the predictable studio surroundings and routine is critical from time to time. Because I'm limited to only the bare essentials in terms of equipment, shooting outside the studio sharpens my instincts. In addition, I always seem to come across unusual environments when I travel. While I was on a vacation on Majorca, Spain, the quality of light and the unique aspects of the location inspired me. Throughout the trip, I looked for situations that I could transform into strong images, which I would be able to use for stock sales to travel magazines and book publishers. This sixteenth-century grotto proved to be perfect.

I traveled light as I explored Majorca, equipped with only a shoulder bag filled with Nikon 35mm equipment. As such, I knew that any photograph I made would have to be simple, utilizing existing light and readily available items. Wanting to feature local produce in a natural setting, I asked a longtime family friend for permission to photograph her traditional Majorcan house. With her assistance, I collected the necessary props from her kitchen: a ceramic bowl, a cutting board, a knife, and a wine decanter and glasses. Once we'd assembled these items, we set out for the village to shop at the local market for cheese, fruit, bread, and wine.

Returning to my friend's house, we went directly to the backyard grotto, which provided a beautiful natural setting for a provincial food shot. We poured the wine, sliced the cheese and the figs, and arranged the other fruit. Then I realized that I needed a bridge to match the bottom part of the frame with the top. I glanced around the backyard, looking for something that would enhance the composition. I quickly found the perfect accent. With the addition of some bright purple flowers picked from the footpath leading up to the grotto, I knew that the still life was complete.

Although I could have attempted to re-create this classic grotto in my New York City studio, achieving a comparable combination of natural light and natural setting would have been quite uninspiring. Conceptualizing and executing this photograph created both a pleasant, memorable morning during my Majorcan vacation and an easily marketable image as a generic stock food shot—as I discovered when *Islands* magazine requested the picture.

Using a Nikon F2 camera mounted on a tripod and a Nikkor 24mm lens, I composed a wide-angle image, maximizing depth of field. Photographing at a slow shutter speed enabled me to capture the movement of the water and to create an interesting effect on the floating petals. I shot one roll of Fujichrome 50 film, varying the composition slightly and bracketing the exposure. The most aesthetically pleasing image turned out to be a slow exposure: 1/2 sec. at f/11. When I saw the processed film, I was quite satisfied with its ability to hold highlight detail, as well as its color saturation.

FOOD PHOTOGRAPHY AND STYLING

Photographing food successfully requires special techniques and skills to enhance the way food looks on film. A food stylist's job is to make food look appealing, appetizing, and natural. The stylist must have a good knowledge of food preparation and chemistry and possess a strong sense of visual design. Until recently, most food stylists were home economists. But over the past few years, people with backgrounds in design have introduced a new dimension to the field, bringing a more graphic perspective to the business of creating food for the camera.

Styling food for photography, whether for still shots or television, is meticulous, precise work that demands patience. Though some people think food styling is a glamorous career, it is mentally and physically demanding, and involves hours of intense concentration. Large projects featuring food usually require a professional stylist. Photographers who try to shoot these alone probably don't know enough about the chemistry of food, how different foods react under lights, or what shortcuts exist for preparing food for the camera.

The working relationship between a photographer and a food stylist should be an extremely close one. Photographing food is a team effort, and the photographer is usually the leader. He or she hires the food stylist (although sometimes the photographer's client requests a certain stylist). There must be mutual trust between the photographer and stylist, along with a shared ability to solve problems. In the end, the way the photographer and the stylist work together makes or breaks the shot.

Pouring Techniques

Styling a good "pour" of syrup onto a plate of waffles takes a bit of finesse, so I decided to use my technique to illustrate one of my promotional mailers. Jack Richmond agreed to photograph the piece for me at his studio. I arrived loaded down with my usual gear and an ample supply of packaged waffles, bottles of dark corn syrup, and several pounds of margarine (its color is more photogenic than butter). I immediately put the corn syrup in the refrigerator to thicken it. Making a pour flow evenly is simpler when the syrup is cold.

Richmond put an 80 x 80cm banklight and one spotlight over a white tabletop, creating an ambient glow on the set. After lightly toasting the waffles, I let them reach room temperature and arranged three on a plate. I decided *not* to spray them with acrylic, a common practice in food photography to prevent syrup from soaking into the waffles. Using tweezers, I added a garnish of fresh raspberries and raspberry leaves.

Then I carefully placed pats of margarine on the waffles. With a propane torch, I heated a small spatula and touched it to the margarine pats to melt their edges. You must do this quickly, being careful not to melt too much of the pat.

Richmond used a small 35mm camera, shooting close to the set (left). Although it was a tight shot, he zoomed in and out to get variations in the composition. Meanwhile, I created a nice pattern of syrup on the waffles, pouring slowly to control the flow and not create a puddle (right). We repeated the whole process several times (using new waffles and new margarine pats) to make sure we got a good shot (opposite page).

Shooting Ice Cream

My philosophy about shooting ice cream is to "just scoop it and shoot it," but some stylists use the dry-ice method: scooping several perfect balls and putting them on a tray in a box of dry ice. The problem with this is that the dry ice creates crystals that must be blown off the ice cream with a straw. Still, some stylists really like this method and have the technique down pat. Dry ice must be handled carefully, using gloves. Zeroll ice-cream scoops contain a freezing agent inside the handle. Always keep scoops in bowls filled with pulverized dry ice or in a freezer.

Photographer Carol Kaplan and I shot an ice-cream assignment to illustrate a brochure for a health-care organization. Because the ice cream's role was strictly ornamental (the client wasn't selling ice cream), we were free to use either artificial or real ice cream. The shoot itself took three days, in addition to a day of preparation that included ordering several gallons of real ice cream and renting a soft-serve ice-cream machine for one shot. Only artificial ice cream was used in the setup of nine cones featuring different flavors. Using real ice cream for that shot would have taken many more hands to produce that many scoops at once. This was an intense three-day shoot. We had to cope with long hours and many design problems, such as making the ice cream look natural and appealing, rather than perfect with every ridge intact. But afterward, when we saw the finished photographs, we all agreed that the assignment was worth the stress.

Artificial Ice Cream Step-by-Step

To make a bowl of artificial vanilla ice cream, first you mix a 1-pound box of confectioners' (powdered) sugar and one stick (8 tablespoons) of margarine. Next, you add 1/4 cup of light corn syrup, and knead the mixture with your hands until it is smooth. This recipe can be mixed in a food processor or mixer. It must be kneaded five to seven minutes for proper texture. Its consistency should be fairly firm, and it shouldn't crumble when scooped. If it seems too soft, add more powdered sugar. If you make the "ice cream" in advance, wrap it in plastic and store it in the refrigerator. Take it out the night before you plan to shoot it to allow the mixture to return to room temperature. Be sure to knead it just before using it.

You can even make different flavors of artificial ice cream. For strawberry ice cream, substitute 1/4 cup fresh crushed strawberries for the corn syrup; for chocolate ice cream, substitute 1/4 cup chocolate syrup. To make coffee ice cream, use a browning agent, such as Kitchen Bouquet, to achieve the desired color. And for butter-pecan ice cream, use butterscotch syrup instead of corn syrup, and add nuts.

Because artificial ice cream dries out in several hours, I usually keep it covered with plastic wrap or a damp paper towel during a shoot. When it begins to look dry, replacing it with a new batch is easy. Once a ball is scooped, brushing its ridges with a little corn syrup gives it a slightly melted look that makes it look more realistic.

To photograph this setup of nine ice-cream cones, Kaplan used a 2-foot square banklight with a strobe head set at 900 watts per second. As you can see in this production shot by Carl W. Scarbrough, this main light was positioned about 2 feet from the cones and angled away so that the background—a painted, textured canvas—would go fairly dark. A large fill card on the right opened up the shadows. Black cards, or "cutters," were put in front of the banklight to cast shadows on the background and foreground.

Kaplan pointed out questionable areas on the cones that might need fixing, and I touched up the edges of the artificial ice cream with corn syrup to give them a melting quality. The whole arrangement was fine-tuned and tested with 4 x 5 Polaroids, but the final shot was made with a 35mm camera so that an enlarged image would emphasize the natural graininess of the high-speed Ektachrome she used.

Here, I was in the process of kneading an artificial-ice-cream mixture. When the mixture had a smooth consistency, I shaped it into a ball in preparation for scooping. On the table you can see balls of other artificial ice creams: strawberry, chocolate, butter pecan, and coffee.

BLACK-AND-WHITE PRINTING/DARKROOM TECHNIQUES

GEORGE SCHAUB

SETTING UP A DARKROOM

You might not have wanted to get involved with darkroom work because you think it is difficult to find suitable or adequate space in your home. But if you're truly committed to the idea, you can find a way. All that you really need is a place that you can make light-tight for a few hours and that you can move around in; this space doesn't have to be huge. You can curtain off a small area with dark cloth or partition a basement space to accommodate your needs. Once you expose and process the prints or load the film in a developing tank in the dark, you can carry out the rest of the steps in white light.

If, however, you feel that you can't possibly find enough space in your home, take heart. A little bit of ingenuity—and the cooperation of the people you live with—can do wonders. I once worked in a darkroom that was located in a 6 x 8-foot laundry room attached to the rear of the house. A table top was set up along one wall to hold the enlarger; the washer/dryer was against the opposite wall. When printing, I placed a Formica counter over the washer/dryer to hold my chemical trays. I ran hoses from the in/out lines of the laundry

service. To get the space light-tight, I glued Velcro strips onto wood and nailed the boards into the molding surrounding the door; whenever I worked in the darkroom, I attached black cloths with matching Velcro strips on the edges to the wood. I put an exhaust fan into the wall over the trays and baffled it to keep the room light-safe. I also screwed safelight bulbs into the fixtures. The electricity was handled by the plugs for the washer/dryer. I was able to set up and break down the whole space in just 15 minutes. And while this darkroom would never have won a design award, it did the trick.

In fact, I've seen darkroom setups in basements, under stairs, and even in walk-in closets. And more than one traveling photographer has converted a hotel bathroom into a workable darkroom area. Some darkroom enthusiasts band together and share costs and space. Others find schools, photography studios, or camera stores and rent darkroom space on a part-time basis. Once you put your mind to it, you should be able to locate some sort of space in which to work, even if you have to set up and break down your equipment each time you print. (Of course, it is ideal to be able to leave

This photograph shows the "wet" side of a well-ordered darkroom. Containers filled with liquid chemicals line the shelves above the sink, while storage containers and extra trays sit below it. The deep sink is used for print processing, and the flat countertop is used for film loading and processing. The Gralab timers, which are needed for film and print processing, have display dials that glow in the dark. This is an almost ideal setup for a home darkroom. (Photograph © Steve Rosenbaum)

your darkroom equipment in place; this saves time and ensures that your enlarger will remain stable and aligned.)

A darkroom setup can be as elaborate and costly or as simple and spare as your budget and printmaking needs demand. While you can spend quite a bit of money for state-of-the-art, computerized equipment, a considerably smaller investment can get you started with basic pieces that will last for many years. You can also pick up used equipment from individuals and photo dealers. If, however, you buy a used enlarger and/or lens, make sure that they are up to par. You can also purchase starter kits, many of which are designed for beginners. You can apply the same approach to paper and chemicals. You can start out working with *variable-contrast* (VC), *resin-coated* (RC) papers that are quite convenient in the home darkroom; their plastic base dries flat and fast and eliminates the need for long washing cycles. Later on, you can get involved with *fiber-based* (FB) papers. Chemicals now come in kit form as well, and liquid concentrates have largely replaced powders. These innovations make mixing and storage simple. In fact, the entire field has grown to the point where price, convenience, and ease of use make getting started less complex than ever before.

The fundamental requirements for a darkroom aren't complicated. Also, they don't take up much room, and you can set up and break down a lot of the equipment with little fuss. A darkroom should: have, or be near, running water and a drain; have electrical outlets and counter space; have some form of ventilation; and be light-tight. All photographic films and papers are white-light sensitive. Stray light causes them to *fog* (darken) or obliterates all the information recorded on them. Keep in mind, though, that other printing papers aren't affected by some wavelengths, so you can use them in certain color lights without the risk of fogging them. Amber is the most common safelight. You can check how light-tight your workspace is by closing the door, turning off all the lights, and sitting in the room a few minutes. As your pupils dilate, you'll begin to see any cracks or

pinholes that allow light to enter the darkroom. Plug these up with cloth, black paper, or opaque photographic tape.

If possible, you should also be able to enter and leave the darkroom without letting white light in from the outside. While a light-trap entrance, unfortunately, is often a luxury, it can save you the bother of securing all your paper each time you want to take a break or view prints in white light. Light traps can be double doors, curved or angled passageways painted black, or simply black-cloth curtains. Be sure to use the sitting-in-the-dark test to check for light leaks in the light-trap entrance you set up.

You'll also need running water in or near your darkroom in order to mix chemicals and to wash developed film and prints. Although it is, of course, more convenient when water is available right in the darkroom, I've worked in many spaces with a sink or even a bathtub a few steps away. You'll be using

Basic darkroom kits are available at a reasonable price from a number of manufacturers. This selection includes chemical-storage bottles, beakers, funnels, tray tongs, a squeegee, and paper. (Courtesy: Charles Beseler Company)

This darkroom sink, which is set up for black-and-white-print processing, contains three trays, one each for the developer, the stop bath, and the fixer bath. A fourth tray for the initial water bath is partially seen in the foreground. A large tank filled with a washing aid is shown in the upper left of the picture, and a vertical print washer used for the final wash is shown in the upper right.

P

Pl
re
of
tr
kr
O
fl
or
in
pa

Po
Al
sil
de
th
di
FE
su
H
sh
pa
th
ha
Ar
of
pa
po

se
In
hig
ge
to
Th
wo
ha
ac
ha

(r
pri
16
se
wo
we
an
for
8 x
we
an
do
st
ex

variety of papers with warm and cold tones. You'll be startled by the extent that the image color affects the subject matter. The decision to print a certain image on a certain tone paper is subjective and is best made when all the possibilities are known. But limiting yourself to one type of paper is like taking only one type of picture; it eventually cramps not only your style, but also your ability to be expressive.

As you work with various papers, you'll detect a difference in the way they respond to exposure and developing procedures. You regulate print exposure with a combination of the enlarger lens' aperture setting and the amount of exposure time. The duration of the light is set by the timer; this has the same effect as a shutter on a camera. However, most modern enlargers don't work with a shutter mechanism as such; the turning on and off of the enlarger lamp sets the "shutter" speed.

Exposure works in a logical fashion with moderate printing times. For example, an exposure of 10 seconds with an aperture of *f*/8 is more or less equivalent to a setting of *f*/11 at 20 seconds. You might want to use these equivalents when working with *dense* (overexposed) or *thin* (underexposed) negatives. Suppose that you test a dense negative and find that exposure is as long as 60 seconds (at *f*/11). In order to shorten that exposure time, you can work with an equivalent exposure of *f*/8 for 30 seconds. This follows the same rules of camera exposure, in which aperture and shutter speed can be adjusted in a similar fashion. Like film, many printing papers are subject to a *reciprocity effect*. Here, juggling aperture and shutter speed when you're working with very long or extremely short exposures might not follow this logical pattern. So be sure to check your paper's instruction sheet for the exposure times in which this takes place, and adjust exposures accordingly.

The speed of a paper might vary from contrast grade to contrast grade. For example, some VC papers might require a 10-second exposure on #2 grade and a 15-second exposure to get an equivalent print density through a #4 grade filter. Usually, the speed break occurs at about #3½ or #4 grade, but this can vary from brand to brand. #0 through #3½ grades take the same exposure, while higher grades might require from one to two stops more for an equivalent print density. Many graded papers work the same way, with paper of the same brand and emulsion stock having similar speeds for the lower grades and requiring longer exposures for the higher grades. Keep in mind that this varies from paper to paper, and that some of the newest papers eliminate this bothersome change. Check the instructions packed with the paper.

Papers also vary in exposure latitude; some are more critical than others. In some cases, you can be slightly off on the exposure time and provide extra development to get the density you want; other papers won't be so tolerant. Similarly, some papers can take extended development times—that is, beyond the recommended 2 minutes—while others don't change over time and will even begin to show a chemical fog if left in the developer too long.

Both the developer you use and the dilution of the solution itself can affect your results. In brief, you can alter contrast slightly by using a stronger or weaker dilution of developer solution, you can change print color slightly by using a hot or cold developer, or you can change the image color noticeably by using a different developer entirely. *Soft* developers enable you to decrease contrast by half a grade or more; these developers can also be used in conjunction with a *normal* developer for a split-development technique that can pull every bit of tonal gradation out of the paper.

When printed on a #2 grade paper, this image displays a good tonal range and echoes the values that appeared in the original scene (top). However, the higher-contrast rendition, which I printed on a #5 paper, gives the image more punch (bottom). In many cases, you should choose a contrast grade based on which one best serves the image rather than on any prescribed notion of matching the contrast grade to the negative.

GEORGE SCHAUB

PROCESSING BLACK-AND-WHITE FILM

There is no point in getting involved with your own printing unless you—or a very trusted lab—handle your negative developing. Too much rides on the results of your work for you to leave processing in the hands of a standard photofinisher or drugstore. If you have any doubts about this, try an experiment. Send a few rolls of the same scene to a number of different labs. I guarantee that you'll be astonished at the variations in density, cleanliness, and overall printability.

The processing instruction sheet packed with film tells you to develop for, suppose, 8 minutes at 68°F. The instructions outline an agitation schedule and advise on adjusting times for variations in temperature. While your following these instructions should yield printable negatives, they don't necessarily result in optimum negatives for every individual. In some cases, the times and temperatures given are an average, and only through testing can you arrive at what is most appropriate for you. In fact, you might have to modify your developing technique in order to achieve the most printable negatives for your style of printing.

The first step in gaining control over your negatives is knowing the look of the negative you want to produce. Some printers like dense negatives, which are slightly overdeveloped and/or overexposed; others prefer thin negatives, which are slightly underexposed and/or underdeveloped. This partiality is based on a number of factors, including the type of light source a darkroom worker prints with. Generally, those printing with a condenser-type head prefer slightly thinner negatives, while those who work with a cold-light head prefer denser negatives. These preferences are valid, but they are too often subjective and can't be quantified or qualified by graphs and charts. The point is to be able to reach your goal consistently and to be able to produce

the kind of negative you want without having to resort to luck. Start with the basics, and get your procedures down cold. Once you accomplish this, you can begin to make subtle alterations in your prints as needed.

A good way to introduce yourself to how exposure and development affect results is to run a series of tests. Shoot the same scene with three rolls of different conventional films, such as Tri-X, HP-5 Plus, or Agfapan 400. Bracket exposures two stops higher and lower than your averaged reading on each roll. For example, suppose the reading is $f/8$ for 1/125 sec. A bracketed sequence for this reading would be $f/4$, $f/5.6$, $f/8$, $f/11$ and $f/16$, all for 1/125 sec. Develop the first roll of film for the recommended time, the second roll at about 20 percent less than the recommended time, and the third roll at about 30 percent more than the recommended time.

Next, make *contact sheets*, and study the negatives. This test will give you a reference catalog of all the variables and how they affect results. It will also help you trace mistakes in the future. You'll see negatives that are: overexposed and overdeveloped, overexposed and underdeveloped, underexposed and overdeveloped, underexposed and underdeveloped, and normally exposed and developed. You might also want to make study prints of the various types of negatives and see how tonal reproduction and contrast are affected by exposure and processing. Testing in this manner can be a revelation.

As discussed earlier, proper exposure and development yield easily printable negatives. They also provide you with the most leeway in making a wide range of interpretive printing decisions. Of course, at times you might have to print a problem negative. There are ways to handle these problems. The next step is to start printing, beginning with contact sheets, or proof sheets, of the negatives.

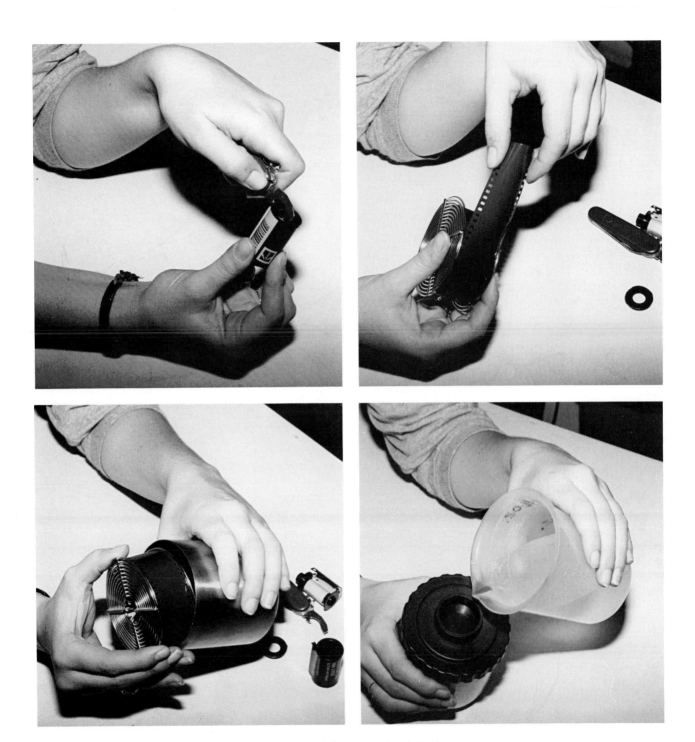

The first step in 35mm film processing is getting the film out of the cassette (top left). Use a bottle opener to pry off the end cap—in total darkness, of course. After you get the film out of the cassette, cut the film from the plastic retainer. Next, cut a half-moon shape in the leader, hold the rolled-up film in one hand, and begin to load it onto the reel (top right). Once you have the film on the reel, place it inside the film tank and cover the tank with the lid (bottom left). At this point, you can carry out the other processing steps in ordinary room light. Film-tank lids have both a lip that enables you to add and drain solutions in normal room light and a cover. Next, the developer is added to the tank (bottom right). After you add the solutions, replace the cover, and then follow the time and agitation procedure. After the developer step, drain the solution and proceed to the short-stop and fixer baths, and washing.

MAKING CONTACT SHEETS

Once you've developed and dried your film, you'll probably be eager to see the results. When you've gained enough experience, you can "read" the negatives by holding them up to the light or placing them down on a lightbox and viewing each frame through a loupe. But even experienced photographers prefer to see a contact sheet, or proof sheet, of their shoot right away. A contact sheet is a print of the entire roll of film. It shows you a positive image of the negative that you can use to check composition, subject matter, and, to a certain extent, the range of tones you've captured on film. Generally, the contact is made on sheets of 8 x 10 paper; an entire roll of 36-exposure 35mm film can take up two sheets. For 35mm negatives, cut the roll of film into six equal strips of six exposures each.

Materials Needed

In order to make a contact print, you'll need, of course, a *contact-printing frame*. This is made of a piece of glass hinged to a printing platform, which is usually covered with a foam or semi-soft support. Some contact-printing frames also come with a latch that, when closed, makes a snug fit of the negative/paper/glass sandwich. These latches are essential if the glass is lightweight because a poor fit might cause an unsharp print resulting from poor contact between the negatives and paper. You can easily build a contact-printing frame; just be sure that the edges of the glass are sanded down or heavily taped.

Before you can process the exposed prints, you'll have to prepare your chemistry. Set up four trays; these can be 8 x 10, 11 x 14, or whatever size you use. The first tray receives the print developer. If you haven't already done so, mix a working solution by following the instructions on the package. The second tray holds the short stop or the water bath. The third tray holds the fixing bath. The last tray contains water with a circulating washer; you might also want to use a wash-aid and a final wash for quicker processing times if you're printing on FB paper. Once you set up the trays, turn out the white lights and turn on the enlarger and safelights.

Contact prints can be made on either FB or RC paper stock. Many people find the RC papers satisfactory since they offer quick turnaround in processing, washing, and drying. In truth, there is little advantage in making contact proofs on FB papers. You can also make enlarged proof sheets, a projection printing setup in which the negatives are placed in a glass negative carrier and enlarged on one sheet of, for example, 11 x 14 paper. To do this properly without cutting the 35mm negatives into very small snippets, you'll need a 4 x 5 enlarger; cut the film in strips of three and put three strips in a glass carrier and enlarge. Custom labs often offer this processing service.

You'll probably want to make your contact sheets on a "normal" contrast grade of paper, such as a #2 grade. Why print on a #2 grade? In order to check the tonal values,

you'll want to print on a normal grade #2 paper, one that displays the entire range of what the negative has to offer. Printing on a higher grade compresses the scale somewhat, while a lower grade might not display the full richness of your images. You'll find that higher deviations from the norm, such as #0 and #4 grades, yield a more radical rendition altogether.

However, even though you print on a normal grade of paper and get pretty close to the optimum printing time for an individual frame, the contact sheet serves only as an indication of the potential of an image. As such, it is a starting point for your considerations of what you can do in making the final print. It also serves as a record of your shooting, one that should be stored along with your negatives in your files.

The Step-By-Step Procedure

Making a contact print is easy. First, place the contact-printing frame under the enlarger. Then put a negative carrier in the enlarger, turn on the focusing light, and raise the enlarger until the entire frame is covered with light. Don't focus the light because any specks of dust or lint on the condenser glass will probably show up in the print. When that is set, turn off the light and place an 8 x 10 sheet of paper emulsion side up (with glossy paper, the shiny side; with matte paper, the side that curls inward or, if the paper is flat, the side that is cooler to the touch) onto the base of the opened frame. Place the negatives in number order (strip 1 through 6 on top, then 7 through 12, and so forth) onto the paper emulsion side down. When the negatives are in place, carefully close the glass cover and latch the sandwich into place.

One problem with this procedure is that when you encounter negatives with excessive curl, you place them down and they curl right back up, throwing off your attempt to put them neatly onto one sheet of paper. This often happens with thin-emulsion negatives and those that weren't dried with a weighted clip at the bottom. It can also occur if negatives weren't cut and stored in file sheets immediately after processing.

There are a number of solutions to this problem. One is to raise the glass slightly and slide the negatives in, allowing the back of the glass to catch and hold the strip upon insertion. This cumbersome process can lead to scratching if you aren't very careful. However, experience will show you that it does indeed work. Another solution is to keep the negatives in the plastic file holder and contact-print them right through it. Of course, this will cause some unsharpness in the proof sheet because you're keeping the negatives from coming into direct contact with the printing paper. However, this can be preferable to pushing and pulling the delicate negatives into the frame.

Another alternative is to purchase a contact-printing frame with retaining bands that hold individual negative

strips. Ribbed frames are available for 35mm film; however, some reduce by one the number of strips you can place in the frame. Whatever solution is best for you, keep in mind that regardless of how carefully you process and file negatives, you'll have some curl in freshly processed film.

The amount of exposure you give a contact print depends on the density of the negatives, the speed of the printing paper, and the output of your enlarger's light source. Because you aren't projection printing, the exposure time will usually be shorter than that needed for making enlargements. Suppose you make an exposure with an *f*/5.6 aperture on your enlarging lens. Contact printing exposure time on a relatively fast paper can run from 1 to 10 seconds. How do you determine the exact printing time? Make a *test print*. Once you have the sandwich in place, set the lens to *f*/5.6 and cover the entire frame with a piece of opaque cardboard. Set your timer to 2 seconds, uncover one-fifth of the frame, and expose. Then uncover the next fifth, and expose for the same interval; do the same with the entire frame uncovered.

Once you process your print, you'll see the effect of 2-, 4-, 6-, 8- and 10-second exposure times. If the print needs more exposure, it will be light and lack full image information; if it comes up too quickly in the developer and is too dark when processing is complete, it requires less exposure time. Check to see which portion yields the best results, with full picture information, and expose an entire new sheet accordingly. With experience and by using the same paper for contacts, you'll be able to estimate the best contact printing times just by looking at the negatives.

However, negatives on the same roll of film made at different times under different lighting conditions might have quite different densities, thereby requiring different exposures for best results. This is quite common with 35mm rolls of film, especially when the photographer's metering isn't exactly accurate. If this happens, make two contact sheets, one at a longer and the other at a shorter exposure time. Doing this will help you get a better "read" of the entire roll of film.

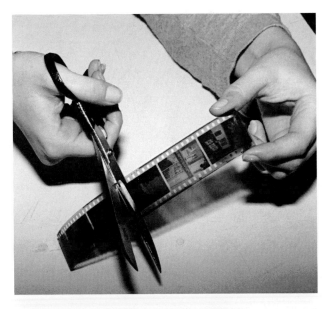

After the negatives are dry, cut them into strips of four, five, or six frames (top). The number of frames depends on the film format and the type of storage sleeve and contact print you want to make. The space between frames can be narrow, so be sure to cut carefully. Doing this over a lightbox can help you see the cut line better. To make a contact sheet, lay the negative strips emulsion side down onto your printing paper, which should be emulsion side up (bottom). Once you line up the negatives, lower the glass; this presses the negatives firmly against the paper, ensuring sharp images.

PRINT PROCESSING STEP-BY-STEP

Processing black-and-white papers is relatively simple. There are three basic steps—the *development bath*, the *stop bath*, and the *fixer bath*—followed by washing, wash-aids, and, for certain prints, an additional step that increases the long-term stability of FB papers. Printing paper holds an emulsion that contains light-sensitive, silver-halide crystals. When they're exposed to light, a latent image forms. The first step of the printing process, development, converts this invisible image to a visible one in the form of metallic silver.

To develop a print, immerse the exposed paper in the development bath, and then rock the tray so that the print is fully soaked with solution. Although the image might begin to appear quickly, be sure to wait at least 2 minutes for FB papers and 1 minute for RC papers before removing the print from the tray. Rock the tray from time to time throughout the cycle to keep fresh solution in contact with the print. After the elapsed time, pick up the print by the edge with tongs, and then allow the solution to completely drain off it into the developing bath. Next, bring the print over to the stop bath, making sure that the tongs you used to take it out of the developer don't touch the stop solution. Failure to do this will result in the contamination of the developer bath.

Again, rock the tray so that the stop solution covers the print. Leave FB prints in the solution for about 30 seconds; RC prints usually finish in about 15 seconds. Lift the print out of the solution with another pair of tongs, allow it to drain, and then move it over to the fixing bath. Immerse the print in the fixer solution, and keep it in motion. In a conventional fixing bath, time the print for about 5 minutes for FB papers and about 1 minute for RC papers. In a rapid fix, you can decrease the time to about 3 minutes for FB paper and 30 seconds for RC papers.

You must then wash the print thoroughly to remove the fixer. To conserve water and cut down on the wash time, first give the print a preliminary washing. Next, immerse it in a wash-aid, which is also known as a *hypo clearing solution*. This can cut down the total wash by as much as 75 percent with FB papers. After this bath, continue to wash and then dry the print. If you're working with FB paper and you want to make it more permanent, you then treat it in a *toning bath*. This converts or coats with the metallic silver to create a more stable form. The most common chemical used in this process is a selenium toner, although sepia, brown, or other toners work just as well.

The total time for FB prints runs about an hour. Of course, you'll probably be doing more than one print at a time. For RC prints, you can have a finished product in as few as 10 minutes, primarily because these papers are made for rapid turnaround time. Also, using certain fixing baths can cut down the length of time needed for the third step by as much as half or more.

Processing Steps for Black-and-White Prints

	FB Papers	RC Papers
Develop	1–3 min.	1–2 min.
Stop Bath	30 sec.	10–15 sec.
Fix*	5–10 min.	30 sec.–2 min.
Wash	5 min.	NA
Wash-Aid	5 min.	NA
Wash	20 min.	4 min.
Selenium Toning**	2–3 min.	NA
Wash	15 min.	NA
Dry Down	Depends on system used	

The fixing time can be shortened with the use of a rapid fixer.

**Selenium toner can be added to the wash-aid step. This eliminates the need for separate toner and final-wash steps.*

Print Chemicals

There are some basic rules to keep in mind when you work with print developers. Although they are generally more forgiving than film developers in terms of time and temperature (a few degrees off in film developing can have a profound effect on results), you still must work within certain guidelines. Every chemical reaction has an optimum temperature range; for print chemicals, this is between 65°F and 75°F. The optimum developing temperature is 68°F. If you work at much colder temperatures than these, the process will be slow at best, and you'll rarely get richness in your prints. Solutions higher than 75°F might damage the delicate print emulsion, particularly if you have a number of prints in the tray at one time.

Also, if your darkroom is colder than the recommended temperatures, you might want to use a *water-jacket* system during winter months, placing your trays inside larger trays or in a sink with warmer water. If your solutions are on the warm side, put a seal-top bag with ice in the tray temporarily; this will bring it down to the right temperature.

If you mix the developer from powder according to packaged instructions, you have what is known as a *stock solution.* You then add a certain amount of water in order to create a *working solution,* the solution that goes into the tray. The amount of dilution from stock is expressed in a ratio, such as 1:2, 1:4, and so forth, with 1:2 meaning one part stock solution of developer to two parts water. If you mix more developer than you'll use in one printing session, you should store the stock solution in a stoppered, opaque

bottle. When you are ready to print, you then make a working solution, or dilution. Don't store working solutions because they'll oxidize and lose effectiveness more readily than a stock solution. Most liquid developers are in "stock" concentrates. You just add water according to directions.

You can vary the dilution of the working solution to control both the rate of development and the print contrast. A highly dilute developer works more slowly than a concentrated one. Higher concentrations produce more contrasty results. If you follow the recommendations for dilutions in the manufacturer's spec sheets, you won't be far off; modify the specs as you deem necessary, but keep in mind that too much dilution makes for a slow and weak developer. In fact, some developers enable you to modify contrast through dilution; however, I find that it is best to make contrast-grade changes via the paper, not the developer.

Developing time varies with the type of paper you use. For RC papers, you should develop between 1 and 2 minutes, even though you might see what looks like a finished print before that time. If an RC print still looks

pale after 90 seconds, increasing development won't do anything; you should give the next one more exposure time. This is also true for FB prints, but with these the developing time should be at least 2 minutes. After that length of time, you'll know what you've got, but you can leave the paper in the developer another minute or so to bring it along even further. Changes won't be dramatic after that time, but the little extra developing time might just give the paper the touch it needs, particularly in the *highlight* (near-white) areas. But be careful not to leave a print in too long because it will fog. Conversely, if the print comes up too quickly in the developer and you see it going too dark, you can't save it by pulling it out of the developer before it is done. This will result in mottled blacks and a weak, muddy appearance in the print.

Developing solutions weaken as you use them. You'll know this has happened when prints develop very slowly or when a thin layer of silt deposit begins to form at the bottom of the tray. The number of prints this takes depends on both the amount of the developer and the dilution and type of print developer you're using.

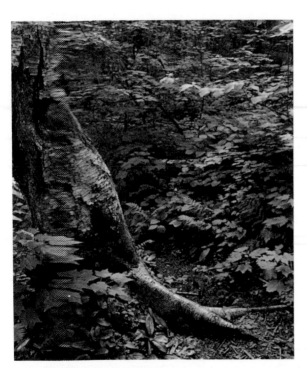

Just as a self-made negative catalog can help you identify negative types, a print diary that illustrates various paper/developer combinations and printing techniques can come in handy when you decide what to use for a particular image. I often use this image of a tree in a forest when I test a new paper or paper/developer combination. I used a #3 neutral-to-cold-tone paper and Dektol mixed 1:2 for this image (left). The result is a bit hard, but it has good blacks and a feeling of crispness. For another version of this image, I used a #1 matte paper and Dektol mixed 1:1 (right). This print has some extra snap from the concentrated developer, which can be good for a low-key image.

ORGANIZING A PICTURE FILE

Before you even think about submitting work to buyers, you'll have to begin at square one and organize, edit, evaluate, caption, and generally prepare your inventory. This will necessarily be an ongoing effort, perhaps more fully realized as you begin to sell, but in any case you'll have to get at least half of your top photographs ready for the market before you begin any serious push.

Assessing Your Filing Needs

A filing system should fulfill a number of tasks: it must provide for easy entry of material; it should make the retrieval of specific slides effortless, be flexible enough to handle cross-referencing; have a specific place for each image; and provide for the safe storage of fragile photographic materials. While you file, a severe and highly self-critical editing process must take place. And somewhere within all this, each and every slide must be stamped with a copyright notice and captioned with pertinent information about the picture itself.

First, figure out a rough organizational plan, one that starts you on the road toward separating subject matter. Prepare a workspace—a large table, for example, with all sides open to the room—and scan the photographs you feel are marketable. You may already have them organized in a loose file, such as by trip, by year, or in other general categories. As you look through your slides, jot down all the topics that come up, and then place those topics in alphabetic order. An initial list might read: "Animals," "Arcades," "Battleships," "Colorado," and so forth.

Take a look at the final list and ask yourself the following questions. Will this setup help me find a slide, a specific slide, if I have to locate it in 10 minutes? Does the list give a good indication of what I have to offer? Is every category on the list strong enough to warrant its own section? Those groups that satisfy these requirements should be retained. Those that don't might be better off absorbed into another topic for the time being. The point is that your filing setup must respond to the type of logic you would use to track down an image. Filing is a very personal matter, and everyone works on a different principle of association. The whole idea is to be familiar with the keys that open the various image doors in your own mind.

Labeling and Cross-Referencing Slide Pages

Placing transparencies in titled pages is next in the series of filing-system tasks. Your own sense of order will dictate how you'll handle this, but here is a suggestion based on some experience. Select as many pages as you have headings on your list and place a 2 x 2-inch piece of white paper with the subject name written on it in the upper-right corner pocket. Alphabetize the file pages and stand them up in a box, and then place the box close to your light table or viewing area. As you take slides out of their present containers, place them under the appropriate

headings in the page pockets. Do this until a subject page is filled, and then place an empty sleeve behind the filled page and proceed as before.

Depending on the number of slides you have to file and the total subject headings, this process can take days or weeks, so be patient. Don't edit too tightly at this time, but do eliminate extremely under- and overexposed shots, or those that have another obvious technical flaw. Put all duplicates, acceptable bracketed exposures, and variations on a theme into the pages.

More complete editing comes later—at this point, just concentrate on getting all your images into the easy-to-view pages. If you come across material that didn't show up in your initial scan and for which you have no file heading, either make up a new subject page (and add the heading to your list) or put it aside for later consideration.

A number of roadblocks may slow your progress. Inevitably, you'll come across slides that you can't easily categorize, as well as some that you could easily place under more than one subject heading. Suppose you have distinct subject headings for "Boating" and "Docks and Harbors," and you encounter a picture of a pleasure boat moored next to some colorful fishing nets. This type of shot will require a judgment call on your part. Base the decision on your instincts as to which categorization will most readily lead you to the picture in your files.

If it is six of one, half a dozen of the other, place the slide in either subject file and begin to fashion a cross-reference list on what will become your "Master File Reference." This is essentially a "see also" list. Suppose you have slides of Buddhist monks in the courtyard of a temple in Thailand. You have file headings under "Thailand," "Religion," and "Houses of Worship," and for ease of finding you decide to place the slide under "Thailand." In your Master Reference List you would now note: "Religion": see also "Thailand," and "Houses of Worship": see also "Thailand." Do this for every possible placement conflict as you encounter it, but take care not to get too obscure in your cross-referencing. Hone in on only those subject listings that will help you find a slide when you need it. You don't have to cross-reference every object or possible clue in a picture.

Some pictures won't fit into any specific category. These usually include "art" shots, abstractions, and nature scenics that don't reveal any particular time or place. While this subject matter is usually more difficult to market than more pointed images, you might as well file these slides under catch-all subject headings, such as "Color and Design," "Nature Scenics," "Trees," and so forth.

As you get more involved with the stock-photography market, you may have to come up with some headings that probably come as a surprise. These might include such topics as "Transactions," "Emotions," "Blue," "Patriotism," "Parallel Lines," and other more abstract notions of what defines what is going on in the picture.

CAPTIONS, CODES, AND COPYRIGHTS

The next step in preparing your slides for the stock-photography market involves the lengthy and time-consuming task of captioning. According to people from all areas of the photography-buying field—editors, art directors, publishers, and stock-agency personnel—an informative caption can increase the salability of a photograph by 100 percent! In addition to this very good reason to caption your slides, most stock agencies and editorial buyers won't even consider pictures without caption information. If you fail to caption upon submission, you'll probably get a call from the potential buyer for the information anyway, so save everyone time and money and write captions before you offer your pictures for sale.

Captions should go right on the slide mount. You can supply separate sheets with supplementary information, but primary captions are most easily read when they sit right along with the picture. Obviously there isn't a great deal of space to work with in the confines of a 1/2 x 2-inch piece of cardboard or plastic, so being concise is very important.

If you have neat handwriting, you can write directly on the mount, but there is always the danger of the pen slipping or of your running into the classic "plan ahead" problem. The best method is to use peel-and-press labels, available from commercial stationery stores, upon which you can write or type as you see fit. Available on long rolls or sheets, these labels can be run through a standard typewriter, giving you an opportunity to type two or three single-space lines of about 20 characters each. Computer programs for captioning are also available, and depending on the typeface you can usually get more information on these than on typewritten labels. With either setup, you should have enough space for the information you need to communicate.

Captions should answer as many of the who—what—where—when questions that apply. Generally, the first line or word of the caption should match that of your file heading; the remainder of the caption can then be used for specific information. Having a caption that merely states, for example, that the photograph was made in Mexico City isn't enough to add to its value through words. When composing captions, you must assume that the buyer has no idea what the shot represents, and that it is your duty to pinpoint information that will increase the possible field of coverage of the picture and, therefore, the likelihood of sales in a number of different venues.

Jot Down Captions as You Shoot

Good captioning practice begins with taking notes in the field. While shooting, keep a small notebook or cassette recorder with you and jot down or record as much detail as you can about the area, objects, and people you're photographing. If the locale has a chamber of commerce or tourist information office, pick up all the maps, brochures, and descriptive material you can carry. These will become aids in jogging your memory when it comes time to caption processed film.

Common-Sense Abbreviations

Abbreviations are certainly helpful in the limited space afforded by a slide mount, but your shorthand should be understandable. Don't make up your own lingo—you may know what you mean, or may feel that everyone across the country knows local expressions. Buyers, however, might be left scratching their heads in wonder when confronted with one of your captions, and this certainly won't help sales.

An understandable caption of a shot taken in the Luxembourg Gardens in Paris on Bastille Day in 1992 might read: "Paris, Fr., Luxembourg Gdns., Bastille Day., '92." An incomprehensible caption such as "G.O.B. w/bru @ Sm. B. Pic., Gv., T.91." might make perfect sense to the caption writer as: "Good Old Boys having a beer at the Sam Bowie Picnic in Galveston, Texas, 1991," but it won't get through at all to most picture buyers.

Caption as soon as possible after the shoot. Double-check your information on specific, and unfamiliar, pictures. A miscaptioned slide can cause embarrassment to a picture editor and result in the loss of a client for you. No one wants to appear foolish, especially when they are on the staff of a high-circulation magazine. If they feel that your captions are suspect, they'll hesitate to buy from you; it is as simple as that.

The Model-Release and Copyright Notations

Another piece of information that should be placed on the mount, although it has nothing to do with where or when the picture was made, is a model-release notation. This is very important in many markets, particularly advertising. These notations, which should go in the upper-right-hand corner of the slide mount, include "MR" (model release available), "NMR" (no model release available), "PR" (property release available) and "NPR" (no property release available).

These marks will tell a buyer that there are certain markets in which the picture can and can't be used. Photographs of people for which you have model releases are certainly easier to sell than those without such a release, and most advertising firms won't even look at people pictures that lack a release. But if you don't have a notation on the slide, the buyer will have to call you back for the information or might assume that you don't have a release. Save both yourself and the buyer time by making sure you include these small notes on the mount. If, however, the shot is a "generic" one, such as of the Taj Mahal, no release information is necessary.

A very important piece of information that you must put on the mount is a copyright notice. This should read:
© (Your full name), 19___.
ALL RIGHTS RESERVED.

This not only identifies the slide as yours, but also serves notice that you are the owner of all rights on the picture, and that only you can assign and lease usage of that image. Without that notice, you put every slide you send out in jeopardy. With that notice, you provide legal protection for yourself and the image. You can use a simple rubber stamp to mark slide mounts with the copyright line. Don't let a slide leave your files without it.

Encoding Slides for Quick Identification

Another optional, though important, caption is a slide-numbering, or encoding, system that will enable you to identify and locate each individual picture in your files. A number or letter-number encoding system accomplishes many things.

1. It assigns a definite place in your files for each and every picture, a slot in which the slide resides and returns after submissions. This is a great help in refiling.
2. It gives you a reference number to use for invoices, rather than a blow-by-blow description of every picture you send out. An efficient code makes transactions simpler.
3. It makes cross-referencing specific to certain images, rather than to a broader topic listing. You can make your "see also" list with coded numbers within even major files.
4. This setup makes the logging-in of new material easier.

A system that works with numbers can give you a specific count as to how many pictures are in a certain file, and then can be expanded just by adding more numbers to the slides as they're logged in. So your last slide in a file gives you the total count under that topic.

The only real disadvantage to starting an encoding system for your slides is the extra labor involved in getting it going. Although no absolute quantity can be given as a cutoff point, a file of 5,000 (or fewer) slides may not require encoding. With a relatively small library like this, simple visual inspection (coupled with topic headings and a cross-reference sheet) helps you locate a slide readily enough. However, larger collections opf slides certainly will benefit from setting up a coded system.

You can make the system versatile enough to include keyed information about the subject matter of the slide being coded. It can also be a "cold" numbering system. The first type of encoding requires more work, but in the long run it is probably more useful. Suppose you're encoding your "New Mexico" file, and decide on "NM" as the file abbreviation-prefix. Each slide in the group thus becomes: NM1, NM2, NM3, etc. To give even more precise information, expand the prefix with specific information within the topic, such as: NMSF1 (New Mexico, Sante Fe, #1) or NMCC2 (New Mexico, Carlsbad Caverns, #2), and so forth. Each time you assign a prefix, note it on a separate sheet of paper and be sure not to duplicate your prefixes in any other part of your slidefiles.

With this setup, each time you add a slide to the file, you merely add another number to the series. This setup has the attraction of making each slide a unique unit, and it makes refiling and billing easier. But it does mean a lot of initial work and continuing work as long as you keep logging in pictures.

Another slide-tracking system used by many photographers is one in which each slide is assigned an arbitrary although unique number. You can work with the date on which the picture was made (6-21-92-3 would indicate the third slide filed or shot on June 21, 1992) or with any number from zero to infinity. This setup is attractive because you can get numbers from sequential numbering stamps available in stationery stores or from twin-check labels used in large photofinishing plants.

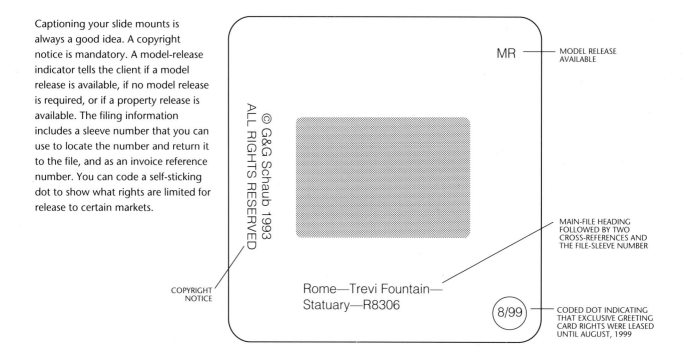

Captioning your slide mounts is always a good idea. A copyright notice is mandatory. A model-release indicator tells the client if a model release is available, if no model release is required, or if a property release is available. The filing information includes a sleeve number that you can use to locate the number and return it to the file, and as an invoice reference number. You can code a self-sticking dot to show what rights are limited for release to certain markets.

© G&G Schaub 1993
ALL RIGHTS RESERVED

COPYRIGHT NOTICE

Rome—Trevi Fountain—Statuary—R8306

8/99

MR — MODEL RELEASE AVAILABLE

MAIN-FILE HEADING FOLLOWED BY TWO CROSS-REFERENCES AND THE FILE-SLEEVE NUMBER

CODED DOT INDICATING THAT EXCLUSIVE GREETING CARD RIGHTS WERE LEASED UNTIL AUGUST, 1999

GEORGE SCHAUB

A MASTER LIST FOR BUYERS

During the filing, editing, and cross-referencing procedures, you should make a list of section headings. This is an ongoing job, and each new file you create should, of course, be included.

At one point, usually immediately before you make your first forays into the stock-photography marketplace, you should sit down and prepare a master list of all the subjects that you'll be offering to buyers. You can prepare this "master list" in any number of ways, including simple alphabetical listings, grouped listings, or listings geared to a particular market segment. Having this list available for potential buyers will improve any sales effort.

Not every client you deal with will benefit from receiving your master list, but magazine editors, textbook publishers, features syndicates, and advertising agencies will often demand such a list before they consider you as a source for pictures. Here are some lists you might consider making of your stock file.

The Alphabetical Listing

The alphabetical listing is just that—it shows every major topic in your files. You might want to aid buyers by indicating areas you have extensive coverage of by putting an asterisk next to the file name or by using boldface type. This should be typeset on a letterhead or a business form bearing your name and address. Don't print hundreds of master lists the first time out; simply make just enough copies to cover your initial mailings, and then update the list every six months or so as you add new topics to your files.

Group-heading lists help buyers focus directly on their needs. Rather than having your "Country" coverage, for example, spread throughout an entire alphabetical listing, you can have a major listing "Countries," below which you specify such entries as "Armenia," "Brazil," "France," or "Germany." You can apply this approach to any other select listings you have extensive coverage of. For example, under "Fishing" you might list "Boat," "Commercial," "Fly," "Pier," "Trout," etc.; under "Cities" you can show "Atlanta," "Boston," "Chicago," and so on.

An even more specific way to show what you have to offer buyers is to prepare separate lists for very select markets. Travel markets, for example, will need to know more than that you have coverage of a certain country or city; they'll want to know festivals, areas of the town or country people, and seasons in which you have pictures of a certain place. Such a detailed list is helpful because it serves as a way for buyers to pinpoint you quickly as a picture source.

Rather than merely naming, for example, "Paris," you might list all the sights in the city under that main heading: "Eiffel Tower," "Les Halles," "Montmartre," "Notre Dame," etc. This specificity may make a difference in who the buyer picks up the telephone to call first. In a competitive market, you need every edge you can get.

A personal computer (PC) is a tremendous help when you're compiling and updating your master list. Retyping it every time you want to enter a new topic can become tedious, and may even stop you from entering updates quickly. A basic word-processing program will enable you to insert and print out topics on a day-to-day basis. Also, the PC can sort topics, thereby making it easy for you to customize lists for select clients.

Another facet of the master list is a travel itinerary that lets clients know where you're going and when you'll be traveling in the future. By keeping clients aware of your activities, you may be able to pick up an assignment on the road or fill a need for an upcoming issue of a magazine. Most publications have an editorial plan that looks months ahead, and although the editors may not be working on a future article at the moment, they usually know what is going to be needed down the road. Keep in touch with them, and you'll be surprised at how much extra work you'll pick up.

How Picture Buyers Use Master Lists

In order to understand the importance of a master list, imagine yourself on the other side of the desk and put yourself in the shoes of a picture buyer. Suppose the buyer works for a national travel magazine. Each month, he or she receives an editorial lineup, projecting articles that will appear 60 or 90 days ahead. Some of the submitted articles have complete illustrations provided, while others have partial or poor picture coverage.

At that point, the picture editor has a few weeks to get the best possible illustrations he or she can for the article. Over the years, buyers develop reliable sources for many areas of coverage, and their first instinct is to call agencies or individual photographers who have come through for them in the past. They usually don't have trouble locating pictures from major tourist areas, such as Yellowstone National Park or Mexico City, but not every article deals with these well-traveled locales.

Once the picture editors have tapped familiar resources, they'll resort to poring over master lists submitted by freelancers. In their search for, perhaps, a photograph of a small-town rodeo in Wyoming, they may come across your master list that includes "Wyoming, Rodeos," or "Western Towns, Festivals." This is where the specificity of listing comes in, and that is when you'll probably get a call.

Once you deal professionally with a buyer, you are more likely to get a call the next time around. When he or she sees that you are a consistent supplier of good photography, you'll then join the buyer's list of regular sources. That is how it works; there isn't any magic involved. All you need is your first lucky break, and then to follow through. For now, suffice it to say that master lists are one of the most important ways in which you let buyers know what you have to offer.

Typical Picture Lists for Buyers

Here is an example of an alphabetical master list with asterisks to denote *in-depth coverage*.

A	Chicago	*France	Las Vegas	**P**	Tools
Abstracts	Children	**G**	Laziness	Painted Desert	Trailers
Agriculture	Churches	Gardens	Leaves	Palm Trees	Travel
Airports	Clouds	Germany	Logging	Parades	Trees
Amsterdam	Colors	*Glacier National	*Los Angeles	*Paris	**U**
Antiques	*Computers	Park	**M**	People	United Nations
Antwerp	Construction	Graffiti	Marathons	Philadelphia	**V**
Architecture	**D**	Greece	*Mardi Gras	*Pinball	*Venice
*Arizona	Dawn	**H**	Masks	Politics	*Vermont
Arles	Demonstration	Halloween	Mexico City	Psychology	Versailles
*Atlantic City	*Denver	Harbors	Mohawk River	**R**	Vietnam
*Autumn	Deserts	Height	Valley, New	Raritan Valley,	Memorial,
B	Docks	Hiking	York	New Jersey	Washington,
Bahamas	Dunes	Hong Kong	Monet Gardens	*Reims Cathedral	DC
*Bangkok	**E**	**I**	*Montana	Rodin Museum,	**W**
Barns	Ecology	Ice	Monument	Paris	Wall Posters
Bastogne	Education	Indiana	Valley	*Rome	*Weather
*Beaches	Elections	Iowa	**N**	*Running	*Western
Belgium	Erie Canal	*Italy	Nature Scenics	Rural Scenes	Landscapes
Bicycles	Evening	**J**	*New Mexico	**S**	West Point
Birds	Everglades	Japan	*New Orleans	*Sailing	Winter
*Boats	**F**	Jelly Beans	Newport,	San Antonio	**Y**
Boston	Farms	Jersey City	Rhode Island	Sand	Yellowstone
Bridges	Fishing	**K**	*New York City	San Diego	National Park
C	*Flags	Karate	Night	School	Yosemite
Cactus	Florals	Kids	*Nova Scotia	Spring	National Park
California	Florence, Italy	Korea	Nuclear Power	Statuary	**Z**
Camping	*Florida	**L**	**O**	*Summer	Zion National
Carnivals	Food	Lace	Occupations	**T**	Park
Caves	Forests	Lakes	Oregon	Tap Dancing	Zoos

A "topic heading list," derived from the same file that yielded the alphabetical master list, might look like this:

Abstracts	Bruge	Venice	Deserts	**Education**	**Gardens**
Color and	Chicago	Versailles	Forests	Art Students	Beekeeping
Design	Cologne		Farms	Colleges	Cultivation
Geometric	Denver	**Countries**	Gardens	Computers	Formal
Multiples	Florence	Bahamas	Lakes	Grade Schools	Greenhouses
Nature	Halifax, Nova	Belgium	Mountains	On the Job	Monet Garden
	Scotia	Canada	Swamps	Religious	Organic
Boating	Hong Kong	France	Valleys	Training	Topiary
Docks	Indianapolis	Germany		Vocational	Vegetable
Pleasure	Iowa City	Greece	**Festivals**	Schools	Versailles
Power	Las Vegas	Italy	Carnivals		
Sail	Los Angeles	Japan	Chinese New	**Farming**	**National Parks**
Working	Mexico City	Mexico	Year	Agriculture	Carlsbad Caverns
Yachts	Newport, RI	United States	Christmas	Animals	Cape Breton
	Paris		Easter Parade	Barns	Highlands
Cities	Philadelphia	**Ecology**	Gay Pride	Fields	Everglades
Amsterdam	Portland, Maine	Agriculture	Parade	Haystacks	Glacier
Antwerp	San Antonio	Animals	Halloween	Harvest	Great Smoky
Arles	San Diego	Beaches	Mardi Gras	Irrigation	Mountains
Atlantic City	Santa Fe	Clouds	New Year's Day	Plowing	Yellowstone
Boston		Construction	Rodeos	Tractors	Zion

LOU JACOBS, JR.

MARKETING YOUR OWN STOCK PICTURES

"Should I sell my own stock photographs, or should I connect with one or more stock-picture agencies to do it for me?" That question is asked by every photographer who contemplates shooting and selling a collection of stock images, as well as by those who have too few pictures yet to market. The answer depends on a number of things, such as your interest and aptitude in selling, how serious you are about shooting stock, and whether you'll enjoy shooting the kinds of pictures that agencies can sell in addition to the kind you like to take.

Should You Sell It Yourself?

Some photographers are really cut out to sell, and some can't face selling because they don't like rejection. Some are less interested in seeking markets than they are in shooting; that is my position, so I work with several agencies. But I know numerous photographers who enjoy the challenge of creating their own stock-picture assignments. They continually build their files, make client contacts, negotiate rights and fees, and welcome being in charge of their own stock business. They believe they'll learn better what to shoot if they're directly involved in selling. Some are reluctant to be tied down by an agency contract and also want to avoid having their images in competition with hundreds or thousands of other photographers' pictures in agency files.

Some photographers have found that their specialties will attract buyers directly without agency affiliation. John Shaw, noted for his wonderful closeups of nature, says, "Basically, all nature photographers today are running their own one-person stock businesses." Such individuals prefer to maintain personalized files and also do what is necessary to promote themselves in the marketplace.

There are also some negative aspects to selling stock photography directly to clients. According to photographer and agency co-owner Grant Heilman, "You can't expect to work profitably in the stock business without a huge existing file of pictures. For a while you won't earn enough to pay for film, but look ahead: the rainbow is there if you're dedicated to details and you can wait for the payoff. Keep in mind that stock photography is very competitive, so quality is vital and creativity is important." He indicates that while you're establishing your stock file, if you let an agency handle sales, you'll be able to shoot more, be less involved in time-consuming details, and have a better opportunity to work at another job while you build your business.

Walter Hodges, a professional stock photographer from Seattle, Washington, sells through two agencies, giving each separate images, and is certain he earns more this way. He says strongly, "Don't sell your own stock unless you have a staff to support the function. You need to shoot. You can't make money selling. If your wife or husband can sell, file, track, and all that, then you might give it a try. Personally, I'd rather go fishing."

In theory it is refreshing to know that if you lease a picture directly to a client, you'll earn the whole fee while a stock agency making the sale for you usually takes half of the money. But that isn't the whole story. Besides payment for shooting time, your income also pays you or an assistant for finding picture markets, sending work to clients for review, filing the images when all or some are returned, negotiating fees, and billing clients, perhaps more than once when they're late paying. Lost or damaged slides leads to additional work and headaches. The overhead of an assistant and the expense of promoting your pictures with mailing pieces or advertising are also expenses, so you aren't keeping the whole sales price of pictures.

While specialists in stock subjects probably net more by marketing their own pictures than by selling through an agency, they work harder handling all their business operations and have less time to shoot. As such it is an illusion to believe that you'll do twice as well financially by not sharing fees with an agency. Choose to market your own work for the independence and control it offers and for the satisfaction of developing personal contacts in the marketplace.

The subjects you photograph should also help you determine how you want to market your work. Those who specialize in photographing animals, babies, or flowers, for instance, can market their work *directly* to clients with more ease than those who shoot a large variety of subjects. Why? It is simpler to monitor the needs of markets for specific pictures than it is to sell all over the client spectrum. A friend who is noted for his pictures of professional football says buyers are more likely to contact him. He regularly sends lists of new material to clients, and with an assistant to fill requests he can spend more time planning and shooting. When the football season is over, his pictures continue to sell for the next season, although he switches to shooting many species of snakes, toads, and lizards. Some of these creatures are kept in crates near his office, and pictures of this second specialty are starting to do well, too.

The number of pictures in your files may also help you decide whether or not to sell them directly. Photographers with a vast number of slides or prints may be more comfortable if an agency handles their work in order to spend more time taking pictures. Prolific shooters could choose to hire an office assistant to deal with marketing, which they can oversee while they stick to photography.

Photographers with a small file of pictures, such as 1,500 or 2,000 slides, might give their images more personal attention by self-marketing. Once they build their files further, they might turn some or all of the marketing over to an agency." On the other hand, part-time shooters may be happier to make agency connections immediately, depending on their aptitude in finding markets, promoting themselves, and negotiating business arrangements.

However, while a dependable agency can be comforting, a satisfactory agency alliance is usually more difficult for the part-timer to find. One agency owner told me recently, "An agency may only do a fair job of guiding some photographers about what to shoot, and it often doesn't give them much feedback about their images. Photographers will find that guidance and feedback depend on their importance to the agency. The more you shoot and submit and the better your pictures sell, the greater the attention you get. As an alternative, being dependent on your own resources may be scary at first, but it will prepare you for a more independent future."

Selling your own stock photographs means having less time to take pictures and research markets in order to be aware of what is being published. Self-representation also means you need marketing guides, as well as negotiating and promoting techniques. Remember, whether you sell stock yourself or through an agency, you must be a self-starting individual in order to be successful. Consider your own needs and abilities objectively. Finally, you can sell stock yourself and have an agency selling it for you if you learn to avoid the inherent conflicts.

Salesmanship and Business Aptitude

Marketing stock images means selling yourself at the same time. Selling directly to clients, you're knocking on unopened doors by telephone, mail, or in person; dealing with strangers; and representing yourself as well as your pictures. If the thought of having to do these things makes you uncomfortable, connecting with a stock-picture agency might be a better option. But if you like meeting and talking with people, researching your own pictures, sending requested pictures out, and can make decisions without anguish, selling your own stock should suit you well.

Selling directly, you may negotiate your own fees rather than accepting fees an agency negotiates for your pictures. That requires standing firm and sometimes risking the loss of a sale when dealing with a buyer who wants your work on a cut-rate basis. In such a case a stock agency should have more clout than an individual, but that isn't always true. Agencies are known to discount pictures to steady users "because they buy so many a year." On your own you might also choose to favor a frequent client price-wise, but the decision is yours.

Being in business for yourself gives you more control over the rights you license, which influences your fees. "I know what my work is worth," a well-known shooter told me, "and I hold out for fees that fit the rights I'm leasing. If I choose to compromise, I have good business reasons and I'm accountable only to myself. I used to sell through XYZ agency and while it had respect for my pictures, it also had a huge overhead. It licensed some of my best chromes for a lot less than I expected because it didn't try hard enough. The agency would say, `We'll sell those same pictures more often than you will,' and that is true; volume makes a difference, but I still receive only half of the money it collects."

If you prefer to handle business details, negotiate sales rates and rights, and feel you can protect ownership of your work better than anyone else might, selling your own stock may be right for you. Success requires drive, organizational talent, convictions about the quality of your work and what it is worth, and an ability to handle such details as filing and filling out delivery memos. Freelancing in any creative business takes determination and character that can withstand what I call living in "permanent insecurity."

While selling your own stock, you must also continually educate clients about the value of photographic rights and the differences in photographic usage. Education includes informing buyers about the meaning of copyright and explaining the reasons why you're asking a higher fee for a specific use of stock pictures. Clients are often on a company payroll with directions to get your pictures for as little as possible. Large or small, stock users will complain to you about having a "tight budget." Sometimes business discussions become confrontational, so the kind of tact and salesmanship you use, combined with your self-confidence, experience, and aptitude at negotiation, can help determine your success. Your personality should be tuned to win friends and influence people without being exploited.

It is amazing how you can establish a rapport with an art buyer at an ad agency, book publisher, magazine, or any other user. And just when you're feeling a little smug about receiving stock requests regularly, that person is transferred or fired. Along comes a new art buyer who may like your work but may have other favorite stock suppliers already. Even if you continue to sell to the company, the new contact may have to be educated about the value of a photograph so what you've been charging won't be lessened. Diplomacy and skill are valuable ingredients in your approach, especially when you sell your own stock. The goodwill and relationship you develop with picture buyers will produce repeat sales and motivate them to remember you when they move to a new company and have stock-photography needs.

But be aware that someone may try to stretch your goodwill to undermine your rates or rights on the basis of friendship. A class in psychology or in negotiating can help you deal more effectively in the business world and give you more confidence. Even with training, trial and error will teach you a lot about how other people think and act in business deals. You don't want to be known as a hardhead or an easy discounter.

Who Do You Want to Sell to?

Answers to that question will depend on what subjects you like to shoot as well as your style or approach. Analyze your photographs and the markets you've sold to previously or the ones you would like to attract. Consider your visual and personal interests. What kind of pictures and subjects do you like to shoot most? What do you dislike shooting and want to avoid? Would you prefer to set up subjects and concentrate on markets for them?

If you think and shoot in a kind of journalistic style, selling to magazines, newspapers, books, and some industry annual reports should be your goals. There are all kinds of publications in the editorial field, and many unposed pictures don't require releases because they are newsworthy or educational. Become familiar with as many potential editorial markets as possible, study magazines at the library, look through textbooks, and note the variations of stock images. Setup shots showing, for example, babies, gardening, or couples, in addition to nature and travel subjects are popular with these buyers.

If you enjoy studio shooting with lights, props, and models, advertisers would be ideal clients for your work. People in everyday photographic situations can also be set up on location, using portable fill lighting and reflectors. A typical picture may show a grandmother and a grandchild enjoying a leisurely afternoon in a park or backyard. Illustrative pictures that tell a minor story and are symbolic of everyday life situations are popular stock subjects. Stock prices for advertising are higher than editorial work, but competition in the advertising field is greater. Releases are necessary for recognizable people, pets, and some types of homes and buildings.

If you are good with people and like technical subjects, targeting corporate markets would make sense. Annual reports, brochures, company newspapers, and sales-promotion shows using slides with music and a soundtrack are common stock uses. There may be hundreds of companies in your area and farther away that regularly want only stock pictures, and they may be easier to find than major advertisers or more distant editorial clients.

If still-life or architectural subjects are your favorites, advertising, editorial, and corporate could all be markets for your stock shots. When you look through books and magazines note the variety of these subjects, which may have come from stock files. If you prefer shooting nature, animals, landscapes, seascapes, and what may loosely be called "travel" photographs, markets for stock are magazines, books, some advertisers and corporations, as well as greeting-card, calendar, and poster publishers. However, thousands of part-time stock shooters concentrate on outdoor subjects, and one buyer told me, "I won't even look at another shot of the Grand Tetons unless it is excitingly moody or dramatic or something I've never seen before. Mountains or national parks are in the public domain, they're sitting ducks, and stock files everywhere are full of them. Some travel subjects *are* hard to market, but if you are original and resourceful enough, your efforts might prevail."

Photographic flexibility is more than desirable, and it is often necessary to shoot numerous subjects that appeal to different markets. Capitalize on your own pictorial strengths and talents for profit.

Marketing Newsletters
Back in 1976 Rohn Engh, author of *Sell and Resell Your Photos*, began publishing a monthly stock marketing newsletter called *Photomarket*. It listed magazines,

greeting-card and textbook publishers, and other potential buyers of stock with some of their current needs. *Photoletter*, which is still available monthly by subscription, lists the lowest-paying markets. *Photomarket* is an Engh semi-weekly that lists higher-paying markets. *Photobulletin* comes out weekly for more established professionals who receive it by fax, computer modem, or overnight mail. Engh also offers videotapes on selling stock.

In 1990 Jim Pickerell, who wrote *Negotiating Stock Photo Prices*, began publishing *The Stock Shooter*. This newsletter doesn't include specific markets but does cover many business aspects of stock. Pickerell reviews agency performances, talks about commissions, and gives cogent advice about selling your own stock. His first issue included a survey showing that more pictures of people and family life were found in stock-agency catalogs than any other type. Business and industry, travel and destinations, and nature and scenics followed. *The Stock Shooter* is published six times a year.

Photographer Brian Seed publishes *Stock Photo Report* monthly. It provides information about new markets, agency reviews, data on legal developments in the field, and trends in stock photography worldwide. Seed evaluates editorial and advertising markets and includes their page and assignment rates when applicable.

Photographer and stock-agency owner Royce Bair publishes two marketing newsletters, *Pro-Fax* and *ExpressLine*. "They let you know what clients all over the nation want to buy," he says. You should have at least 3,000 stock photographs on file to effectively utilize *Pro-Fax*, and more than 1,000 filed images to make subscribing to *ExpressLine* worthwhile. At least three stock requests per day are sent via *Pro-Fax* five days a week, averaging 21 times a month. *ExpressLine* is available via recorded messages and mailed newsletter about 11 times a month.

The Guilfoyle Report is a well-produced quarterly newsletter directed originally at nature photographers. Its scope has widened to include evaluations of the magazine, textbook, card, calendar, and travel markets.

Advertising Your Business in Catalogs
Professional photographers may advertise their stock files in several annual books distributed to prospective clients, but these media charge several thousand dollars a page and are better suited to assignment photographers. But two catalogs are tailored to stock photographers.

AG Editions publishes a thick directory called the *Green Book*, whose subtitle is "The Directory of Natural History and General Stock Photography." The 1991-1992 edition describes the stock files of 403 photographers and photo agencies. According to the book's introduction, "Most *Green Book* participants are natural-history specialists. But many also have general stock files, including travel and outdoor adventure subjects." Photographers and agencies provide and pay for their own listings, which include types of subjects, geographic areas, publication credits, and personal comments. The *Green Book* is sent to thousands of magazine and corporate buyers, book editors, and

researchers. This classy publication details promoting your stock files. The listings of so many stock photographers may give you a complex, but they'll also give you insights about the stock business.

Describing itself as "the only direct-access stock catalog" is a new publication, *Stock Direct*. In this book individual stock photographers can show and advertise their stock images in numerous categories. "It puts you and the buyer together," says the brochure. "No middlemen, no fees, no commissions." You can place a full-page ad in one category or choose quarter- or half-page units in several categories for the same $1,950 per-page price. *Stock Direct* is distributed free to about 20,000 firms, such as ad agencies, publishers, public relations, and design companies. The publishers of *Stock Direct* seem to understand the needs of photographers and buyers as well.

Promotional Mailers

These may be 8½ x 11 individual sheets of quality paper printed on one or both sides with some of your choice stock images. Some mailers are folded in various configurations. Your name, address, and telephone number should be included along with a short sales pitch if you wish, such as, "The finest images of America's rivers and lakes." If hiring a designer is too costly at first, make your own layouts and rely on a good printer for advice and direction. When you get cost estimates on printing your mailer, remember that all printing quality isn't the same.

The expense of promotional mailers may seem high because you need only a limited number at one time, perhaps just a few hundred. But self-promotion helps you compete, and you may reduce the cost by arranging with the printer to use your mailer for his or her own promotional advertising, complete with imprint. If the printer is agreeable, the cost should be cut or eliminated in an even trade. If that isn't feasible, you may get more reasonable printing charges by promising to come back in four to six months with another order. Sending mailers at regular intervals is a good practice, even after you're established, especially if your sales efforts are aimed at ad agencies. Plan a promotional campaign you can afford over a one- or two-year period. This could more than pay for itself in sales.

Showing Photographs to Buyers

Responses to your picture lists, promotional mailers, or personal letters will usually come by telephone or mail. Typically, requests will be fairly specific. Listen carefully and make written notes to clarify the order. Mention your rates and rights if the buyer doesn't ask in order to avoid misunderstandings later. Choose pictures carefully. Send a few similar pictures when you have them in order to give buyers a choice.

Editors and art directors appreciate the opportunity to make selections. But they'll be annoyed to receive material that is unrelated to their needs. If you're asked for good shots of the Canadian Rockies, unless you query ahead of time and know that it is okay, don't send images of the Rockies in Colorado as well or instead. It is smart to find out how extensive the buyer's needs may be, so you may suggest photographs the buyer didn't think to ask for. For instance, if the request is for "children playing a game," find out if the client wants an indoor or outdoor setting, and how many children would be ideal. Does the client prefer an action game or a card game?

Remember, your talent as a photographer isn't everything. You have to be a communicator as well. Clients value tactful, friendly communications and they're usually rushed, so be systematic and friendly. Save chattiness until you know people better. These suggestions come under the heading of enlightened self-interest.

Be sure that your name and copyright symbol are on every slide or print (they can be on the back). When you type out a sending list, add more caption data where necessary. Carefully log each photograph by file number. *Never* neglect these steps in haste. Being thorough is a form of business insurance. The good records you keep may save your business reputation and can add to your profits.

And when you send your pictures to potential clients, be sure to include a delivery memo. There are various ways to fill out a delivery memo for pictures. Briefly, pack slides and prints well to avoid damage and then with a delivery memo, send them by insured or registered mail or an overnight-express service. If you use the United States postal service, buy a return receipt. Become familiar with insurance specifics for the carriers you use. Find out if the insurance you pay for covers replacement value of the pictures up to the limit you set, otherwise the carrier will try to re-evaluate your pictures. Some carriers offer a $100 insurance limit unless you pay for more. If you use a mailing service to send your work by the United Parcel Service or another carrier, determine who is responsible in case of loss or damage. The mailing service deals with the carrier but may say that it is only your agent, while the carrier may ignore you and deal only with the mailing service. Try to avoid such Catch-22 situations.

The best evidence you can have in case of loss, damage, or unauthorized use of pictures is paperwork. This includes a delivery memo, shipping lists, and delivery receipts. An important warning: *Never send unsolicited pictures to any prospective stock user.*

Anyone receiving unsolicited pictures isn't responsible for them. With your copyright symbol on each picture, the shots can't be legally reproduced, and if they *are* reproduced, you can collect damages. But unsolicited pictures may be thrown away, carelessly or on purpose. Paperwork is your protection.

Suppose that you've contacted a buyer with a list, letter, or promotional material, and you get a telephone call asking for specific pictures. The pictures *are* solicited but the company may be unknown to you, so ask for a faxed request in order to have something in writing. If you have no fax machine, try a fax service nearby. If time permits, ask for a letter request. You can say diplomatically that since you don't know the client, you've been advised to get something in writing.

LOU JACOBS, JR.

THE BUSINESS SIDE OF SELLING STOCK

Now you are ready to get down to the nitty-gritty of stock-photography business practices: negotiating and setting fees, copyright, protecting rights, and making the most of paperwork. As one photographer told me, "There has to be a paper trail that tabulates what you're sending and substantiates your fees, as well as the replacement value you put on the work. Everyone needs to keep good records to stay in business, and it is easier today because of computers."

Although I assume that average stock photographers who sell their own work or market through an agency, run a solo operation, most of the information in this book applies even if you have an assistant or a staff. As stock files multiply and your work is in more demand, you may need help in the office or while shooting, but wise business techniques stay the same. Success will make you more inclined to remain firm when negotiating fees and protecting your rights. Being part of a team can be a very satisfying arrangement. Talk to an accountant so business benefits are assured for you now and in the future.

How Much Should You Charge?

You may be quite familiar with this fundamental, but I'll repeat the primary business principle of "selling" stock: *Ideally, you lease reproduction rights; you don't sell the actual images which must be returned to you after use for further leasing.* Legal permission to print your pictures is governed by the rights you lease. Charging for usage and setting time limits have been long practiced by photographers as well as writers and composers. For example, Cole Porter licensed only limited rights to his song "Anything Goes" to a record company. He also licensed rights for sheet music, for a motion picture, and for use in other media. He retained ownership of the copyright to the music. He leased usage rights, which is logical and financially sound.

The same reasoning applies to leasing or licensing the use of stock photographs. You own the copyrights, and you should benefit each time images are reproduced—no matter where. Cole Porter and many other creative people earned a great deal of money licensing their original and often unique work. You are creative with your camera, as well as your visual talent. So when I talk about "selling," I mean leasing or licensing pictures that I continue to own. Only in rare cases does a photographer actually sell an original picture for exclusive usage, and then the fee is usually many times what it would be had the picture merely been leased.

Would it seem desirable if the reproduction fee for your photograph of a sailboat gliding full tilt through ocean waves, complete with a handsome background of blue sky and white clouds, was determined through continually updated data sheets supplied by The Union of Photographic Price Setters? Of course there is no such outfit for legal and practical reasons, but if there were,

perhaps a visually superior image and a more ordinary one would have to be sold for the same price. Uniform pricing tends to ignore the special merits of pictures that aren't all equally appealing or exciting.

Deciding what to charge for stock photographs in a free market has its risks. When you're pricing for usage, keep these criteria in mind:

Where and how the client intends to use the photograph

Whether the picture is for advertising, editorial illustration or other usage

The uniqueness of the picture

The client's budget or prevailing rate of payment

The publication's circulation

The length of time the client needs the photograph

The time and expense invested in getting the shot.

As you consider these basics individually, remember you are a businessperson as well as a photographer. Also keep in mind that it is normal to be overanxious in the beginning. You want to see your pictures in print, so when a buyer calls and asks how much you charge for that sailboat shot, you may undercut yourself by quoting too low a fee. Being overeager can result in charging too little, but you'll soon discover that it is all right to talk about money and to ask a fair fee based on the criteria listed above. Keep in mind, too, that the buyer isn't doing you a favor. Your photograph is needed for a specific place in a publication, a poster, a greeting card, an ad campaign, or whatever. Photography may still be a serious avocation for you, but to the buyer it has commercial value.

The question of how the photograph is going to be used may appear to be a simple consideration, but it actually isn't. There are many facets of usage for you to investigate before you come up with a price for the buyer. These include:

Type of medium. Whether you lease to a newspaper, magazine, brochure, or poster influences the charge for usage. Rates for advertising use are higher than for editorial because in advertising, stock pictures occupy space purchased by companies to influence people and make profits. The same is true for stock images in annual reports and business brochures. For editorial use in a magazine, however, the value of a photograph is determined by its size and uniqueness as part of an article or other spread.

Size of the final image. Another important consideration is the size the image is going to be used. The base for usage of photographs is considered a quarter page and one-time use, and other rates are established from those figures. A use smaller than a quarter page is usually billed at the quarter-page minimum.

Circulation. Fees charged for use of a photograph in advertising also depend on the circulation of the

You may also find it necessary to charge a *holding fee*. Usually, a client holds pictures sent for review for two weeks without being charged a holding fee; however, photographers and stock agencies can't afford to have potentially profitable images remain out of circulation in the marketplace for unlimited time periods. Holding fees can pressure clients to make more timely decisions. After a stipulated time, a fee of $5 per week per transparency, or $1 per business day, may be charged. This charge should be stated in your delivery memo. In *Negotiating Stock Photo Price* Pickerell says that most textbook publishers hold photographs "unusually long, and some companies encourage photographers to send dupe transparencies. Costs of duping could be unusually high," he adds, "greater than the total income you might receive from the sale of usage rights to textbooks."

How you handle holding fees depends on various circumstances, such as how a client may respond to reminders that you want a decision and the conviction you have about operating in a business-like way. Holding fees or research fees are optional but may serve you well to expedite inefficient buyers.

Understanding Copyright

The copyright law is the primary legal device by which a creator proves and maintains ownership of published photographs. The copyright sign—©—on a slide or print warns others that they may not reproduce or exhibit the work without first getting permission and, usually, by paying for the rights. If a photograph has no copyright notice on it, it is still protected by the copyright law and by the Berne Convention, which doesn't require a notice to be placed on the work. Occasionally when no copyright notice is there, someone may not bother to contact you about rights or fees and may ignorantly assume that the picture is available simply because it is on hand. This can lead to headaches even if payment is offered later. It is good business practice to stamp a copyright symbol on your work with a year date; if you ever have to sue, this is a distinct advantage.

The copyright law places ownership of pictures in the hands of the person who made the exposures unless there is an agreement in writing to the contrary. The main exception to automatic ownership by the creator is a category in the copyright law called *work-for-hire*, which primarily covers *salaried* photographers. The law says employers own the copyrights to pictures taken by employees unless other arrangements are made in writing. This affects company photographers and isn't related to working with a stock agency. However, if a prospective buyer asks you to sign a work-for-hire agreement, you should know that you're handing over ownership and copyright to your work—and you should have a very good reason to give up future sales of a stock image. A huge sum of money is often a primary reason.

There is also *joint copyright*, which means that two or more individuals hold the copyright on a photograph. This would cover a team who shoots stock together. Only in special circumstances is a photograph part of a "joint work" even though it may be combined with other pictures in an ad or editorial piece.

Always label your slides and prints with a copyright symbol, the year, and your name. If you shot a picture several years ago and it has never been published, you may date it the year you first submit it for publication. The copyright notice may be handwritten, but using a rubber stamp is more efficient. The law says that the copyright notice must appear in a "conspicuous area" of the photograph in order to be valid. Either the front or back of a print or slide mount is suitable.

With or without a copyright notice, when you submit pictures you've taken and you own to a client or agency, the images are copyright-protected. If a publication fails to use a copyright notice with your credit when your pictures are printed, your ownership of the material isn't affected. Copyright of the publication itself also protects your pictures.

And although it isn't required, there are several good reasons to register your photographs with the Register of Copyrights. Request Form VA from the Information and Publications Section and ask for Circular 1, called "Copyright Basics," which explains all the ramifications in clear detail. In addition to individual pictures or a collection, Form VA can be used to register books, brochures, posters, postcards, advertising materials, and individual ads.

If your published photograph has no copyright notice on it and hasn't been previously registered, you have up to five years to register it. However, you must copyright your pictures within three months after publication if you want to collect full damages in case of infringement. "Copyright Basics" explains it all.

The fee to register a photograph is about $20, and you must send one copy of the work. Since you would go broke registering one picture at a time, for convenience and economy unpublished slides or prints may be bulk-registered. (Published work is ready to send in a magazine or book, when you haven't previously registered the pictures in your own name.) For bulk registry, you can assemble a lot of slides in plastic sheets in a looseleaf notebook. Keep a concise list of all pictures by number for your own records, or make a duplicate notebook. Be sure to send the collection with one Form VA and one registration fee. Give the collection of pictures a title, such as "Collected Work of J. P. Photographer, January-October, 1992." In this way the Copyright Office can easily distinguish each of your image collections from the others. Call or write the Copyright Office if you have questions.

There are several other ways to register groups of pictures. You can photograph a group of slides on a light table and send enlarged prints, or using a copy machine, make sharp color copies of 20 slides inserted into a plastic sheet. Send contact sheets of black-and-white or color negatives for bulk registration. Dupe slides shouldn't be too far over- or underexposed so the images can be

readily identified. Sending a very similar slide instead of a dupe you want to copyright isn't acceptable; the "almost-like" picture could lead to complications the Copyright Office wants to avoid.

In terms of copyright, the most frequent problem photographers encounter is unauthorized use of pictures by prospective clients who happen to have your slides or prints on hand. Whether or not your copyright notice is on the images, you can claim infringement. When legal action is necessary because of infringement, the picture must be registered previously. (As mentioned earlier, you have three months after first publication to do this.) If the user is obstinate, point out that your copyright has been registered and that the user may be liable for $10,000 in damages and more for "willful" infringement, which means the user knew what it was doing. You'll need an attorney at some point if the user isn't willing to pay a fair fee, and you may also sue to collect legal fees.

However, in case of copyright infringement it is good practice to discuss the problem with the user and determine a fee. You may now negotiate for more money than you would have asked had the two of you discussed payment before the shots were used. According to photographer Mark E. Gibson, "A procedural infraction we encounter is clients that select a photo, go to press with it quickly, and then try to negotiate a low fee after it's in print. We explain this 'shopping' procedure is backwards, and we charge accordingly."

To help discourage unauthorized use of pictures, you may use slide enclosures that when broken open can't be resealed. There is also a transparent "anti-ripoff" seal to tape over the edges of a slide mount. It says, "Copyrighted image—No unauthorized use—$250 minimum fee if any seal is broken."

The Art of Negotiating

Part of stock photography is the pleasure of shooting pictures and seeing them published. Smart business practice includes understanding leasing rights and using business forms. You wear two hats: you are a creative person and a businessperson. Even if stock is a part-time enterprise for you, operating at a loss is discouraging and eventually will cause the IRS to deny some or all of your expense deductions. Therefore, to support your creativity and advance your business, you must become a reasonably good negotiator.

As you know, business is partly a social process. Working with local clients, you may have a chance to know them better, and they you. When clients are out of town, get acquainted over the telephone when it seems appropriate. I recently read about a successful investment banker who hosted lunch in his private dining room for visiting celebrities and local friends. "No real business gets done at these luncheons," said one guest. "But what is business, really? Doesn't it start with the assembling of goodwill?" That's the basis of successful negotiating.

Dick Weisgrau, old friend, former photographer, and currently the executive director of ASMP, holds another view. He says, "Negotiating is the process of resolving disagreements. It's a logical extension of the selling process; it's a technique you can learn. Even if there is no disagreement between you and a client about rights or other conditions of a stock deal, fees may have to be negotiated to arrive at an agreeable figure between what they want to pay and what you want to charge."

There is a wealth of information available about negotiating for the sale or lease of photographs in the *ASMP Stock Photography Handbook*. In Jim Pickerell's *Negotiating Stock Photo Prices*, he explains his beliefs about negotiating the minimum pricing goals photographers might maintain. "My definition of being professional means being paid at a level that would enable a person to support himself in this profession. However, don't feel that if you aren't making a full-time living as a photographer, you aren't qualified to charge 'professional' prices for your photographs," he says.

Keep that in mind as you study the art of negotiating. When clients find your stock images worth paying for, the fees you charge should be based on that fact. Don't put yourself down and be tempted to charge less than basic fees because you are a part-timer or because you don't have much of a track record yet.

Maria Piscopo, author of *The Photographer's Guide to Marketing and Self-Promotion*, sees negotiation in a different light: "Photographers weak on business practices and pricing tend to attract clients who know how to take advantage of that weakness. Protect yourself with strong pricing policies and standards for pricing."

Your business success depends in large part on your ability to make agreements that satisfy yourself and clients you would like to hear from again for future stock sales. When making deals, you must strive to be clear in what you ask or state, so that confusion and misunderstandings can be avoided. Your manner on the telephone, in person, and/or in writing should be friendly. And you should make your interest in the client's picture needs clear even if this seems evident. Strive for a calm, cordial approach. You want to be relaxed, so the client's mood will be friendly, too, even if he or she sounds frantic. Establishing a rapport is important, and the way you do it will differ according to the personality and business position of each client.

Psychologically, your awareness of how clients think pays off handsomely. Learn as much as you can about what they want, the type of pictures, the usage planned, and any special conditions, such as space needed for type. If a client isn't clearly informed, explain that you can't quote a price until you know these things, and that not all your stock images are priced the same way. Some may have cost more to produce because of, for example, model fees or high travel expenses. Perhaps you have a specialty that few others can offer, or you have access to remote countries or industries. You may work well with children or animals, you may have an unusual panoramic or high-speed camera, and in particular, your years of photographic experience count. These are all abilities the

client may not be familiar with. You'll hear it over and over: client education is a consistent part of the stock-photography business.

But negotiating shouldn't be a contest. You aren't in a personal confrontation that one person wins and one person loses. If there is a clear winner and a clear loser, the negotiations have failed you or the client in some way. Find out what is negotiable. Once you have the facts and a price is offered, look at the deal and decide if you can accept it.

When you're asked to discuss photographic fees, it is important to know as much as possible about clients and their requirements, and to take your time. Never rush or be hurried through a negotiation. Explain that you're shooting or involved in another deal, and offer to call back soon. It can be risky to start answering questions without adequate preparation. Then you may refer to your own pricing list or perhaps call another photographer for advice.

Many professionals will be helpful when you ask about pricing because if you aren't sure of a fee and you underprice your pictures, you're really hurting the market for other photographers who are experienced. By checking with a veteran and getting a recommended range of fees, you're helping maintain standards in the stock field in general. You may charge at the lower end of the range if you're just starting out, but try not to diminish your own value because you don't have a lot of years in the stock business.

When you discover the client's idea about a fee for pictures, ask yourself, "At what point will the client compromise and still feel that it came away satisfied?" One way to accomplish this is to imagine trading places. As the other party, how badly do you want this deal? How important do you seem to the client? What kind of fee limits can you imagine the client envisions? Does the client seem to be under pressure to make a deal with you? Asking yourself how the other person sees his or her goals and bargaining position can help stimulate your negotiations.

During negotiation, you should also show empathy. When appropriate, acknowledge the client's point of view. For instance, if a buyer says the budget allows only X dollars for a wanted stock shot, you might respond, "I understand you have pressures and I'd like to accommodate you. But I've researched the market with some colleagues, and the fee I've quoted is slightly less than average for the usage you want. Perhaps if you told this to your people, they'd be more satisfied." Suggest the buyer check and call you back. If the client wants to continue negotiating, suggest a fair fee. That may be what the client wanted all along.

Let clients know that you really want to make a deal, and you feel they do, too. Speak candidly when you negotiate. You aren't saying you'll accept their offer, but you're showing that the sale is important to you, as is their business. This can pave the way for a compromise on the fee if that is your goal.

Listen carefully. Perhaps the buyer will offer a fee for pictures that you find acceptable, and this is fine. But maybe you wait for a question about fees, and none comes. Listen and analyze the client's tone and the words used. If they are upbeat, you may be inclined to quote a higher fee to start than you would otherwise.

Consider options. If clients hedge when you ask what the budget allows, find an opening and ask again what they're prepared to pay. If the response is still vague and they ask how much you would charge, offer a range, such as $250 to $500, "depending on how the picture will be used." Good negotiation means you keep your options open and are ready to propose alternatives until both sides can settle on satisfactory figures. If the buyer immediately accepts the $250 figure, ask more about usage. Then say something like, "Based on what you've said about circulation and the size, a more realistic price would be $375." You may get a lower counter offer or a "yes." In either case, you've tried to be flexible.

Delivery and Invoice Forms

The essence of good business, and an excellent way to avoid conflicts and confusion with clients, is thorough record-keeping; this is also referred to as "paperwork." No matter how friendly a picture buyer may seem, an oral agreement is too easily misunderstood and can be a problem when solid evidence of your viewpoint is a necessity. Written agreements are helpful to photographers and clients alike because their respective obligations are clearly visible to all. If there is a disagreement paperwork is far more reliable than memories, which may fade and become subjective.

As discussed earlier, one of the most important parts of your paperwork is the stock-photography delivery memo. Be sure to send a delivery form in either the standard ASMP format or your version of it, with all stock submissions. It should have your name, address, and telephone and fax numbers on top, or the form may be printed on your letterhead. List the pictures being sent with their file numbers plus other data and an evaluation of each in case of loss or damage. List picture titles only if you choose to send more detailed captions separately. If you need more room, use another page to list additional slides. It should also have your name, address, and other pertinent information on it and be marked "Page 2 of 2" (or whatever). Note that "Terms, Conditions" should be printed on the reverse of the first page in case the two (or more) pages get separated.

Make a photocopy of the delivery memo (except for the standard terms and conditions, which you should already have on file). File copies of the delivery memo along with client correspondence, a photocopy of the slides if you make one, and/or the slide list with expanded captions.

The delivery memo serves as an agreement that gives the client 14 days to make a selection and stipulates a holding fee along with other conditions. Paragraph 3 of the terms and conditions makes it clear that the user may

only examine the photographs and make a selection. The delivery memo doesn't grant any reproduction rights, which are licensed by the stock-photography invoice. Paragraphs 4 and 5 obligate the user to take care of your pictures and return them safely, and makes the user liable in case of loss or damage.

Paragraph 5 of the terms and conditions stipulates $1,500 each (*or another amount of your choice*) for loss or damage to each original slide. You should also indicate a specific dollar amount for loss or damage of dupe transparencies (less than originals), black-and-white negatives and prints, and contact sheets. Court decisions, in New York especially, have recognized the $1,500 figure for loss of an original slide, but there are other circumstances to consider when evaluating your work. While $1,500 has been asked for and collected by some photographers for loss or damage of their slides, prints, and negatives, the amount should bear a reasonable relationship to the provable value of the work in these terms: your experience, fees collected or usage prices charged for other similar pictures, individual style and reputation, the ease or difficulty of shooting the slide(s) in question, unusual expenses involved, and the volume of your stock sales.

You can see why stock photographers find delivery memos important: all that small print gives you a useful framework for business transactions. Courts find delivery memos helpful in making decisions about lost or damaged photographs, and using the memo form indicates that you are a professional.

Practically speaking, if you are an aspiring or new professional, using a delivery memo is a good business technique. However, value your work according to your experience and ask advice from other photographers. If a user lost or damaged some of your slides during a negotiation about their value, your stipulated price may have to be lowered. So be sure to set it high enough at first. Consider a figure somewhat less than $1,500 to express reality.

Another essential piece of paper is the stock-photography invoice. You may have your own invoice form, but the ASMP format has terms and conditions on the back that, as discussed earlier, can be very helpful in case of disagreements. Again, use your letterhead or be sure to include basic identification on the invoice. Not only does the invoice indicate what you're charging for the pictures involved, but also serves as a license of rights. This, then, is your written permission for the client, preferably after payment is made, to use the pictures within the limits you've discussed and indicated on the invoice. Be specific in the terms you record on the invoice to help avoid confusion, ill will, and possibly even litigation later.

Look especially at Paragraph 11 of the terms and conditions. The *ASMP Stock Photography Handbook* explains that if you want arbitration to occur in your home state, and in some areas if you want to assure the possibility of arbitrating, you must fill in that blank and have the invoicing memo signed by the client. This book also states that the arbitrating provision is included because that means of settling disputes is generally faster and less costly than going to court. In some areas litigation may be preferable, so ask an attorney about using the arbitration clause.

Notice that the terms and conditions of the stock-photography invoice also request the safe return of all materials, editorial credit line and copyright notice, liability in case of the misuse of photographs or model release, timely payment, and free copies of printed materials.

When you know in advance what pictures will be used, you can send a delivery memo and stock photography invoice along with the images. This is likely to happen when your picture is known from a catalog or other reproduction. Remember that rights granted have to be filled out on the invoice in any case. Another important business form is a model release, which is particularly necessary for advertising stock photographs.

To ensure success in all facets of finding and servicing stock markets, you should find both shooting and business activities to be a challenge. If you don't enjoy contacting people, keeping track of submissions, and negotiating fees, you'll be better off spending your time shooting and selling your work through a reputable stock-picture agency.

It is impractical to discuss whether you're making a profit from stock, or how long it will take. Each person's situation is different. When you've been in business a while, assess your expenses and income along with your satisfaction. If you are happy and feel success coming on, you've made the right choices. It is very likely that success means you've also made some wise business decisions.

Clearly, negotiating rates and rights for any sort of stock photographs requires knowledge of the market and how to compromise. Gracious compromises can satisfy clients and achieve the points you find acceptable. Flexibility, conviction, and awareness are also essential to successful negotiation.

INDEX